ART BASED GAMES

D1344490

7

ART-BASED GAMES

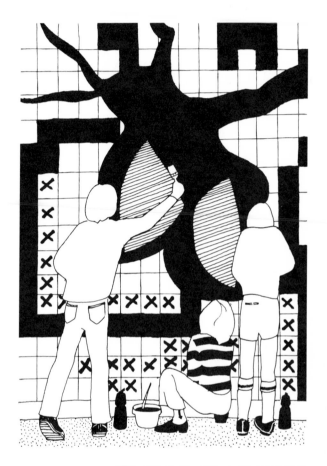

DON PAVEY

METHUEN

First published in 1979 *by*
Methuen & Co. Ltd
11 *New Fetter Lane, London* EC4P 4EE

Filmset by
Northumberland Press Ltd, Gateshead, Tyne and Wear
and printed in Great Britain by
Fletcher & Sons Ltd, Norwich

ISBN 0 416 71420 X *(hardback edition)*
ISBN 0 416 71430 7 *(paperback edition)*

British Library Cataloguing in Publication Data

Pavey, Don
 Art-based games.
 1. Arts – Study and teaching
 2. Educational games
 I. Title
 707′.8 NX282

 ISBN 0–416–71420–X
 ISBN 0–416–71430–7 Pbk.

Contents

vi Contents

List of figures

Acknowledgements

Without the initial suggestion of Dr Michael Smith, Head of the School of Liberal Studies, and his continuous support, and that of the Directorate of Kingston Polytechnic no project could have come about. I am especially grateful, too, to Dr A. G. Catchpole, Chairman of the Research and Consultancy Committee, for his understanding of and patience with our special research problems.

I am grateful to Professor Bruce Archer and staff of the Department of Design Research at the Royal College of Art for introducing me to axiological ethics, though opinions and arguments in the text should not be attributed to Professor Archer or the RCA. I am also grateful to Tina Eden (Design Research and Painting) at the RCA for participating in Art Arena games and exhibiting Art Arena material at the 'Games and Simulations' exhibition at the RCA.

It is difficult to believe that there could have been a project without the team we have had; the inspired work of Ken Beagley (games sculptor, teacher and social worker) who thought of the name Art Arena, and Jill Beagley who collaborated in the creation of the AAg movement; Michael Challinor (research assistant to the M.Phil project 'Use of Games in Education through Art') who has researched technical and evaluatory aspects of the AAg; Polly Binns, who is now applying AAg to vertical ceramic structures; Beverley Richards A'Court, who is applying AAg in youth and remand work; Jon Effemey, Ian Robertson and Fiona Forrest, who have also made special contributions to AAg.

Others who have worked closely with us have been: Mike Halward, Play Organizer to Milton Keynes, who introduced AAg to several groups of playleaders; Keith Hutchinson, Leisure Organizer to Portsmouth; Spencer Thornton and Tim Bennet for Kingston Polytechnic Community Action Group; and the Rev A. Michael Handley, who introduced AAg to Norwich Youth Clubs. Many thanks are also due to the National Association for Gifted Children London and Surrey

groups; to Dr Agnes Kaposi of both Kingston Polytechnic and the NAGC, for advising us on binary applications in AAg; and to staff of different schools of the Polytechnic for advising on the application of gaming to their subject.

Special thanks to all parents, and especially the parents who have organized groups, and to the children participating; to Owen Tudor, who started a new way of thinking; to David Priestland, who has been responsible for several innovations and for researching ideas for a lot of games. Photography: Ken Beagley; David Buckley; Colin Curwood; Jon Effemey; Roger Hildick; Philip Hughes; Christopher Thomas; Mark Richards; Stephen James.

The author and publishers wish to thank the following for permission to reproduce material from the publications named below: Dryad Publications for Fig. 2, from W. R. Lethaby's *Designing Games* (1929); the *Journal of the Colour Group* for Fig. 19, from *J. Colour Group*, 17, 317 (1974); Attleboro public schools, Mass., for the curriculum programme reproduced on pp. 150–1.

Introduction

The aim of this book is to describe a new approach to art education which makes use of ideas taken from the field of game-playing.

The approach is new in that it develops activities which draw not only on skills that are commonly linked with art education but with others as well – inductive and deductive thinking, for example, and social skills. One of its most important features is that it develops social interaction and group work. For this reason the approach has proved of interest to social workers and also to teachers of handicapped or difficult children. The approach has, in fact, been tried out with an unusual variety of groups; with mixed ability and low ability groups, groups of gifted children, undergraduates and adults. Naturally the level of playing – and art – varies, but the approach seems generally unusually successful at eliciting high involvement on the part of its participants.

How to use the book

The first two chapters describe the thinking that led to the development of the Art Arena model of the art-based game, and look at the structure of the game (scenario, strategy and tactics) and the way in which games develop.

For those who want to start a game right away, brief general instructions are included in Chapter 3 (pp. 23–5), and lists of requirements and suppliers are provided in Appendix 2. If you want an idea of the variety and scope of art-based games you will find accounts of ten games in Chapter 6, and a list of games in Appendix 1. Chapter 7 describes model games, the most developed of our games, which have been used as a basis for inventing many other games, and Chapter 8 includes accounts by two children, a student and two adults of how they invented games.

The final chapters discuss the evaluation of the game through voting and scoring procedures (Chapter 9) and review the objectives of the Art Arena game-model and the development of education in and through art (Chapter 10).

The organizers of Art Arena games described in the text would be interested to hear of any art-games which are being invented by children or adults. Games are being collected for the next book, which will be a compendium.

November 1978 DON PAVEY

I Beginnings

In this book I shall be describing an educational approach which makes
use of art-based games. The approach has been tried out now with over
a hundred groups, from children of eight to students of over eighteen,
from children with high spatial and art ability to those with very
limited ability, from highly gifted children to children with special
difficulties. Many people have contributed to its development, not least
the children themselves, but it might be interesting to say something
about how I personally became involved.

My interest in art-games dates back just over ten years to something
which hardly merits being called a 'game' – an art competition in the
local paper. It consisted of a line drawing of a vase of flowers for children
to fill in for prizes as part of the local Arts Festival. I felt it was wrong to
give children the idea that art was solely a matter of filling in shapes,
and wrote to the newspaper listing many more valuable things children
might be encouraged to do, hoping there might be a response from
Festival organizers, teachers or parents, a dialogue and perhaps con-
troversy. No one took up the challenge. On the other hand something
I hadn't bargained for happened. A child wrote to me directly, asking
'Please, when do we begin?'

It was the sort of appeal that is hard to brush aside; almost
before we knew it my partners in design practice, Marjorie Hayward
and Audrey Mitchell, and I had cleared an attic in our business house,
and a small gang of kids were hard at work (they called it play)
creating monsters in GRP (glass-reinforced plastics) and robots with
micro-circuitry. It might well be called a sophisticated form of play in
which the children had the ideas and did the research, while I did my
best to provide suitable materials, equipment, sources of information
and know-how (sometimes making heavy demands on different parents
for technical and scientific help). The small gang became a large gang,
and a workshop at East Sheen became the chief of what we called

2 Art-based games

the Junior Arts and Science Centres (JASC), with splinter groups in Hanwell, Molesey, Richmond, Norbiton, Petersham, and as far away as Liverpool. All these workshops might be described as playgrounds for ideas, though as yet, there was no thought of using gaming techniques.

We found that many of the children wanted to play with ideas from the domain between art and science. They seemed to have a natural understanding of the area, an area existing in its own right before teachers divide it up into its subject boxes. On being asked the difference between art and science, one nine-year-old thought that science was 'finding out about things' and art was 'making use of what you find out'. It was interesting to watch how, in a rudimentary way, the children automatically tried all the different scientific and creative forms of method that characterize adult science and art – inductive, deductive, and so on.

This is not the place to discuss in detail the work of the JASCs. But it is interesting to note that the JASC log for those years shows that whatever the level of ability, intellectual or manipulative, each child did well. The fever of creation was transmitted from the bright, capable ones to those less bright or handicapped, even the educationally subnormal and spastic. Sometimes those who had been labelled as weak in art seemed to outdo the really good ones. The workshop world as structured and 'lived-in' by the children themselves seemed to give a great incentive to coherent perception, assimilation and problem-solving. They seemed to develop workshop sense and professional practice beyond what one would expect from their academic status at school.

The crucial spur to my thinking came when I was asked to find a way of producing the same richness of experience for large numbers of children rather than the small handful at East Sheen. Very small JASC groups had been working with expensive electronic components, casting in metals and polymers or making and acting in science fiction films, but I was now asked to start a group at Kingston Polytechnic, where there would be no funds for sophisticated materials, no professional staff and where there would be many more children.

I therefore began to think about other approaches to art teaching besides the workshop one, and began in particular to wonder if some kind of group structure might work. I listed the various kinds of experience that, in my view, it would be essential for the children to have:

1 *Imagining and visualizing.* The creative leap must be encouraged by an environment capable of providing evocative clues. Disciplines other than art might well be involved here, to provide a breadth of learning upon which to exercise the imagination.

2 *Thinking.* There should be scope for sequential thought, in a visual rather than verbal context: opportunities, for example, to manipulate colours, shapes and forms logically. (Many of the exploratory experiments at the East Sheen JASC before the inauguration of the games concentrated on group drawing and processes such as squaring up and using grids, coordinates and distortions.)

3 *Group activity.* I wanted to provide opportunities for greater interaction between the participants than before, and for experimenting with communication systems and the exercise of rapport.

4 *The handling of materials* and the acquisition of a mastery of and familiarity with various media and visual skills.

5 *Achievement.* There must be task-achievement, even if the problem to be solved were no more than an attempt to create a continuous spectacle. In fact, there should be possibilities of both a sought-for outcome and/or an open-ended one. Moreover, the achievement would have to be 'superordinate', that is to say, something no one person could achieve alone.

6 *Enjoyment.* The whole experience must be fun for everybody.

In the attempt to find a way of retaining something of the richness of the children's experience in the workshop situation it became increasingly clear that the answer to my problem might be found in some kind of gaming, based on art, and like a project, have its end in assessed achievement.

But what is 'gaming'? In searching game-theory literature I came to the conclusion that the most useful and academically sound definition was that of Maria Montessori who thought of 'games' as 'free activity, ordered to a definite end'.[1] I too, see the 'game' as structured play with a sought-for outcome, but I feel it is essential to add that the play must be *enjoyable to all parties all the time.* This rules out competition (see pp. 116, 157), at least until the player's motivation has reached a level at which competition and losing is not counter-productive and a curb to enjoyment.

In a survey of hundreds of gaming concepts, I recognized four which corresponded well with the first four factors I wanted to accommodate in the gaming procedure:

4 Art-based games

1 *Scenario.* The elaboration of the scenario, or games topic, provides the universe of clues for the imagination to work on. The player, as seer, must observe and assimilate. Out of the incubation of this material comes some form of visualization of the 'answer' to the brief.

2 *Strategy.* This represents the thinking and consciously logical component. It requires the player to become planner or designer.

3 *Teamwork.* This involves cultural, social and group judgement. It requires that the player, as artist and critic, indulges in qualitative and aesthetic judgement.

4 *Tactics.* This is a matter of manoeuvring on the field of play. It requires the player, as craftsman, to practise sensibility in the spontaneous handling of materials and media.

The fifth and sixth factors, achievement and enjoyment, need no translation into gaming terms.

The first four aspects of gaming are easily seen as art-producing processes. If they could be phased partly over time, I thought, and partly distributed among players, perhaps such a procedure might prove capable, not only of producing a game, but also of simulating art-production. When at last the opportunity came to try out games based on these processes, several different groups of children wanted to take part, children with high spatial and art ability from the JASC, others with high IQ, the 'locals', and some with special difficulties. It also became possible to try out some of the techniques with degree students. Soon a system was being developed which not only entertained and educated, but did so at many different levels.

Reference

1 Montessori, M. (1912) *The Montessori Method*, London: Heinemann. 180.

2 Art-games as we found them

A search for ready-made art-based games was only partially successful. Many gaming projects were being evolved and carried out in schools and clubs, but each one seemed to miss out an essential ingredient. In fact, some of the features I required demanded a search further afield than present-day educational gaming. I began to search among games of the past for ideas consistent with my essential criteria, which could be put under the following headings: (1) imagination and the intuitive leap; (2) visual thinking; (3) group judgement; (4) manipulative sensibility; (5) the sense of achievement, and (6) enjoyment for *all* participants.

Games of the imagination as 'scenario' projects

One of the most visually imaginative and game-like projects of past years was the collective mural painting done by children of various age-groups under the organization of Vige Langevin, a French artist and teacher who had been a Resistance leader during the Second World War. Her main approach was an adaptation of traditional mural painting techniques, and the essence of her system lay in the provision of an evocative scenario (*le sujet*) – the topic or theme. Each child did a painting on a given subject; the painting which was voted by all the participants as being the most capable of development was then chosen as a 'maquette' or masterplan. This was divided up into sections, and one section was allocated to each child in the class. When these were finished they were all joined together. Mme Langevin went to special trouble to ensure that the modules did not join up too perfectly, and the result is that the collective paintings of all her groups have a variety and vitality unusual in group-generated art. The paintings varied from great panoramic views such as 'La Ville', by 40 children, to 'Polyphème', a single giant figure made by 25 thirteen-year-olds.

6 Art-based games

This game-like procedure offers art teachers many possibilities for development. The symbolic and representational aspects of the Langevin scenarios call to mind the original meaning of the word 'scenario', ultimately from the Greek, 'skene', a scene or a stage set. They are in marked contrast to most educational simulations, which provide the participants with almost entirely non-visual scenarios consisting of data-tabulations and documents. However, although the Langevin experiment, while rich in possible scenario elaboration (*composition globale*) preserved each participant's contribution intact, the projects provided a rather limited visual interpenetration of ideas or logical clash of strategies. In fact, Mme Langevin went so far as to recommend that a teacher should strive to leave his 'logical adult mode of thinking outside the classroom'.

Games of visual thinking and 'strategy'

Try as I might I could find no drawing or painting games of any calibre that involved visual logic. I didn't want games which consisted solely in the manipulation of prefabricated parts, even very beautiful ones like those designed for children by Vasarely. Nor did I find logical and mathematical puzzles, like the 'Wff'n Proof' games, very helpful at this stage. I began to realize that if a visual thinking component was to be programmed into art-based gaming projects it was going to be a matter of starting from scratch.

It was clear that certain painters used logical progressions which might well also be used in art-gaming. The 'Metamorphose' paintings by Mauritz Escher, for example, show rigorously thought-out transitions from birds to fish, fish to ships, lizards to hexagons, and so on.[1] Max Ernst used superimpositions to produce a fusion of forms. Many painters have thought in terms of two or more contrasting structural principles, and painted as if they were continually changing sides in a highly-motivated patience game. Vasarely himself, in his paintings rather than his games, demonstrates the use of the parameters of colour as the interactive forces, the result of which is the art-work produced as if by a highly sophisticated mechanism.

Much contemporary painting can be read as 'in-gaming' for the visually initiated; and in a great deal of non-representational art, Op Art for example, the dynamic forces at work may be no more than parameters of colour – representing themselves.

I was struck, however, by one kind of painting which makes use of

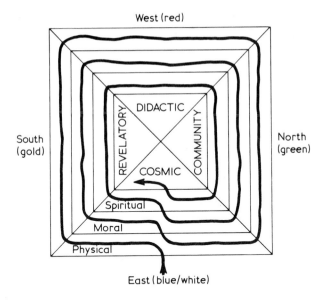

Fig. 1 The influences of the yantra

aesthetic elements to stand for important physical, moral and spiritual influences on life. This is a type of Indian painting called a 'yantra' or meditation pattern. Meditation is carried on in the contemplation of a large painted square, as if the plan of a temple, and is guided by two aspects (see Fig. 1). The eye enters the square at the middle of the base and continues round the inside of the square in a left-handed inward spiral. With each circuit your meditation becomes more spiritual, while its aspect is determined by the orientation. Each of the four triangles made by the diagonals of the square has its own colour or colours. The blue and white eastern influence at the base of the square reminds you of the past, of history, things distant and cosmic, your ancestry, and more recently your parents. The golden southern influence to the left stands for wisdom and enlightenment – your teachers and your guru. The western red and uppermost triangle is concerned with your ministering to your family and children or pupils. The green triangle to the right draws your attention to your community of friends and your environment. Thus the form of the meditation is set by the character of the cross-influences.

It might be said that the meditator plays a meditation game or simulation as if walking round the actual precincts of a holy place. The

word 'game' is not derogatory in this context; indeed, one Indian legend sees the universe as a creative being continually playing hide-and-seek, finding and losing himself in all his manifestations. The yantra is also the origin of many popular games, such as 'Snakes and Ladders', the earliest known European example being in spiral form, made by F. H. Ayres of London in 1892. In India and Tibet, however, the rectangular shape of the 'Snakes and Ladders' board is actually older, deriving from an early thirteenth-century dice game devised by the Tibetan monk Sa-pan for the spiritual delight and occupational therapy of the ailing and enfeebled. The board was a table of Buddhist moral and spiritual principles, and a throw of the dice determined the aspirant's progress towards liberation.

It was later used in education, and pictures of snakes and ladders were added to signal the presence of vice or virtue and indicate passages down to the various Hells or upwards to the more propitious states of enlightenment, which flourished at the top of the board.[2]

The artist of the yantra can well be thought of as a 'strategist' who has to interpret the forces and influences in terms of colours and shapes so that they wholly permeate the meditation; he is as it were executing some grand strategy, each orientational force being something like a strategy in warfare. The word 'strategy' derives from the Greek for generalship, 'strategia'. In gaming, however, it refers to an individual's or a team's complete plan for winning and taking over the field of play. In art-based games strategy must be, as in the yantra, a pattern ingredient contributing to the successful achievement of the art-work by its appropriate representation in the finished work.

Another, more modest example of strategy in 'designing-games' is that of the embroidered sampler. The main purpose of the sampler was, according to W. R. Lethaby, to display 'samples of certain elements of patterns and lettering in varieties of stitches for future reference and use ... rules, as it were, of a game to be played, and all designing is a kind of "playing a game" '. He explained that 'there are fixed elements in all games – the moves or strokes – and the interest arises in solving new situations by fresh combinations – all games are played as it were from a sampler or pattern book.' He went on to describe how two or more people could play a designing-game by following simple procedures (see Fig. 2).

> Draw four lines straight or curved, crossing in a symmetrical way as at A ... , then add extra pieces on at the ends as B, go on in

Fig. 2 A design game from W. R. Lethaby, *Designing Games*, Dryad, 1929

the same way to any extent and then close up as in C. An infinite number of patterns can be 'found' by playing the game in a bold experimental way, seeing what will come. There should be no preliminary sketching and timid trying, but put the lines in boldly and trust to luck.... An extension of this designing game may be made by two persons playing it together, and this leads to interesting results as the pattern which 'comes' can in no way be foreseen.... It should be remembered that the players do not try to block the way or spoil the pattern, but rather lead it on into interesting and ingenious developments.[3]

The most naive example of design strategy is that of the nineteenth-century 'Metamorphosis game', which consists of a set of tiles or slabs with dissected images on each face. A later development was the picture brick. Arranging a set of Victorian picture bricks together to make a coherent image uses a single strategy, while on the other hand a mixture of dissected images produces a 'hybrid' or figure of fun. If two or more people were playing, this could be seen as a minimal interplay of strategies.

This simple discrete use of visual strategies without interpenetration was practised by the Surrealists in their examples of the 'Hybrid' or *'Cadavre Exquis'* (a version of the party game 'Heads, Bodies and Legs') in which they drew objects and landscape as well as human and animal details. After each portion was finished it was covered with paper so that the next artist would not be influenced by what went before; just as in 'Heads, Bodies and Legs' each section of the body is folded so that next person cannot see what the previous player has done. 'Heads, Bodies and Legs' is quite an old party game. The earliest example I have in my collection is of a complex folded picture of Lazarus and Dives with a skeleton, dating from 1778 (see Fig. 3).

1 *Folded up*
Lazarus begs food
off Dives the rich
man

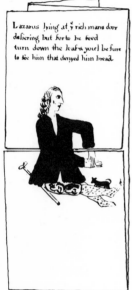

Lazarus lying at y̌ rich mans door
desiering but for to be feed
turn down the leafs yoúl be sure
to see him that denyed him bread

O Father Abraham i beg that you
would send back to my breathren
least they come to this place of wᵇ
it one rise from the dead may hinder
them

Here comes rich Dives who denyd
the crumbs which from his table fell
turn up the leaf be sattisfied
that he is going away fare well

3 *Back two folds
closed*
Dives with bags of
gold

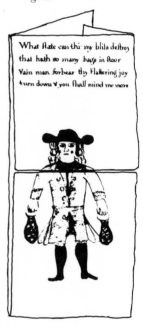

What state can thi' my bliss destroy
that hath so many bags in store
Vain man forbear thy flattering joy
turn down v̌ you shall mind me more

2 *Front two folds
opened up*
Dives denies food
to Lazarus who
prays to Abraham

Fig. 3 Dives and Lazarus

4 *Lower back fold opened*
Dives sickens to death

5 *Both back folds opened together with a side fold*
Fate overtakes the rich miser who is stricken with disease and death

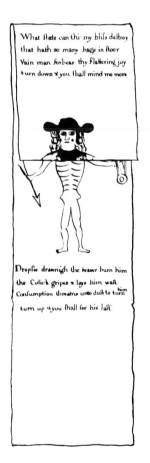

What ftate can thi my blifs deftroy
that hath ſo many bags in ſtoor
Vain man forbear thy flattering joy
turn down & you ſhall mind me more

Dropſie drawnigh the feawr burn him
the Colick gripes & lays him waſt
Conſumption threatns unto duſt to turn him
turn up &you ſhall ſee his laſt

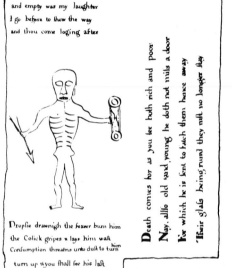

On this falſe world was my ſtay
and empty was my laughter
I go before to ſhew the way
and thou come loging after

Dropſie drawnigh the feawr burn him
the Colick gripes & lays him waſt
Conſumption threatns unto duſt to turn him
turn up &you ſhall ſee his laſt

Death comes for us you ſee both rich and poor
Nay, allſo old and young he doth not miſs a door
For which he is ſent to fatch them hence away
Their glaſs being rund they muſt no longer ſtay

An early, perhaps the earliest surviving, example of a Heads, Bodies and Legs game or 'Picture Consequences', dated 1778 drawn by Richard Hawes of Lelant in Cornwall

(Don Pavey collection of historic art games)

The changeable images of Lazarus and Dives, folded and dissected, seem to be the result of a game by only one person, the artist himself; but then, there has been a long tradition of artists as solitary puzzle-makers playing tricks and games of surprise, from the Greek illusionists[4] to the Enigma painters[5] of the seventeenth century, not to mention the Mannerists of a century earlier.

The dissected image had its earliest origin in ceramic mosaic-picture tiles, though the artist of the 'Lazarus' is likely to have seen more recent precedent in the dissected puzzle which helped children to learn about geography and history, a brainchild of the Harrow schoolmaster, John Spilsbury, in the 1760s.

Eventually, both the straight-line cuts through a puzzle and the naturalistic cuts around a face or country on a map gave way to the ogee, or undulating cut – at the edges first where it helped to lock the puzzle together – and then all over. By the beginning of this century the dissected puzzle became known as the 'Jigsaw'[6] after the instrument which was used for its mass production, and which imposed the familiar inter-locking wavy curves of the commercial jigsaw puzzle.

A recent classroom application of the dissected image has been described to me independently by Martin Thaler of USA and Roger Elsgood of Camberwell. This entails the cutting up of a reasonably spectacular photograph into squares that are so small that the image can no longer be recognized. Pupils copy the light and shade of their allocated squares onto a scaled-up mural surface using the appropriate coordinates. When most of the squares have been filled in a giant image of the original photograph suddenly appears to the young artists, who until this moment had no idea what they were creating. This comes as a surprising revelation and contributes much to their understanding of scale and breadth.

Another, similar, transformation device was that of 'Cubomania', invented by the Surrealist Gherasim Luca, who cut up a picture, usually an engraving, into recognizable fragments and then re-assembled them in a new and surprising configuration. This strategy has been used a great deal in contemporary painting. In fact, we used it ourselves in an AAg game called 'Billboard'.

Games of contest and 'teamwork'

Group participation in art projects has traditionally involved a maestro directing a team. Michelangelo felt his abilities to be so far beyond those

of the team he was provided with to help with the Sistine ceiling that he dismissed all his assistants, preferring to tackle the monumental task single-handed.[7] The same gulf between the designer and his team often still exists today.

The contest of skill has also been the model for many art-games. There is a long history of art contests, one of the earliest on record being that between the ancient Greek painters Zeuxis and Parrhasius. The first painted grapes so realistically that birds came down and tried to peck at them. The second painted a curtain so convincingly that a human being – his opponent – was deceived into trying to draw it aside.

The traditional art-contest game or the game led by a director and his team, was the very antithesis of what I wanted in the new art-based game-model. It was by no means easy to find a precedent for games in which creative participation was to be on an equal footing for everyone, no matter what their talents. Eventually, however, I came across an early Victorian book of party games, *Darton's Book of Sports Indoor* (c. 1846).[8] The Darton family had been toy- and games-makers since the 1780s and subsequently also published books on games and sports. They advocated a very cultured and civilizing attitude to the playing of games, one which would be endorsed in many primary and middle schools today. The Dartons said that in all our games and amusements we should do nothing to hurt other players' feelings but try 'to please others as well as ourselves', even returning kindness for unintended hurt. Reading the Dartons' advice about 'fair play' and good sportsmanship, I began to appreciate how losing a game could bring sympathy rather than scorn for the loser. To my surprise, what I had always thought of as vicious punishments, the loser's forfeits, were often eagerly sought and sometimes even preferred to the games themselves.[9]

The Dartons saw the play area as a 'little world', and explained that 'the passions and feelings that operate there, are exactly of the same kind as those that will continue to operate to the end of man's life in this world.' If this is so, I thought, it must be sensible to use the 'play area' to educate and develop these feelings and sensations at source in childhood.

It was sentiments such as those of the Dartons that led me to the conclusion that, just as in a party game the object is enjoyment, and in art the object is usually to create an art-work, so in an art-based game the target ought to be a double one, that of enjoyment *and* art creation. I

hoped that two kinds of judgements might be made in the game: on the appropriateness of the art to the scenario, and decisions as to how enjoyment for all might be increased. This would mean that players would be forced to make aesthetic judgements, and if these were good judgements they would satisfy the two targets: (a) balancing all teams' interests so that there was a reasonable unity and shared representation of, for example, team motifs and territory; and (b) a reasonable share of enjoyment in playing and satisfaction in the outcome. The first target is a formal and academic one leading to a maturity of judgement in assessing shape, form, colour, line and proportion – the basic aesthetic elements in design. The second target, enjoyment, might add a dynamic to the first. It must be part of the fun that basic aesthetic elements become the 'possessions' of teams of players.

It was almost impossible to find any precedent for this. Perhaps an element of the kind of team interaction I was searching for could have been seen in the *commedia dell' arte*, in which each actor–player made a different improvisatory contribution to the whole performance. A better precedent is even further removed from our own culture – that of Trobriand cricket. Missionaries brought cricket to the Trobriand Isles a hundred years ago, but the Islanders developed cricket along lines of their own. Trobriand culture is non-competitive, and the Islanders changed the game in a way which obviated the need to compete. In their game, the winning side is decided on beforehand. This allows a complete concentration on perfection of play, so that ritual and personal aesthetic judgement combine to override any unsporting tactical moves to win out of turn. The game becomes more difficult if you are the stronger side and it is your turn to lose. Trobriand cricket is a great spectacle, especially with fifty-nine players to each team and a war dance after each wicket has fallen. Even Trobriand cricket, however, in retaining its inherent win–lose dichotomy, is restricted to an opposition of two similar team operations. The contrast of different patterns of opportunity might well lead to more surprising and unpredictably interwoven spectacles of performance.

I was particularly interested in the Bauhaus idea of integration, and in their group exercises and experiments which aimed at training both the intellect and the emotions. This played a part in creating an attitude to art and design in schools in which 'play' became a serious element capable of being brought to 'purposeful results'. The Art Arena model, indeed, attempts to realize an aspiration of Moholy-Nagy of the Bauhaus that 'Group activity of the future must be more consciously

aware of the mechanism of its own operations as well as of its results'.[10] It is self-monitoring by the group that constitutes one of the most basic aspects of teamwork, without which a game is vapid and spiritless.

Games of free expression and the idea of 'tactics'

There is a whole range of little games related to scrying (seeing things in a crystal ball, bowl of water, mirror, tea leaves, burning coals, etc.) in which one player has to add to or alter the random lines or scribble (blot or accidental effect) made by another player. They used to be variously titled from 'Retsch's Outlines' in 1882 to 'Artists' Doodles' of 1935. The Dadaist and Surrealist painter, Max Ernst, explored these in his team drawing project 'Fatagaga' (1919–22), and other Surrealists used various automatic techniques which made use of the alien mark for teasing out imagery from 'the unconscious'.

These simple games were the first in which players in some way negotiated each others' drawings. They involved what I would like to call 'tactics without strategy', without, that is to say, any conscious deliberation or forethought. I was anxious that this intuitive side of creativeness should not be left out of the art-based game-model, and that there should be plenty of opportunity for resourcefulness in the use of paint and other media.

Tactics without strategy can also be found in the lateral thinking and skilled action characteristic of the Zen arts. The painter Wang Hia (c. A.D. 804) dipped his head into a pail of ink, and wiping it on a piece of silk, created an exquisite landscape of trees, lakes and mountains. A troupe of Kendo dancers will show remarkable spontaneity in handling the sword: substitute brushwork for swordsmanship, and we've made another step on the way to creating the art-based gaming-model.

In the West, Maria Montessori pioneered the use of basic games or play exercises which developed perceptual and tactile discrimination: she defined 'game' as 'play organised towards a specific end'. Froebel introduced a creative and constructional element to simple play exercises. He invented 'Gifts', including a paper-folding project similar to Japanese Origami. In our own games use has sometimes been made of paper and cardboard for speedy constructional work for game accessories; but it has occupied a central theme only in one game, 'Dragon' (see p. 82), in which the children made and 'wore' the

Dragon, stalking down to the local Spring Festival as soon as it was finished.

Task-achievement and the 'group target'

The object of the art-based game has usually been three-fold: task-achievement, the creation of a spectacle, and enjoyment. These are found in the parlour games called 'Drives'. This game-form requires the addition of some visible part to some creature or object on a player's achievement of each of a series of tasks. Popular Drives have been the 'Beetle Drive' (also called 'Cootie', 'Bug' or 'Humbug'), the 'Elephant Drive', and during the Second World War the 'Plane Production Drive' or the 'Car Assembly Drive'. The task to be achieved may have nothing to do with art – it may be throwing a dice, a game of whist, etc.; and there is no need for very careful consideration of the shape of the final Beetle, Elephant, Plane or Car. If such games were played with more attention to the creation of spectacle, on the other hand, the drawing and painting of an elephant or the wings of a plane might be developed into an impressive art game.

The Drives were competitive, and were therefore not quite what I wanted. Nonetheless, they suggested a way in which to make a visual record of the stages of the game. In my new games model there would have to be targets which required success from all participants, not just winners. In fact, the target, I finally decided, would have to be the equal or appropriate representation of the interests of all the teams and the resolution of conflict through aesthetic creativeness. The target must be, that is to say, something which no one team could do alone. It was to be an achievement of the whole group, and essentially a supra-personal one. Its success as a whole must be inherent in the success of its parts.

Enjoyment as the essence of the game

The essence of a game is the opportunity it gives for enjoyment. Without this a game is more appropriately described as a device, project or competition. The word 'game' itself comes from an Indo-European root-word 'ghem', carrying the sense of 'to jump for joy'. All the same, a game which is programmed to result in inordinate enjoyment for one party at the expense of the disappointment and loss sustained by another is not to my view a 'pure' game. I do not deny that in many sports

enjoyment of the game itself may be so great and sportsmanship so prevalent that even the losers are able to enjoy the game in spite of losing. However, I was once impressed to hear one of the JASC children say 'I enjoy most a game that is a tie. It is like a double win!' Over the years the significance of this began to sink in. Maybe it wasn't beyond one's ingenuity to devise a game-form in which there did not have to be losers. Then it struck me that in a game whose target is enjoyment in a difficult group accomplishment there shouldn't be any need to programme a failing group into the set-up. The emphasis would be on the quality of the game itself, and the success of its achievement as a whole would be a cause for enjoyment and celebration by all its participants.

References

1 Teachers may be interested in Escher cardboard cut-out sculpture: Schattschneider, D. and Walker, W. (1977) *M.C. Escher Kaleidocycles*, New York: Ballantine. (17 sheets of partly die-cut board, many brilliantly coloured, and a book of instructions for 'making Escher sculptures'.)
2 Tatz, M. and Kent, J. (1978) *Rebirth: The Tibetan game of liberation*, London: Rider. (Includes a poster-size paper gaming board reproduced in colour from a reconstruction by a present-day Tibetan. Full instructions for playing are given in the text together with details of the symbolism.)
Grunfeld, F. V. (1977) *Games of the World. How to make them. How to play them. How they came to be*, New York: Ballantine Books. 131–3. (Describes how to make the traditional Indian version of 'Snakes and Ladders' called *moksha-patamu*.)
3 Lethaby, W. R. (1929) *Designing Games*, Leicester: Dryad.
4 Gombrich, E. H. (1972) *Art and Illusion*, London: Phaidon.
5 Montague, J. (1968) 'The painted Enigmas', *J. Warburg Institute*, 31.
6 Hannas, L. (1972) *The English Jigsaw Puzzle 1760–1890*, London: Wayland.
7 See Sheard, W. S. and Paoletti, J. T. (1978) *Collaboration in Italian Renaissance Art*, New Haven and London: Yale University Press.
8 Darton, J. M. (1846) *Darton's Book of Sports Indoor*, London: Darton. See also Love, B. (1978) *Play the Game. The book you can play*, London: Michael Joseph. (Over forty board games of the

eighteenth, nineteenth and twentieth centuries are reproduced along with their counters in cardboard.)

9 *Cassell's Book of Indoor Amusements* (1882), London: Cassell. 23.
10 Moholy-Nagy, L. (1947) *Vision in Motion*, Chicago: Theobald. 66, 358.

An early nineteenth-century Metamorphosis game (Don Pavey collection)

3 The Art Arena game – a new game-model

This is the scene that might confront a visitor to an Art Arena game. An enormous piece of paper, about 12 feet long by 8 feet high, covers one wall of the room. Groups of players are at work painting with varied degrees of spontaneity, some with wild abandon, others with thoughtful precision. Back from the wall are knots of players calling out apparently rather cryptic information to those at work on the paper. For a few minutes the visitor is puzzled as to what is going on. To make matters worse, the visitor may have come on a day when the information called is coded and transmitted using noises from hand-held organ pipes, whistles and other sounds. Colours appear to be phased across the wall, sometimes colliding, sometimes mingling or encircling each other. But what is the connection between the sound-flow and the actual painting?

On looking again the visitor will realize that each group away from the wall is calling map-type references for finding points of growth and development for the hustle of improvisation going on at the wall face. The information sent by each group is picked up by its own agents at the surface of the wall. Several different teams may be split up in this way, each team having its own unique character and outlook, not only in its mode of sending data, but more especially in the form and content of its work on the wall.

Behind the knots of players sending data are tables strewn with coloured pencils, paints, adhesives, scissors, scrap paper and 'plans'. These are the teams 'houses' or 'headquarters', and are often screened off from the Art Arena wall to lessen the distraction of checking back visually too frequently.

At this point a general outline of the game model will give the visitor (or the reader) a clearer picture of what is happening, and then its processes can be gone through in greater detail with reference to one specific game.

Outline of the Art Arena game-model

The game begins when the scenario, or 'story-line', and final target are described to the players, both verbally and on a printed data sheet. The scenario can be taken from almost any discipline: biology, physics, chemistry, etc.

A biological scenario will have a target such as symbiosis – a living together. A chemical scenario may require fusion as a target, a physics scenario, equilibrium, and so on. The target, however, is as yet a long way off, and there are more immediate tasks to be attended to first.

After understanding the scenario and appreciating the target, the next step in the game is to know which team you are in and to understand its strategy. A team's strategy is its whole attitude and policy towards the solution of the game's problem, but the term especially refers to the use of certain visual ideas allocated to it. For example, in the biological game 'Virus' (see p. 65) one team, Biocell, exploits enclosures and cells, while the other, Virus, uses radiations from fixed points. In an atomic physics game, 'Squircles' (p. 64), the Carbon team uses circles (as if sections of carbon rods) in cold colours, while the Uranium team uses squares in hot colours. Strategies are thus contrasts derived in some way from the scenario itself.

Having understood his team's strategical ideas, a player begins to assemble shapes, colours and lines on a piece of squared paper called a plan blank. This is a miniature copy of the grid on the wall. Each player fills up his own plan blank with a pattern of forms according to the concepts and motifs allocated to his team. When all the plans have been made, the team uses the best features from each of its members' plans in constructing a composite 'masterplan' for that team. In this way each player contributes from the very first strategical idea throughout the game to the final group achievement in the art-work.

As soon as team masterplans have been made, they are imaginatively enlarged and chalked in onto the Art Arena grid – the mural surface now becomes the field of play. One player, the planner, looks after the masterplan and decides which parts should be transferred to the wall first. Another player, the caller, calls the coordinates of the feature to be transmitted to the wall: 'D5 to G7 – a green line' or 'Q6 to S12 – a blue monkey', for example. This information is received at the face of the empty wall grid by the team's designers, who mark in the coordinate references and join them up to form lines and shapes, or use them as reference points from which to generate some more spontaneous flight

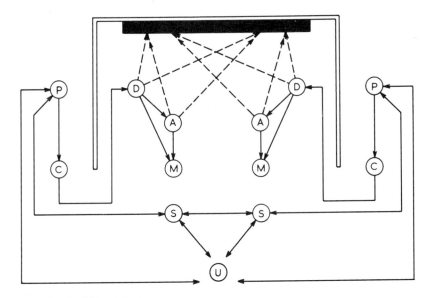

Fig. 4 Flow chart of the communications network

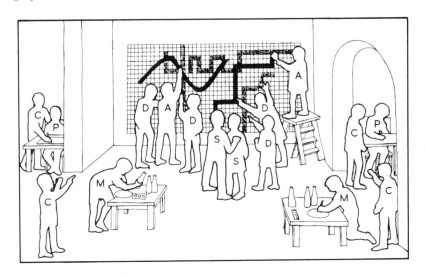

Fig. 5 Layout of a typical Art Arena game

A = Artist/painter M = Mixer
C = Caller S = Stabilizer (negotiator)
D = Designer U = Umpire
P = Planner

of ideas. Figs 4 and 5 show the layout of the teams' communication relay.

What makes this a *game* is that each team now puts into action a masterplan for taking over the whole surface of wall available for the art-work. As the drawing in with chalk or paint progresses, the mappings of one team begin to interpenetrate those of another. In spite of tactical adjustments and manoeuvring, tension mounts as the full extent of the areas of joint ownership is discovered. When the mappings are finished there is an 'unscrambling conference' to decide on the ownership of overlapping territories and other areas of ambiguity. As soon as teams have made their intentions clear the painting proper begins.

Interaction grows as teams hasten to establish their cherished motifs – without which they would feel they had no real identification with the finished work. Conflict increases as areas are found which were unaccounted for in the unscrambling conference. Players can usually resolve clashes of interest in skilful painting and tactical negotiation at the wall face (here the stabilizer comes into play). But serious disagreements are settled at a special 'Court of Appeal'. This opens with the ritual of reminding contestants that the game's target must always embody the idea of the *appropriate* representation of each team's interests (without this the game fails for everyone) and the unity of the finished work. The Court of Appeal generally achieves a unanimous decision, but where this is not possible a vote is taken.

As the game draws to a close and the painting is nearly completed, a representative from each team explains aloud for the benefit of players and observers what his teams' intentions were, how they have changed and to what extent his team thinks they have succeeded in achieving their intentions and their contribution to the target. Finally, one of the players assumes the role of announcer or master of ceremonies, calls everyone to vote on the success of the game and introduces his commentator, who explains the voting category and gives an impartial appraisal of the performance of the whole group in each category, without dwelling on individuals or teams. After each summing-up, the announcer calls the names of the participants and the vote of each in turn is entered by a recorder into a score chart. The voting categories are explained in Chapter 9.

Sometimes there are lengthy and even heated discussions in each section; and sometimes more work is done on the painting after the voting, if only to tie up loose ends.

Instructions for inventing and playing –
by BEVERLEY RICHARDS A'COURT

1 *The scenario.* First think of a topic and story-line involving 'direction': it might be about things growing (plants, crystals), changing (modifying land use, customizing a car, weather), discovering (an exploration, space journey).

2 *Teams.* Are there contrasting ideas in your scenario, different forces, moods or poles? Name these as teams.

3 *Strategies.* Now recommend appropriate shapes, colours and effects or particular patterns and symbols for each team.

4 *Tactics.* Recommend the appropriate techniques (brushwork, sponging, collage) for each team, and suggest what rules a team might make to deal with overlaps, e.g. should certain colours be painted over or mixed with other colours?

5 *Target.* Try to visualize the final synthesis when all the teams have been fully represented. For example, four different life forms may produce 'symbiosis', a living together. Different parts of a machine may attain equilibrium or homeostasis; crystals may fuse; human attitudes may produce a group mind.

6 *The brief.* Now prepare a brief for each team, detailing (1) scenario, (2) team names, (3) possible strategies (colour, shapes), (4) recommended tactics (techniques of painting), and (5) describe the game target or 'super-goal'.

7 *The plan example.* This is a specimen design on a plan blank for the whole mural surface for one team. It is the visual counterpart of the verbal instructions. Players rarely actually copy it.

Now you are ready to play. For painting games you will need:

(1) From 2 to 16 players, with ages from eight to eighty.

(2) Time – from $2\frac{1}{2}$ to 3 hours.

(3) A wall or floor about 10 ft by 8 ft covered with paper and ruled in 4-inch squares labelled 1, 2, 3, etc. along the top and base, and A, B, C, etc. down the sides. We discovered that if we painted our soft-board wall with white emulsion paint and squared up with a thick black line using a felt-tip pen this would show through most grades of white paper that we use. This saves a good deal of time spent squaring up in preparation for the game.

(4) Plan blanks (A4 copies of the wall grid) and paper for scribbling on.

(5) Coloured chalks, paints, mixing bowls (e.g. plastic margarine tubs), brushes (2 inches across the bristles), pins, string, ruler, scissors, and an adhesive.

HOW TO PLAY

1 A player reads out the scenario. Teams are named and players allocated to sit in team groups.

2 Each team reads out what it may do, under strategy, and how to do it, under tactics.

3 Each player makes a design for the *whole* wall on a plan blank. (Stages 1, 2 and 3 take about 15 minutes)

4 Conference within teams: Choose the bits you think best from each of the designs by the members of your team. Cut these out. Then arrange and stick them (or redraw) onto another plan blank. This is now your strategy, i.e. the masterplan which your team will try to put in its entirety onto the mural surface.

5 When each team has drawn a masterplan players chalk up the outlines of their team's design onto the mural surface using a team colour. They are helped by one team member who calls the coordinates, e.g. 'B2 to E2, red'.

In this way the small masterplans are transferred and enlarged onto the mural – whole square by whole square. With circles and more naturalistic drawing, the squares are plotted first and the shapes drawn in with a large sweep of the arm.

6 Conference between teams: All players stand back from the mural and discuss how to combine the overlapping motifs. Players are reminded that the object of the game is the proper representation of teams' interests in a balance and unity appropriate to the scenario; and ways of achieving this are discussed. You might mix the colours of the shapes overlapping, or interweave and fuse the shapes themselves. For example, a final design might derive from masterplans and individual player's plans as shown in Fig. 6.

Remember the game belongs to the players. They make any rules, and change them for better ones by majority vote at any stage. (Allow about 10 minutes – longer if the players want to act out in mime, movement or drama the values they place on their patterns)

7 *Painting begins.* All players take part in painting the teams' designs, and gradually think more and more in terms of the whole rather

possible final design

1st player's plan

2nd player's plan

masterplan A

TEAM A

3rd player's plan

4th player's plan

masterplan B

TEAM B

Fig. 6 Process of creating a design

than parts. It usually takes about two hours – longer with adults. At the end, success is decided by vote.

8 *Voting.* Players vote (a) on how well they think the target balance and unity has been achieved, and (b) how much fun the game has been. Each player gives a score out of ten. If the target and fun together have a mean of four out of ten the game has been 'won'. It helps in devising new games to have votes also for (1) the appropriateness to scenario of the final painting, (2) the strategies (the effectiveness of the masterplans), (3) the teamwork -- how well players worked together within and between teams, and (4) the group's estimate of its skill and sensibility in the tactics.

Game players

ROLES

As an AAg game has to be adapted to the players and not the players to the game (as in conventional games), players may concentrate on one job for a few seconds or several hours. They may opt for, or be assigned to duties which are more or less specific according to their capacity for enjoying sustained activity.

To make this flexibility possible there are a number of roles which

are usually basic to the game. The first and least demanding is that of planner. After a team has made its masterplan someone needs to be appointed to look after it, and suggest the direction operations should take. This becomes the job of the team planner. It may last only until the drawing has been mapped on the wall or work surface, and it is a good role for a quiet or shy person, who need only whisper directions to team callers; though it may be necessary to be sure that the planner is seated at a table, and that the caller cannot snatch the plan away and take over. The callers, on the other hand, need loud and clear voices.

With the youngest players, say six- to seven-year-olds, the work of the designer can be divided into those who 'look after' the rows of letters, and those 'looking after' the columns of numbers. The 'letter-minders' or 'letter-pointers' will point their fingers along the row of the letter called out by the caller, and the 'number-pointers' will do the same up and down the column of the numbers called. The square at which the letter- and number-pointers' fingers meet is marked in with a dot or a cross by another player, the artist-designer. All players may become artist-*painters* after the unscrambling conference. If there are enough players, it is helpful for a planner to remain in charge of a team's plans, and to watch over the team's progress in the game. This player is then usually called a 'stabilizer' and is concerned with the proper balance of teams' contributions. In addition, an 'ecologist' is sometimes engaged to correct inaccuracies and mess, and to cope with any areas not accounted for on the plans.

Such are the main roles in the art-based game; apart from the one important, external, 'player' who makes the game possible, the 'facilitator' or 'animateur', usually called the organizer or umpire, whose job it is to see that material and equipment is available, to keep time, and to be the ultimate arbiter in unresolved conflicts; with the younger age-groups this player will act as announcer and master of ceremonies and recorder. Above all, it is his job, as organizer, to decide on the kind of communication involved and whether the game is solely for aesthetic enjoyment, or is to carry important academic content which should be made clear at the beginning and evaluated at the voting. Everything must depend on the special interests and knowledge of the organizer and the players themselves. In a school one might expect there to be a greater emphasis on the academic content of the game and its airing and interpretation. Played by an art-club, a game might equally well be entirely non-verbal.

In more sophisticated games there is likely to be less exchangeability

of roles, and in design and simulation games the addition of, say, a treasurer and administrator in each team as well as players in charge of information and material resources may be found helpful. Moreover, the organizer in his role as umpire might be replaced by an assessment panel, providing a measure of objectivity to set against the subjectivity of the voting.

TEAMS

The essential thing about a team is that it is a 'package' of roles with a common strategy and tactics. In fact, the whole purpose of having teams is to make alternative or complementary means available for the achievement of a mutually satisfying result. Teamwork transforms solitary art and design performance into a group activity, in which the team spirit is spread not only within the teams but also between the teams. This is of paramount importance in the A Ag model. For the team is a group of players contributing towards the achievement of the same ultimate goal as another group or team of players in the same game, though through a different mode of performance and different initial targets.

But how do players sort themselves into teams, and how many players should there be in one team? Our most successful method of arriving at teams has been to ask players each to choose a colour from colours already symbolizing a team attitude which they may or may not recognize. Another, completely random, method has been to have different coloured beads or balls, the different colours again standing for the different teams. Players put their hands into a narrow-necked, opaque jar one at a time and without looking into the jar pick out a coloured ball which assigns them to a particular team. In many of the games devised by the players, however, the teams are tailor-made for the different members of the group.

The number of players in a team can profoundly influence the nature of the game. There is no golden formula for a 'correct number', although organizers can do their best to weigh up the potentialities of the players against the space, time and materials, as well as the complexity of the game. A game can be played with one player to each team, but it will take much longer. Eight teams with three or more players in each can be mind-blowing for the organizer, even if the strategical motifs are very simple. However, one primary school teacher, Gerard Maloney of Manchester, has worked very successfully with a class of 39 children (divided into three teams of ten and one of nine players).

The process of the Art Arena game

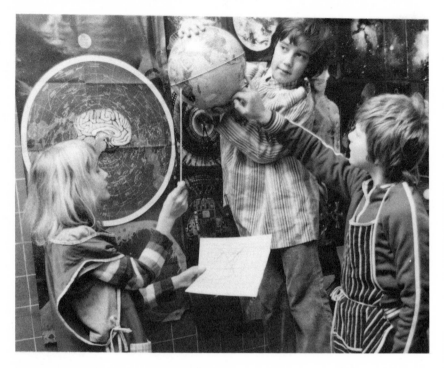

1 *Setting the scenario*

Players familiarize themselves with the topic of the game by looking at and handling all the things which have been collected together to set the scenario. The game about to begin is 'Psychon', a science fiction game.

The scenario is further settled into and explored as players scribble and rough out random ideas about the project, before giving serious thought to the strategy.

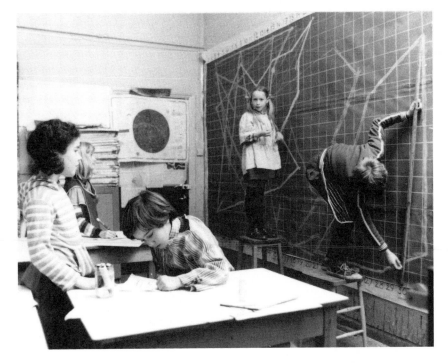

2 *Strategy in action*

A planner at his headquarters (the table) is selecting coordinates and colours to give to the caller (left) who will call this data to a designer (centre) waiting at the wall (the Art Arena grid). This stage of the game sees the beginning of teamwork and role-playing. The game in progress is 'Planet of the Apes', played by eight- to nine-year-olds.

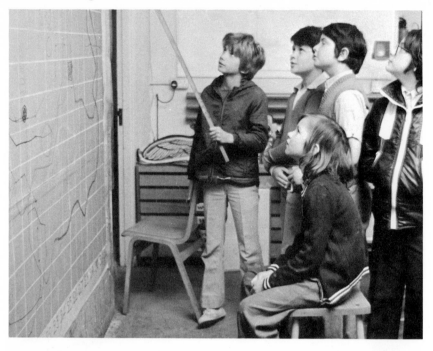

3 *Teamwork as group judgement*

At the unscrambling conference shown here, representatives of the teams, one after another, explain which territories they need to have or share in order to preserve their identities. As in all conferences and Courts of Appeal in the game, players balance their team's interests against those of the group as a whole. The game being unscrambled here is 'Treasure Trail', in which the maps plotted onto the wall by the different teams are being made into one single treasure island.

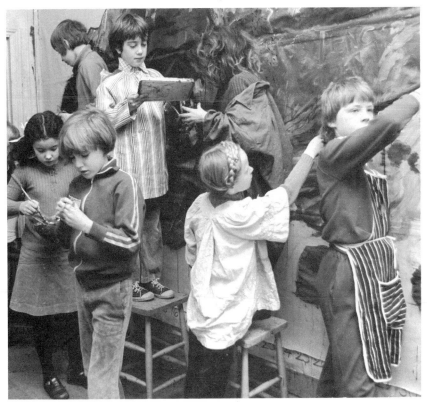

4 *Tactics in the interplay*

Teamwork gathers momentum in the interplay of the game, and players manoeuvre and interweave on the field of play, using hands, intruments and media. A balance is found between freedom and control. The game being played here is 'Treasure Trail' with eight- to twelve-year-olds.

Squircles: hot squares–cold circles

Crystals: cubic-tetragonal

5 *Game target*

Appropriate representation of team concepts

Virus: enclosure-radiation

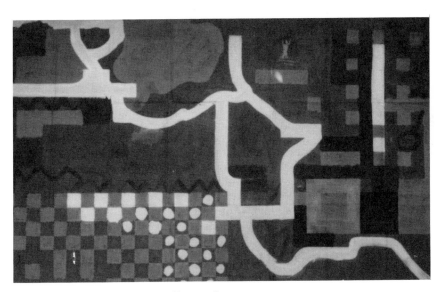

Spaghetti Junction: roads, railways, houses, nature

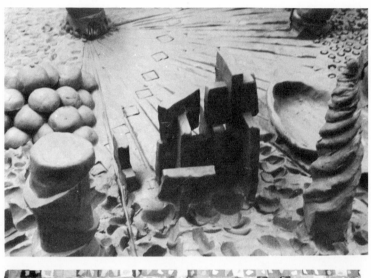

6 *The game medium*

The game medium doesn't always have to be paint.
Above: Here clay has been used and built up from a flat surface, (but too high to be cut up into tiles and fired to make a ceramic mural. See pp. 100–2. The game outcome shown here is a three-dimensional version of 'Psychon'.
Below: 'Pulsar' played with paint (squares) and collage (coloured paper).

7 *A conference*

A typical Court of Appeal

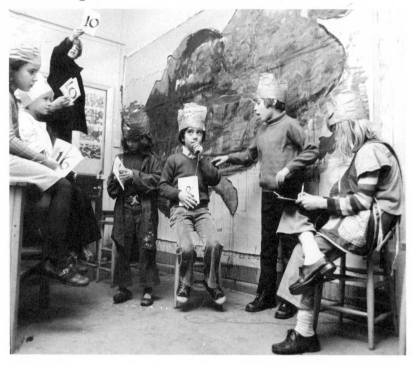

8 *Assessment*

Players conduct the voting and evaluate the successes and failures of the game. The assessment is conducted by an announcer (centre, holding the microphone), a commentator reviewing what has happened in the game and explaining the voting categories, and a recorder (right) entering votes onto the score chart.

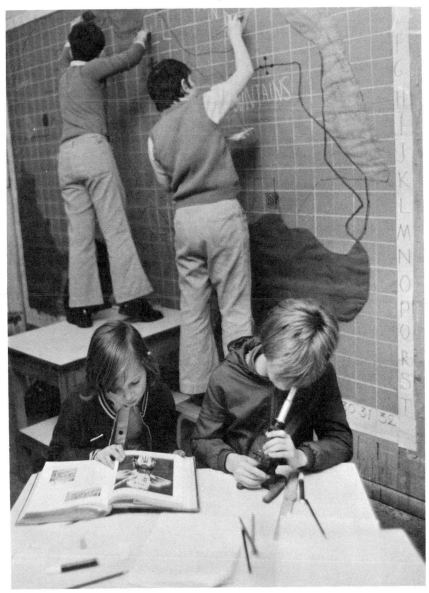

9 *Enjoyment*

The player as learner and enthusiast. For a short while, the duration of the game, players construct their own world. Can the all-round quality of their experience arouse a permanent desire to learn and be enthused?

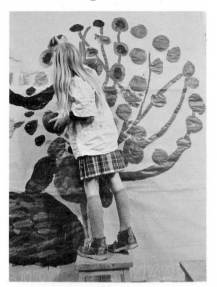

10 *Individual performance*

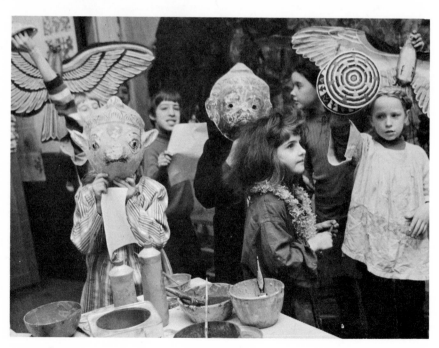

... enhanced by group effort

4 The thinking behind the Art Arena game-model

The Art Arena game-model, as I have already suggested, was first devised to help juniors enjoy themselves to the full, while at the same time attempting to achieve something quite spectacular. Enjoyment was to spring from the quality of experience generated in the process of creating the spectacle – through the different modes of thinking and judgement it called upon. Indeed, these faculties were to be the determinants of both success and enjoyment. Their importance as aspects of education and culture generally is discussed under the following headings: inductive imagination under scenario, sequential thinking under strategy, communication and judgement under team-work, and manipulative sensibility under tactics. All these are seen at work in the activities of the art-based game.

The scenario and the inductive imagination

The topic of a game has to be large enough to provide a feasible universe of possibilities for the purposes of the game and its story-line. This universe of clues is called the scenario.

Every game (and every lesson in school) must have a scenario even if it is abstract and minimal – a board and counters (or chalks) and a theme. Some scenarios may be extremely elaborate, as in many war games and simulations. In the Art Arena game-model (AAg) the scenario can be simple or complex, depending upon how much learning data a teacher wants to put into it.

It is usually helpful to provide the players with a lot of visual information on the chosen subject: pictures, photographs and diagrams to build up the universe of the game. If you know your group of players it's fairly easy to predict how much data a group can assimilate. Some of the early AAg games came perilously near to disaster because

of too great a desire for pictorial realism resulting in an attempt to handle too much visual information within the time available.

Even if the scenario is a science fiction one, you still need very particular visual clues. In one of our science fiction games, in this case about undersea life, the teams were Fish and Molluscs; part of the development of the scenario involved familiarizing players with the world of the game by providing fish in tanks and other sources of (mainly pictorial) data concerning shapes, forms, colours, etc. The scenario of the A Ag science fiction game 'Psychon' (described on pp. 28ff., 88ff.) consisted of astronomical illustrations and photographs of astronomical subjects hung around the walls, ranging from pictures of spiral nebulae to diagrams of orbiting planets. The same pictures have been used for a number of different games with the same subject area, such as many of the cosmological games invented by the children.

In an A Ag game a minimal verbal statement is used to introduce the scenario. It can be conjured up by a word or two on the game information sheet. This sets out the theme and story line of the game. Some examples are as follows:

'VIRUS' – Living tissue.

'FIRELIGHT' – It is fireworks night.

'SPACE LACE' – You are investigating the gravitational fields of two hitherto unknown galaxies in outer space which are about to collide.

CUSTOMIZED CONNOISSEUR – A group of designers get together to design the most attractive and unusual car in the world. The company expects the car to be customized by each different designer in his part of the car.

'THE PSYCHONIC COMPUTER' – Four teams of scientists are working on a computer which has telepathic capacities. Suddenly it short-circuits and hypnotizes the team, so that their own thoughts are wildly amplified, and they must use these same thoughts to remove themselves from the illusion.

If the scenario is sufficiently evocative it will provide something of a 'dream-screen' for the incubation of material. It may even be possible to pass from the game universe to act directly upon flashes of insight and carry out painting manoeuvres straight onto the Arena wall, bypassing consciously thought-out strategy, as long as other players approve. Otherwise the next process is strategy, which disciplines and limits. This is what makes it valuable – normally anything which

helps to select and simplify will be a great asset. In many educational simulations too much information is available and there is too little structure for easy assimilation, so a player may be bewildered rather than stretched. It is best if especially significant data can be clustered around structural aspects of the scenario, giving guidelines to players in their selection of clues, and in this giving a boost to the inductive imagination. For example, in devising the game 'Crystals' I had to find out from a geology teacher which crystals yielded sections that gave the simplest contrast of shapes. (It was quite impossible for me to discover this from popular books and equally impossible from the most comprehensive textbooks on geology.) Appropriate colours and names of crystals could then be clustered around the different types of crystal and these could be allocated to the different teams.

The player who can see useful and meaningful patterns in the apparently random data of the scenario is being what scientists call 'inductive'. But a player does need signposts, and these are provided as patterns of opportunity (described in the next section). Trying to see patterns in the outside world, where at first sight there are none, is an approach encouraged by art teachers generally. For them it is a familiar use of the imagination. Once you have 'looked with intent', to use the well-worn art teacher's cliché, you will have induced or recognized the principles upon which you are going to act, and you can settle down to applying them in the planning, deducing from them answers to planning questions.

Strategy and patterns of opportunity – sequential thinking

While the scenario provides random data and information resources, it also presents more cogent help to the players in the form of certain structured opportunities upon which a team's strategy can be based. Remember that the worlds of ideas the players are concerned with are visual worlds, and you will have no difficulty in appreciating that the patterns of opportunities available to the teams are visual possibilities – squareness or roundness, dark or light, red or blue, hard edge or soft edge, and so on. These are the 'forces' at the disposal of the teams. Clearly they are likely to be most effective if they are oppositions or contrasts between teams. The square and orthogonal may be contrasted with the circular and the curvilinear, vertical with horizontal, hot with cold, and active with passive. Such properties as these are allocated to different teams according to the character of the scenario. In 'Floods',

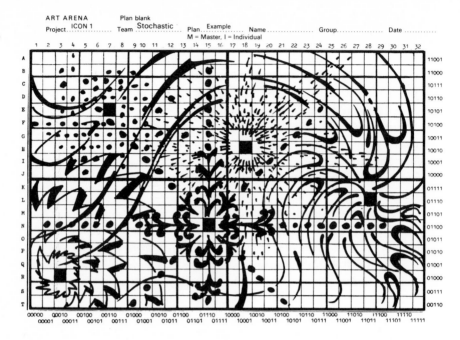

Fig. 7 Four masterplan examples given to teams in 'Icon 1'

ART ARENA Plan blank

Project....ICON 1....... Team....Holistic....... Plan....Example........ Name................ Group................ Date............
M = Master, I = Individual

ART ARENA Plan blank

Project....ICON 1....... Team....Metaphysical.... Plan....Example........ Name................ Group................ Date............
M = Master, I = Individual

a geographical game, one team was curvilinear (Water) and the other rectilinear (Land masses). In a game about making sea-lanes (Nuclear Battleships) one team used symmetry about a vertical axis, and the other symmetry about a horizontal. In 'Billboard', an advertising game, one side experimented with the shapes of large letters of the alphabet, while the other used illustrations cut out of comic papers.

Where there are more than two teams, the contrasting factors may be more subtle, and involve three-, four- and five-fold polarities, or even more. The strategies in our geological game of 'Crystals', for example, were cubic (i.e. square-sectioned), tetragonal (diamond-sectioned), hexagonal (six-sided section), and so on, with colours appropriate to crystal specimens of each.

To help players appreciate something of the potential of their allocated strategies each team is provided with an 'Example' (see Fig. 7). This is an important accessory to each game. It consists of a plan blank with a simple diagram of a possible configuration of shapes and colours. Its simplicity helps to dissuade players from producing realistic or over-complex patterns, and should help in demonstrating the application of the strategical idea allocated to the team. Over-complicated masterplans are likely to be impossible for younger children to transpose to the wall grid, and even with seniors the process is liable to take longer than the time available. It is best to play one's first art-games with whole squares rather than fractions. Lines of squares, and straight lines between centre-points of squares are fine, or yet again, curves constructed from square-centres using chalk, string and a drawing pin. A simply constructed masterplan in no way prevents the painting on the wall-grid from becoming as complicated as players want it to be.

The Example is presented in an envelope after the instruction sheet has been read. In fact, it is sufficiently schematic to be described as the visual counterpart of the verbal instructions. It gives weaker players confidence to exercise their imaginations much more than they might otherwise. It can really be used as much or as little as is felt necessary. Better players may only want to look at it after they have roughed out their own designs; on the other hand, there need be no rule against copying.

A team has three successive strategical targets. The first is to use its allocated concept to construct the team's masterplan, a diagram in miniature of the team's idea for the final art-work. Secondly, this strategical pattern has to be enlarged and mapped onto the prepared

surface, generally the mural wall. Thirdly, the mapping will be seen to overlay or interpenetrate the patterns enlarged onto the same surface by other teams, and will therefore, when eventually painted in, have to undergo some kind of change by overlay, interchange, counterchange or even fusion.

The strategical concepts or opportunities allocated to the teams might well be called 'meta-strategy' where 'strategy' is what the players make of those opportunities. In our game information sheets, however, the same word, 'strategy', is used for both. What no one wanted to do was call the meta-strategy 'rules' or even 'rule principles'. The word 'rules' seems inhibiting and best avoided – it stresses constraints rather than opportunities. In the A Ag, then, strategy is taken to mean the total contrasting principles or opportunities available to a team, as well as the complete plan drawn up by a team outside the arena, for the direction, disposition and development of resources in the team's attempt to achieve the main target of the game.

The strategy of a game provides players with a special chance to use their powers of deductive reasoning. Complex decisions can be answered more easily if they are broken down into a sequence of simple questions. What shape do I use? What scale should it be? Where within the field – up, down, right or left? What hue, tone, intensity and so on? The creation of motifs has to be appropriate to the team- and game-criteria, as well as to one's own aesthetic sense. However, in most games the finished plan drawn up may be more a chart of reference points for growth and development than a thumb-nail sketch for a masterpiece. In fact, the kind of thinking which goes on in the mind of the designer-player is beautifully illustrated in the experimental projects of Jerome Bruner relating to concept identification[1] although in A Ag games the designer-player has to go further and deduce and apply appropriate particulars from the concepts identified.

Teamwork – communication and judgement

Because the success of one team in an A Ag game depends on the success of another, players need to have some awareness of the relative importance of their work in the scheme of things as a whole, and be able to sense the relevance of other players' activities. Thus all the operations of the game depend at some stage on communication and shared judgement. 'Whose lake is this half-way up the mountain?' says one player in the game of 'Floods'. 'The volcano got out of hand, and

I had to move it. I didn't think it worth while calling a conference,' says the Water team representative. 'Oh well, so long as the Mountain team doesn't mind and it doesn't get bigger and run down into my forests.'

The concept of judgement needs special comment: the level I am interested in is qualitative rather than quantitative. Both kinds of judgement depend on comparison, and are related through the notion of value. Qualitative judgement is concerned with complex evaluative assessments and ethical questions of good and bad, appropriate and inappropriate, about states and conditions of things and people. Jung used the term feeling-judgement or value-judgement, though he was more concerned with people than with propositions or things. Qualitative judgement, basically a process of comparison, is by no means entirely unquantifiable, as will be seen in Chapter 9, on assessment and scoring.

The provision for qualitative judgement in group play (in addition to opportunities for dreaming things up, solving puzzles, and the exercising of sensibility in physical action) raises the potentialities of the game-model to a high order. It may have been something like this which Froebel had in mind when he described play as 'the highest expression of human development in childhood'.[2] Other educators throughout the ages have believed, no doubt for similar reasons, that life itself should be 'lived as play'[3] and that the 'highest form of civilization lies in the playing of games'.[4] Quite recently Marshall McLuhan has echoed these sentiments in a chapter entitled 'Games – extension of man'.[5]

When there is no rapport between players a game must fail. And for a team's judgements to be acted upon there has to be an effective mode of communication between, for example, a team's headquarters and the prepared art-work surface. Visual data about colours, shapes and lines and their positions on the grid have to be transmitted to the wall. This is done through a calling routine, which consists of a communication relay in which messages about drawing and painting motifs with their coordinates are passed from planner to caller, and then shouted by the caller to the designer at the wall surface (see Figs 4 and 5). The vertical axis of the arena grid is labelled with letters and the horizontal with numbers, as on the A4 plan blanks. Then, as in the children's game 'Battleships', a letter and a number are called, and the square indicated is marked upon the wall or art-work grid.

In some games the players prefer not to use the human voice for transmitting this information. Manufactured sounds, perhaps sounds

from musical instruments, can be used for this process on a binary system. The printed plan blanks are labelled according to the binary system on two adjacent sides, and on the other sides according to the better-known alpha-numerical map-reference system (see plans in Fig. 7). Different sounds can indicate references on the binary system: one sound indicates 'o' (left) and another '1' (right); or again, 'o' (down) and '1' (up). In this way it is easy to specify any square within the grid using five symbols to represent its position right or left and another five to place it above or below a central horizontal line. Colours and shapes can be indicated by a difference in timbre.

In some games the team headquarters is out of view of the arena grid, and the planner in charge of a team's masterplan does not know what is happening at the wall surface unless his callers report back, or until he emerges from his headquarters (by half-time all players whatever their roles will be working at the wall) at which point he can be stunned by the spectacle.

The communication chain from planner and caller to designer and artist-painter can be deliberately interrupted by 'noise', as in 'Chinese Whispers' (a game described by Kate Greenaway in 1889 as 'Russian Scandal') – the distortion of a message passed along a chain of players. In fact, this tends to happen anyway in the tactics of Art Arena, and contributes to its fun and success. But if it seems a good idea it can be deliberately intensified. In one version of the game 'Squircles', for example, the caller was gagged and had to make signs. The designer had ear plugs and wasn't allowed to draw, but he could guide the arms of the blindfolded artist-painter who painted with a brush on the end of a pole. Children with real handicaps, used to coping with disability, would have found this game much easier.

Tactics and the moves of the game – manipulative sensibility

At the climax of the game players use art materials with a balance of freedom and control. They are simultaneously expressing themselves and their team's attitude, and constantly negotiating with players of other teams, while bearing in mind that the target lies beyond the limited goal of an individual team. The tactics of a game consists in the art of manoeuvring on the field of play, negotiating the controlling forces of one's own and other teams, and inter-relating with other teams' motifs by overlay, counter-change, interpenetration or fusion.

The absolute primacy of tactics should not be understated. 'Tactics'

refers to the 'moves' of the game and the making of the art-work. For reasons both of enjoyment and of aesthetics, the wishes of the players should be given special consideration at all stages in the operation of the game, and an organizer should be prepared to allow total changes in the nature of the game provided all players agree happily.

The whole nature of the game outcome may depend on decisions made at the tactical stage. It will also depend on the particular materials and the way they are used – from the pigment and medium to the instruments used to apply it (which can mean anything from brooms to small sable brushes and sponges to fingers and hands). 'Tactics' refers to the way players use these to negotiate obstructions presented by the work of other teams, so that they can realize as much as possible of their original strategical plan. In other words, it is the actual practice of carrying out theory in the face of the unpredictable hazards of moment-to-moment circumstance.

PRACTICAL NOTES

Practical know-how in handling materials is most important. In order to produce an effective painting, the paint must flow well without dribbling over everything, and children need to be shown how to mix, say, powder pigment with a little water at a time, stirring very thoroughly (unless a special streaky effect is wanted). Other media require different skills. Collage can be exciting, and the use of stencils and templates (the parts you cut away when you make a stencil) is sometimes just right for the player. A small group of Indian children in Jawalgira, Karnataka, used dried leaves and petals in an Art Arena collage and painting experiment.

A tactical device which has proved useful particularly in mathematical games, or whenever random sequences have been required, is the floating teetotum. Our improvised version is described on p. 125; but we have also used electric shoot dice and electronic 'Traka' randomizers, which can be bought from most games shops.

TACTICAL VARIATIONS

The area of tactics has proved one of the most fruitful and stimulating in many games involving art, perhaps because it is the area of active creation. Several games I studied showed interesting tactical ideas. In

one spectacular kinetic game I saw in France the actions of an imaginary machine were mimed in arm and leg movements to the accompaniment of a sound-track previously prepared by the players. After the physical part of the game had been worked out, it was transposed onto paper by fitting the human machine with paint brushes and reactivating it. This game was carried out in the Games Invention Seminar conducted by Madame Madier at the World Congress of the International Society for Education through Art in 1975.

The tactical game devoid of conscious strategy approaches various kinds of performance art. The Ludic movement in France, for example, is concerned that people should realize their capacities for bringing about changes, according to its chief exponent, Claude Pasquer. By changes he means transformations that might not otherwise have been predicted through a logical progression of thought. In Italy, *Arte Povera*, also a kind of performance art, demonstrates the importance of 'process' itself 'in the act of becoming, attributing no validity at all to the end product'. This frees the 'player' from all obligation to produce for any other time than the present. Neither past antecedent nor future outcome is relevant.[6]

Some of the characteristics of the tactical game can be seen in the spontaneous group murals produced in some British and American primary schools. These may take only a couple of hours to create, and be preserved just long enough to be seen at the next open day. A more permanent basis for tactical invention, in a real art-based game, was offered by the Islington 'Circle' project, a maze-painting system in which large mazes up to 40 feet in diameter were painted by children in their play area. A simple technique of producing the circles was developed so that the children themselves could do most of the painting and designing. Once the basic shape was laid down, further sub-patterns were developed by interweaving coloured lines. These patterns enabled the children to play a great variety of games, from hopscotch and pirates to more complex mathematical exercises. Perhaps most important, it stimulated the children to invent a number of their own games.

This pattern of circles has much in common with our squared-up wall surface. For example, the A Ag network in one of our games provided a race track upon which a player had to keep his brush full of paint while running as fast and as far as he could, making sure his brush remained on the wall surface and between the designated lines or 'fences'. This game was invented by a twelve-year-old and proved

a good test of dexterity, while neither focusing too much attention on the very skilful nor showing up the cack-handed.

References

1 Bruner, J. S. *et al.* (1956) *A Study of Thinking*, New York: John Wiley.
2 Froebel, F. (1895) *The Education of Man*, Fairfield, N.J.: Kelley.
3 Plato, *Laws* 803–4, 685. See, for example, Penguin edition, Harmondsworth, 1970.
4 Huizinga, J. (1970) *Homo Ludens*, London: Pan. 238.
5 McLuhan, M. (1964) *Understanding Media*, London: Routledge & Kegan Paul.
6 Popper, F. (1975) *Art – action and participation*, London: Studio Vista. Goldberg, R. (1978) *Performance. Live Art 1909–1977*, London: Thames & Hudson.

5 Game outcomes

To the observer of the art-based game the most spectacular outcome is the fulfilment in the art-work of the scenario's story-line. The end product must also, however, be seen as an achievement of the whole group; and in addition it can only be considered successful if the cross-currents of teams' conflicting interests have been properly resolved in the progress of the art-work. Nevertheless, the most important outcome, in my view, is enjoyment. A game-project must generate enjoyment for all the players and be capable of motivating them to assimilate a great deal of learning data. Most important of all, enjoyment will come from the experience of exercising basic human faculties such as intuition, thinking, feeling and sensation. Enjoyment so derived seems a good basis for further educational experiment.

Art as a goal

The finished art-work contains a paradox. In one sense the intention of the players is to perform well so that the outcome will be a satisfying painting in which each part enhances the others, and in which one is as proud of other players' work as of one's own. Such a successful painting proves that the game has transcended competition; nor could it easily have been achieved by one team, let alone one person. In this the goal is a superordinate one. However, once the art-work is finished it is in a sense no more than a very nice record of a splendid experience (if the game has been a good one), showing how well or badly the group were able to find a solution to the problems posed by the scenario. As such, while it might please the spectator and seem worthy of translation into tapestry, glass or a ceramic mural, for the players it may be no more than an affectionate memory of a game well played. Nevertheless, in the process of playing the game the performers will have learned, perhaps unconsciously, quite a lot about art: both about

the artist's attitudes to the art-work, and, at a more practical level, about techniques. The AAg game is not intended as a substitute for individual art-work; but it does aim at accustoming pupils to using art techniques and processes fluently and speedily, while at the same time providing a method that will serve in the production of a serious art-work, whether made by an individual or the group. What may seem simply an enjoyable game is also capable of producing very acceptable art – and by the time all the implications of games like 'Icon 1' and '2' have been assimilated – perhaps quite good art.

The art-making process can be divided in two ways. Longitudinally into phases:

1 assimilation of the scenario on rough paper;
2 planning on squared paper (plan blanks);
3 mapping out on the mural surface; and
4 painting or building.

Latitudinally:
From planner to caller to designer to artist-painter – though this sequence is rarely strictly adhered to.

Dividing up the art-process in this way makes it possible to produce to a specific theme a tolerable mural (of varying quality according to the participants) in perhaps three hours without any previous preparation.

Conflict resolution as target

In addition to the achievement of a well-planned and executed art-work in answer to the set scenario, there is a more specific target in the AAg which brings all the other objectives to a focus. This is the appropriate sharing out of effective resources and territory during the end game. It also involves a constant awareness during the whole of the game interplay of all other players' activities, so that every player is sure that all teams are flourishing appropriately, neither dominating nor being overwhelmed by others.

Each team must be allowed to achieve appropriate (not necessarily 'equal') representation according to its part in the scenario. In 'Psychon', for example, one team must be 'powerfully' represented, another 'with spontaneity', a third 'with ingenuity', and the last 'with ambiguity'. This leaves a lot of room for negotiation and manoeuvring. Consequently, whenever a Court of Appeal is called over a territorial

dispute (it may impose a rule of sabotage), the litigants are reminded of the target of the game – the not necessarily equal, but *proper* representation of the teams. Without this, the game fails and all lose.

If all players keep a watch for both over- and under-representation, then when it comes to a conference vote, the views of the majority are already well-informed from observation. Personal animosities are often resolved through such an aesthetic device as this, and with most groups a sense of responsibility and judgement is soon seen to be more rewarding than self-aggrandizement.

A valuable aspect of this process is that one player's, as also one team's, contribution to the group art-work can usually be recognized in it right to the end, in spite of changes it might have undergone. Yet at the same time in a good result the whole composition will take on a fusion and unity, giving an impression of wholeness rather than a ragbag of parts.

Enjoyment as motivation

Learning is strongly influenced by both pleasure and pain. In many researches substantiating this, the learning investigated has been what the teachers want their pupils to learn. Thought is less often given to what the pupils would like to learn.

The way the A Ag model has evolved suggests that research workers might do well to study the rate and depth of learning in relation to the identity of interests of teacher and pupil in a specific learning task. In other words, the degree of acceptability of the learning project enjoyed or endured by the pupil should be subject to scrutiny. The romantic idea of the artist who learns through suffering may have some truth in it, but the pupil needs to be fired with enjoyable enthusiasm before he can sustain the trauma of failing. The A Ag game-form is squarely based on enjoyment, and there is little point in a player taking part if he knows it is going to be agony.

It was most important to me that the A Ag model should at every phase be sensitive to the needs of the players, and flexible enough to take advantage of all human resources available. Even the most exciting innovation can become repetitive without a built-in means to constant renewal. By the heightening of experience at each phase of the game imagination becomes the active visualization of inner fantasy, thinking becomes the unravelling of puzzles, judgement may even be spiced with

hectic but innocuous competition, and speed of response tinges the operation with enjoyable vertigo.

Not all present-day systems of education in the West have their origin in attempts to make children happy. Christian culture has made pleasure seem suspect and pain salutary. Classical education stressed the rigour of the learning process despite a philosophy which accepted happiness as a blessed and perfect state in which the powers of the agent are in full activity.[1] Happiness could also be conceived as an ultimate object of action, and defined as a higher plane of agreeable experience resulting from harmonious action of our powers under the guidance of intelligence.

It would be sensible to make the intellectual decision to take enjoyment and happiness at least as a motivation for learning, if not as an end worth studying in itself. Not wishing to be pompous we began thinking along these lines by using the term 'fun', but this turned out to be a more difficult concept to explain than pleasure, enjoyment or happiness.[2] Even in this country some teachers are disconcerted by the idea of children having 'fun' at school,[3] and when a Japanese team played an A Ag game it took several minutes to explain the voting category we call 'Fun'. I was reminded of a linguist who told me that in translating the Bible into Eskimo, which had no word for 'joy', the nearest equivalent, on the analogy of a dog's expression of pleasure, resulted in a passage rendered literally '. . . and there will be tail-wagging in Heaven'! Surely the concept of joy as a serious curricular basis for learning need not be so alien.

References

1 Aristotle, N. *Ethics* I.iv. See for example Faber edition, London, 1973.
2 Fun also includes the idea of humour. See: Barolsky, P. (1978) *Infinite Jest. Wit and humour in Italian Renaissance Art*, Columbia: University of Missouri. Eysenck, H. J. (1947) *Dimensions of Personality*, London: Routledge & Kegan Paul. (This includes a useful chapter on humour, analysing it into the comic (cognitive), wit (conative), and, for example, the belly laugh (affective).)
3 Kraft, I. (1976) 'Pedagogical futility in fun and games', *Nat. Ed. Ass. J.* 56, 71–2.

6 Ten games and their derivatives

The following is a wide-ranging cross-section of the Art Arena games, representing differing levels of complexity rather than the ten best. The games are grouped as 'pictorial games' with varying levels of abstraction; games drawing upon school subjects (science, reading and writing); 'games of abstract fantasy', based on eastern systems of thinking; and 'carnival and pageant games' – space, form and movement projects. Finally there are a few words about 'simulations'.

The games may appear to begin at a level too sophisticated for the primary school, but you will find on looking closer that not only are they quite easy for younger children to pick up, but they also shed light for the learner on very basic aspects of learning such as its purpose and meaning as well as its content.

Preliminaries and cautions

If necessary, younger – nursery school – versions of the games can be improvised by doing away with all the elaborations such as squaring up the paper, and, having allocated contrasting strategies (suitably interpreted) to different clusters of children, allowing them to work straight onto the paper on the wall or floor. Before beginning the games described in this section it might be wise to introduce the idea of working together on the same wall with more naive game scenarios such as 'Sunshine and Storm' or 'Cowboys and Indians'. 'Sunshine and Storm' was first used at a games invention seminar at Sèvres. French and German teachers were just deciding on a theme for an A Ag game when there was a clap of thunder and a sudden change of light and shade. Masterplans were made on graph paper by two teams, Sun and Storm, and coordinates called to a squared-up wall. Since then the game has frequently been played by maladjusted and by ESN juniors, chiefly in the city of Rheims. 'Cowboys and Indians' was played as

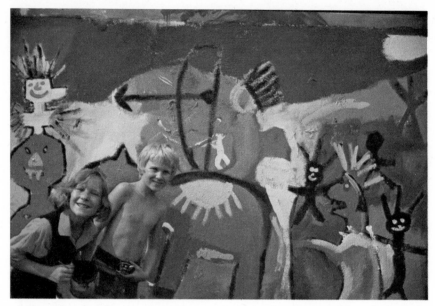

'Cowboys and Indians' was painted across two adjoining walls by a group of children with an age-range of 5–15 years. The older ones laid a foundation of landscape and sky for the little ones. The Indian camp (above) included big chief Sitting Bull, bionic Indians and a totem pole. The cowboys' fort complete with an enormous stars and stripes was defended by Buffalo Bill, Desperate Dan, and a stage coach with troops and vultures. There was a lot of mobility between the teams, and a great deal of painting over each others work was tolerated so long as the results were an improvement. The game was devised, organized and photographed by Jon Effemey.

a painting game on an area of wall around a play space in New Malden, Surrey, by a group of local children run by Jonathan Effemey. No masterplans or squaring up was used. In primary school, the discovery of the advantages of squaring up can come quite naturally for some children; but it should not be taken for granted. A good way of ensuring that everyone understands the process is to get the children to help you to square up one of their own paintings. Then, under the pretext of wanting to make a special kind of jig-saw puzzle, have it cut up into squares, taking the precaution, however, of marking the coordinates on each square (or on the squares from one-half only of the jig-saw puzzle). If the latter idea is used, labelling only half the puzzle,

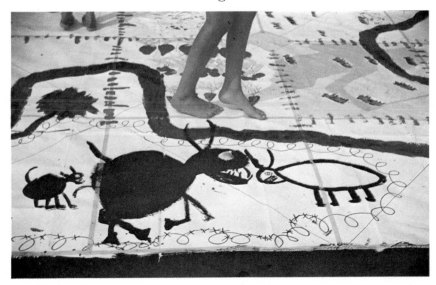

The 'Farmers' game' for 7–11 year-olds. Players had to relate animals and crops to different kinds of fields. The older children made a map of the area and drew it onto a large squared-up sheet of paper weighted down to the asphalt playground with stones. Being town-bred (New Malden), the children brought into the countryside a number of urban features: zebra crossings, double white lines, and so on. The menace of town traffic, however, was transferred to man-eating bulls (see one of them above)! This was another game devised, organized and photographed by Jon Effemey.

then there can be a race to complete the two halves – teacher against all the children together. When the teacher's half is done 'in a flash' the children are likely to want to know how it's done, and you've won an attentive audience.

Equally, at any level, even the most advanced, say that of art students, one might try a game without squaring up. The procedures must never become rigid routines, and should always be interpreted with the utmost flexibility – played above all according to the preferences of the organizer and players.

The most pictorial of our games have been games devised by children. The great problem with pictorial group murals is, as every art teacher

'Billboard' – illustration-topography (age 9–14)

knows, how to get some idea of what the child is going to put on the wall without dissipating the verve, intensity and naivety of the idea by asking the child to show you first. By the time the sketch is done it has everything, and the work on the wall becomes a copied and devitalized enlargement. It is far better to work straight onto the wall! The game belongs to the players, and many of the children prefer, as players, to learn the hard way. So we have some exquisite drawings on plan blanks. But they have often been too difficult to enlarge properly onto the wall, and on this account haven't provided the best art-gaming strategies. After all, a player skilled enough to do an exquisite drawing in miniature usually has at least the latent ability to work directly and freely onto the wall without a lot of preparation.

It is true that most of our games are not pictorial. When they are, however, the problem is avoided by using the squares as part of the picture itself. For instance, the pink panther in 'Detection' is made up of squares only, with here and there a concession to 'reality' in the form of an eye or hand and foot, or perhaps the oblique angle of a leg. People, animals and trees are subjected to this formalization, making a changing but easily controllable pattern – changing, as the different team motifs map onto one another. But there is another way of doing it which, as beautiful as the results of this way of working may be, is much less austere.

'Mutant' – human-alien (age 10–16)

Pictorial games

The procedure we have found most successful for pictorial games has been the following:

1 Scribble on rough paper to give the idea.
2 Mark out *areas* of squares on the plan blank to show where the motifs are going on the wall.
3 Translate the marked-out areas from the plan blank to the mural grid by calling coordinates.
4 Draw into these areas freely with paint where they are your own, and map your own motifs freehand in chalk where they are in areas of joint ownership.
5 Unscrambling the areas of joint ownership will mean that the different team motifs will be either (a) masked, (b) displaced, (c) one condensed into another, or (d) made into a hybrid.

The masking of one player's drawn motif by another's can prove an upsetting experience, whether expressed openly or suffered in silence. The younger the players the less acceptable masking becomes, though one should never take it for granted that a player doesn't really mind, no matter how old. If there is no other way, then it is very important for such a sacrifice to be accorded full public recognition. But there are

usually other less drastic possibilities, such as, for example, displacement of a motif to another part of the wall or its condensation into another motif in such a way that small touches indicate the dual purpose of the motif. The most satisfying and fairest answer is fusion by making a hybrid, a new species displaying equally features of both its parent motifs. Alternatively, extra territory elsewhere in the picture may be negotiated for in compensation. As always, however, one must point out the objects of the game at each dispute (appropriate, balanced representation of each team, appropriateness to the scenario, and proper enjoyment for all).

'PEACOCK'

The first pictorial game I shall present, 'Peacock', involves players in drawing and painting exotic birds. It was devised by Rebecca Selley, aged nine, with help from Beverley.

'Peacock'

Peacock A bird drawing and painting game

Duration – About 2½ hours, which could be divided into five ½-hour
 periods
Players – 12 ± 4 players aged 8–13

Scenario target
One very big peacock on an island of magnificent birds. Each team
has a bit of the peacock and the whole of at least two other birds
not so big.

Teams
SEA BIRDS, LAND BIRDS, WADERS, FOREST BIRDS

Strategies

	Colours	*Shapes*	*Effects*
Sea Birds	Mainly blacks, whites and greys	Big wings and talons	Fierce
Land Birds	Blue and green and/or red and pink	Plumed tails	Beautiful
Waders	Black, white, grey or pink and mixed colours	Long legs, necks and beaks	Dignified
Forest Birds	Bright colours	Large crests, big bills	Odd

	Your bit of peacock
Land Birds	You show where the peacock is to go on the wall and do its tail
Sea Birds	The peacock's wings
Waders	Legs, neck, beak and body
Forest Birds	The peacock's head and crest

Tactics
1 Keep clear of the peacock's tail, but you can go behind it.
2 Two or three birds in the same place may be made into a new
 kind of bird. One team will have the head, another the body,
 another the legs, and so on.

At the end of the game the players painted in smaller birds wherever
there was space.

This is a science fiction game, with a scenario devised by a ten-year-old, Richard Alston. Here, although the young games inventor did not know the draughtsman's term 'exploded' drawing (one in which the inside of a piece of machinery is opened out for display), this seems to have been what he was after; though the actual game as played also showed explosions in the more usual sense of the word.

Space Shuttle A science fiction game

Duration – About 3 hours, which could be divided into six ½-hour periods

Players – 10 ± 5 players aged 8–14

Scenario

An inside view of alien space with a space shuttle opened out in the middle.

Teams

SPACE SHUTTLE, SKY WEED, ELECTROS, LUMEN, ORBICULARIS

Strategies

	Colour	*Shapes*	*Effects*
Space Shuttle	Silver, black, white and greys	5 compartments (interiors)	Efficient
Sky Weed	Blues and greens	Curved lines	Weed-like creatures
Electros	Blues and purples	Mazes and circuits	Electronic
Lumen	Very light colours	Square beams of light	Luminous
Orbicularis	Pure colours	Concentric circles	Radioactive dust rings

Tactics

Space Shuttle	Occupies the central area stretching almost from edge to edge of the wall grid
Sky Weed	Radiates from the top left corner
Electros	Radiates from the lower left corner
Lumen	Radiates from the top right corner
Orbicularis	Radiates from the lower right corner

Group target

A balance of alien influences upon a space shuttle passing through deep space.

Games based on school subjects

The next four games ('Squircles', 'Virus', 'Treasure Trail' and 'Toy-Test Ticker-Tape') include scenarios that draw upon the traditional primary school subjects. They vary greatly, however, in their possible scenario elaboration, from very simple ('Squircles') to quite complex ('Virus'). The object of these games is enjoyment *in learning* – it is not possible, for example, to play 'Treasure Trail' without making strenuous attempts to read and write well. Other games of this type are 'Double Star' (p. 126), which brings in arithmetic, 'Pulsar' (p. 121), which relates to mathematics, 'Landscanner' (p. 119), which links with geography, and 'Crystals' (pp. 41,44), which draws upon science.

'SQUIRCLES'

A very simple and undemanding game, in which the science idea is no more than a stimulus for making a powerful painting.

Squircles A game drawing upon themes from general science. The extent to which you fill in the science detail depends on you and the class.

Duration – About 3½ hours or about seven ½-hour periods
Players – About 10 players aged 8–12

Scenario
An atomic pile. As blocks of uranium are added, radiation grows; as carbon rods are added, radiation decreases.

Target
To prevent flashpoint being reached, and to achieve a balance between carbon rods and uranium blocks so that a high level of radiation is maintained without an explosion.

Teams
URANIUM, CARBON

Strategy

Uranium The Uranium team place three squares on their plan blanks. These represent blocks of uranium, and are painted yellow. The smallest square should be large enough to contain at least four squares on the plan blank grid. Each uranium block should be surrounded with hot colours: mixtures of red and orange. The surrounding squares should grow darker as they grow bigger.

Carbon The Carbon team places three circles in their plan blanks. These represent carbon rods, and are painted blue-purple. The smallest should be large enough to contain at least one square of the plan blank grid. The rods should be encircled with rings of cold colours: blues, greens and greys. The rings round the circles should grow lighter as they grow bigger.

'VIRUS'

This is a biology game which can be played at many different levels. A great deal of data can be programmed into it, especially if the Organizer is a biologist and can specify the two living organisms, making the game into a simulation instead of a biological fantasy.

Virus A game drawing upon biology

Duration – $2\frac{1}{2}$ hours or five or more $\frac{1}{2}$-hour periods
Players – 10 ± 4 players aged 10–16

Scenario *Teams*
Living tissue BIOCELL, VIRUS

Target
Symbiosis – the two life forms must grow over the whole area and live together to best advantage.

Strategies
Biocell Not more than three very large cells over the whole Art Arena wall and a few smaller ones. Each cell should contain (1) a protective covering or membrane and nerve areas for sensing; (2) some part where the cell engulfs food; (3) a part where the cell can get rid of waste; (4) a nucleus or centre-piece which can divide to produce new cells; (5) a part which breathes; and (6) parts which help with movement. Its colours are soft and light mixed colours.

Virus One main colony pushes out branches in several directions. Each branch ends in a new colony. Each new colony also sends out smaller branches with smaller colonies on the ends, and so on. The Virus must be able to grow, eat, get rid of waste, grow new branches, and move. Its colours are dark colours and also sharp and acid colours.

66 Art-based games

Art-based games

Tactics

This game is usually played without much, if any, preliminary chalk drawing on the wall, especially when teams are well balanced and not very competitive. In such a situation the following might prove helpful guidelines: Biocell will occupy any area of the Art Arena so long as it is not already occupied, but it may also eat the Virus over six squares in one direction where the Virus has contaminated Biocell by splash or overlay covering over 1 sq. cm. Similarly, the Virus may occupy any area so long as it is not already occupied, but it may also cause disease and contaminate up to six squares in one direction where Biocell has encroached by splash or overlay over an area of at least 1 sq. cm. Alternatively, with proper unscrambling the game is capable of development over several weeks.

'TREASURE TRAIL'

The next game, 'Treasure Trail', develops the idea that children's visualization of imaginary geographical places will be enhanced by a process of questioning each other to discover clues which might lead to the finding of hidden treasure. When players believe that they have discovered something of interest as a clue they write it down in a letter or on a postcard. This enables the organizer overseeing the receiving depot to evaluate the efforts of each child, in a way that will help him most in his academic work, under the pretext of having to satisfy the need to find other clues at other places, in an enjoyable romp from one place to another across a painted map.

The game is a special exercise for the imagination, for if any story or sequence of incidents arises out of the treasure trail theme it will have been invented entirely by the players. Each team thinks others have been supplied with more data than they have, when in fact they all have to rely on the initiative and invention of each other.

Treasure Trail A game bringing in reading and writing practice

Duration – About 6 hours, which could be divided into nine 40-minute periods

Players – About 16 players aged 9–12

Scenario

A treasure map has been found, and you have got a team together to seek the treasure. One of your team is left behind to piece together the clues you send home. Information coming in from other sources will also help to do this. Three other groups have offices at home, and also think that they have found treasure maps. They may be willing to exchange information.

Target

To find where the treasure is hidden and to share it out amongst everyone.

Teams

HOLIDAY-MAKERS, THE FORCES, NEWSPAPER REPORTERS, TRADERS, HOME ADDRESS BUREAU

Strategy

The map – Design the map of a treasure island on your plan blank. Place on it a city, a seaport, a village, and a lonely cluster of huts and caves. Give all these places names. At least one person in each team should be able to describe buildings, inhabitants, and the countryside in these places; and be able to show someone round a place (by drawing parts of it when necessary) and describe it in words as well as answer questions about it. Arrive at the Treasure Island by painting your kind of line (see below) into a seaport (not your own because of spies reported to be there).

 When you arrive, question the locals about the place generally. Try to find clues as to where the treasure is hidden, but don't mention the word 'treasure'. When you think you have a clue write home saying what it is. You will then be told where to go next. Paint your line to the next place, and ask questions again, etc. This continues until the treasure is found.

	Trail routes	
	Colour	*Character of the lines*
Holiday-makers	Yellow	Curved, straight, and sometimes zig-zag
The Forces	Red	Following the squares up or down (i.e. orthogonal)
Traders	Green	Dead straight line to the towns, cities and villages, but also often following blind trails
Reporters	Black and white	Following the natural features, and spiralling in to the towns and cities. Waving in and out of the lonely settlements and caves

Addresses to write to

Holiday-makers	Mrs T. Cheshire-Trove (that's Auntie Tessa who found the treasure map), Old Map Centre, Museum Street, London w1
The Forces	Colonel Tycoon of the Treasury, Whitehall, London
Traders	Mr Jules Diamond, Treasurer, Swag-Coffers Ltd, Merchant Bankers, Golden Square, London EC1
Reporters	Ms Penny Silver, The Editor, Daily Fortune, Fleet Street, London EC4

Special instructions to the HOME ADDRESS BUREAU

1 Make your own simplified diagram of the island as it appears on the wall. Only put in place-names and routes.
2 Read all in-coming letters immediately.
3 Reply immediately saying the clues received help to suggest where to go to next. Then
 (a) Say where to go next (not to one of the team's own places).
 (b) If there is time invent a reason. It could be:
 (c) You need information about a picture (enclosed in your letter) which you think relates to the next place they are going to. (In fact, the picture can be chosen at random.)

End game – Decide where the treasure is buried.

4 Send a bit of the treasure picture (see below, p. 70). Be sure the picture has clues to the site of the treasure on the back, which when pieced together with the other bits will reveal the site coordinates. Alternatively, a place name might have one letter on each of a number of adjacent cards.
5 When all the treasure pictures have been given out, ask the searchers to meet to solve the picture puzzle.
6 When the site has been discovered congratulate the searchers and distribute the 'treasure' (e.g. paper hats, chocolate money, etc.).

Development of tactics

As in other AAg games each team produces a masterplan, but this time the masterplan is a map. When the maps are superimposed on the wall, the island will become much more complicated. The different drawings of the shape of the island become contour lines. Forests, swamps, hills and cliffs can be decided upon at the unscrambling conference. Settlements are labelled and marked with a symbol (a grid square for a town, a circle for a seaport, a quatrefoil for a village and dots for a cluster of huts). As soon as the island is complete the treasure trail can begin.

Each team paints its particular kind of line (described on the information sheet) from the edge of the map into a seaport (not its own seaport). On arrival, the locals are questioned (the locals being the designers of the place). A note is sent home about anything that sounds suspicious, and a reply details where to go next. The teams paint their lines from place to place representing their travels.

At each place a team can adopt its own particular role in asking questions. A reporter might talk quickly and write lots of notes. A member of the Forces might salute, and say 'Sir', and talk in a loud voice. A trader might put everything in terms of making a sale, a swap, or buying something; and the holiday-maker making his enquiries might like to imitate someone in his or her own family, or act in a way thought to be like the average British tourist.

If plenty of geographical magazines are available, there will be two kinds of reading going on: (1) scanning for information, and (2) precise message reading. The 'writing', too, might be of two kinds (1) fast but

legible, and (2) simulated: a neat and flowing scribble, which will advance the player's capability of creating fluent graphic forms.

The Home Address Bureau should be as far from the treasure island as possible. It could be manned by as few as two members or one teacher, but it would be better to have four players, one for each team, taking on the teams' special identities as described on the information sheet. It is the job of the Bureau personnel to receive letters, read them and answer them imaginatively, sending instructions supposedly based on the information received, e.g. 'because of the information you sent, I have been able to discover that there may be another clue hidden in the village to your south. Enclosed is a picture of a landmark to ask about.'

Towards the end of the game the Bureau sends out a number of pieces of a picture of the treasure (stuck onto card and cut into about eight pieces, say two for each team). At the end of the time available for the game, all searchers for the treasure should meet to see if they can piece together the treasure picture. When we play this the organizer puts letters and numbers on the back of the treasure picture describing the site of the treasure and its coordinates. It takes about five minutes for two teams of nine-year-olds to piece the picture together *and* to turn it over successfully so that the information on the back can be read clearly.

As soon as the Bureau sees that the treasure picture has been pieced together and the coordinates of the site discovered, it is announced that the Treasury has already unearthed the treasure and a fortune awaits distribution amongst the teams. Treasure can take the form of gold coins (chocolate money), ceremonial headgear (paper hats), and so on.

'TOY-TEST TICKER-TAPE'

The aim of this game is to give children the opportunity to develop a sense of the composition of numbers through seeing their factors visually.

Toy-Test Ticker-Tape A painting game based on arithmetic

Duration – 3 hours including toy design and number practice, which could be divided into six $\frac{1}{2}$-hour periods

Players – Between 9 and 15 test-chartmakers plus any number of toymakers, aged about 9

Scenario

A toymaker has to try out three sets of moving toys to see if they can complete a series of tests. (Each test consists of a hit with a soft hammer, and then seeing if the toy will still travel the proper number of squares.) To record his results he puts up a progress chart. All the toys do, in fact, pass the test, but the toymaker wants to check his progress chart to be sure that it works properly when it comes to the really busy time next year.

Targets

1 To test a toymakers' progress chart (Scenario Target).
2 To achieve an equal performance of the three teams and a simultaneous finish; otherwise the project fails. (Team Target)

Teams

The teams are three different production lines named after the number of squares on the testing floor that their toys are expected to travel over:

PRIMES which travel over prime numbers of squares (1, 5 and 7)
DUO-KITS which travel over two and multiples of two (2, 4, 8 and 10)
TRI-KITS which travel over three and multiples of three (3, 6 and 9)

Players should change teams at the end of the first and the second thirds of the game.

Strategy

The blank progress chart – The Art Arena will become the finished toymakers' progress chart, and each team will need to use a plan blank to prepare its test runs.

Each team travels along one row of squares. The first band of rows (one for each team) crosses high up on the Art Arena. Altogether there are three bands of three across thirty of the Art Arena Squares.

At least two squares in between the rows will allow plenty of space for numbering the squares. A vertical line with large numerals (10, 20, etc.) at intervals of ten will do this effectively.

The top row of each band belongs to the Primes. The second row belongs to the Tri-kits, and the third row to the Duo-kits. Figure 8 shows the Art Arena wall prepared for the game.

Chart entries – The information about the toys (see p. 73) is entered onto the progress chart. As each boundary of a multiple of ten is crossed, the organizer rings a bell or whistles and the painter or one of his team calls out the last number to have been painted in and adds it to the team's total so far. Every other player, especially those of the other teams, should look up and check from the chart that the calling is correct. If a mistake has been made the discoverer should be appreciated with a clap. As there is no time limit for each team, only the fast and hasty teams are likely to make mistakes.

How to begin – First the wall is prepared in the usual way (like the plan blank grid, but with squares of 4″ or 10 cms). The game begins when one of the teams is detailed to fill in its colours. After it has reached 10 and has called its numbers and their addition, the next team begins, and so on. Action is continuous without alternation. Some teams will work faster than others. No significance is attached to this, unless they make mistakes.

Which colour to put in – As long as two colours are not repeated one after the other, the following ways of deciding which colour to put in are possible: (a) team choice; (b) Dice or teetotum; (c) electronic randomizer. Different teams might use different methods of colour selection. The following colours can be used to represent the various toys.

	Colour	*Toy*	*Number of squares*
Primes	White	Foal – trots around	1 square
	Yellow	Tiger – stalks around	5 squares
	Violet	Space shuttle – travels around	7 ,,
Duo-kits	Pink	Panther – trips around	2 ,,
	Red-		

	orange	Parrot – flies around	4	,,
	Orange	Spaceship – travels around	10	,,
Tri-kits	Light blue	Humming bird – flies around	3	,,
	Green	Sailing ship – sails around	6	,,
	Turquoise	Time machine – vanishes around	9	,,

Tactical aids

To help in instant addition by the immediate recognition of the number bases:

DUO-KITS' rows should be divided into twos by vertical line divisions in another colour;

TRI-KITS' rows should be divided into threes by vertical divisions in another colour;

PRIMES' rows may have black discs painted into every yellow or white square, and white discs in the violet squares.

Fig. 8 'Toy-Test Ticker-Tape'

It will be apparent that in this game an observer will see at a glance what happens to a number as it is added to any of the three lines every time the sum crosses the boundary of a multiple of ten. This enables a child to see and understand how an added number divides either side of the ten mark.

Note – Organizers should be careful to see that the paint used is not too watery. It should be the consistency of thick cream, so that it does not easily run when it touches other wet painted areas.

Further practice in adding

Once the toymakers' progress chart is complete it can be used regularly for addition practice, e.g. in the simulation of in-coming figures at the toymaker's busy time of year. For this activity, a player is stationed in front of the 'ticker-tapes' pointing to and calling out numbers on the chart as before, but this time waiting for the addition to come from other players. The timing of responses will help to identify groups needing more practice.

FURTHER DEVELOPMENTS FROM 'TOY-TEST TICKER-TAPE'

1 *Toy design*
If there is time all the players might be given the chance to make paper mock-ups of the toys, as if they were to be passed on to a toy-workshop to be built and animated. Alternatively, a whole session might be devoted to making the toys.

2 *A progress-chart refinement*
An added aid to numerical visualization and to learning more about colour mixing is to make the two lower triple bands proportionately darker, adding a very little black to each colour on the second band, and twice as much black to the colours of the third and lowest band. Low numbers will be seen as light colours, and so on.

3 *The game of 'Flags'* (a subtraction game)
Given one set of colour-numbers, each team multiplies its numbers by four to provide a sufficient number of squares for each team to design a flag with.

PRIMES are recommended to take 5, 7, 13 and 17
DUO-KITS ,, ,, ,, 2, 4, 6, 8, 10 and 12
TRI-KITS ,, ,, ,, 6, 9, 12 and 15

When a team's set of numbers is added up and multiplied by four, that team will have the same number of squares (168) as the other teams. Using this number of squares each team designs on a plan blank a flag consisting of large squares, rectangles or bands of colour. The outlines of each team's design are transposed to the wall grid so that they overlap as in AAg generally. The colours of overlapping areas have to be mixed with each other, and the art teacher will be able to suggest the best proportions of one colour to another in the mix where there is doubt. Some areas may be found which do not overlap other teams' designs. Teams possessing such areas on the wall grid can paint them in using their original pure colours as on the masterplans. Some teams owning such areas of squares may like to collect all such grid squares that they possess together and design separate symbols with them, to be placed on the mural grid in positions agreed upon by all teams. In fact, a team wanting to do this from the very beginning should watch where other teams are placing their main blocks of colour and, having subtracted from the total number of their team squares the number they need for their symbol, they can then allow their remaining main blocks of colour to be overlapped completely by those of the other teams. This means they will have done their subtraction sums first, and manoeuvred their main bands of colour into place by agreement with the others. Areas of the wall grid not occupied should remain white unless the teams find by majority vote another colour more suitable. This project may bring players to notice discrepancies between arithmetical and aesthetic equality of representation (e.g. although each team has an equal number of squares do their team contributions *look* equal?).

4 *Lace trace* (a multiplication game)
The scenario for this game can vary from a lace-maker's attempt to keep count of how much coloured thread is required for a particular pattern to calculating the amount of metal required in a mesh (jewellery, science fiction, etc). In fact, each player might invent his own scenario for this one.

The player takes one of the lowest numbers (excluding 1) from the previous coloured numbers. This is arranged as a pattern of squares on the middle lines of the plan blank, well to the left so that its furthermost left squares are in column 1 at I, J or K. This simple pattern is repeated twice as near as possible in the next columns, then three times, next to that, and then four times and so on, fanning out and

ending to the right in about column 32. The plan blank may, however, be turned with its longer dimension vertical if this helps. If necessary, each wall square can be divided into four, and graph paper used for the plan blank. Each player should complete a plan blank with each of the coloured numbers given above. Players might well qualify for further games by learning the multiplication patterns or *tables* they have made. When all the number multiplication patterns have been completed there will be many ways of bringing the best examples together and combining them in one big pattern, even if it means putting some of the fan shapes together to complete a rose pattern, or reversing and superimposing one on another, etc., to reveal new and surprising arithmetic facts.

The success of 'Lace Trace' will depend quite a lot on the use of printing (rapid reproduction) rather than painting techniques – potato cuts, lino-printing, felt pads, plastic foam, or even collage. Painting, on the other hand, would tend to become tedious unless square-ended brushes were used. For the plan blanks a square-sectioned stick would be fine, or rubber erasers cut to a square section.

Games of abstract fantasy

The most spectacular of the games of abstract fantasy, indeed, two of the most inventive of all our games, are perhaps 'Lotus' and 'Prophecy', both devised by a twelve-year-old. Sometimes a young person who is totally new to an area of culture has such wide-open eyes that he can pick up polarities which might escape anyone more familiar with the subject, for whom broader issues get taken for granted in the search for subtleties. The designer of 'Lotus' and 'Prophecy' doesn't get entangled in this way.

'LOTUS'

The first game, 'Lotus', is based on the yantra, the meditation pattern abstracted from the plan of an Indian temple, or 'stupa', which I described on p. 7. With this basis in mind, the designer of 'Lotus' set an archaeological scenario, with two teams of explorers entering the temple by the north and south gates respectively; and he made friendly spirits out of the Dhyani Buddhas which preside over the different orientations of the temple, and which in 'Lotus' influence the colours of the two spiral paths of the digs.

Lotus A painting game based on a yantra

Duration – 4 hours, or six periods of 40 minutes
Players – About 12 players aged 11–15

Scenario
Two parties of explorers excavate an Indian temple of square plan.
They have heard that there is a magnificent 'Jewel in the Lotus'
somewhere inside. They are helped in their search for the jewel by
the spirits of the temple.

Target
To reach the 'Jewel in the Lotus' and discover its meaning.

Teams
LION, EAGLE, ZENITH

Strategies
The Lion team enters from the south (the left in Indian tradition);
it is yellow ochre, and makes the Lion gate and a square spiral into
the temple from the Lion gate.

The Eagle team enters from the north (the right in Indian
tradition); it is turquoise, and makes the Eagle gate and a circular
spiral into the temple from the Eagle gate.

The Zenith team are the spirits of the temple; they create the colour
influences over the four quarters of the temple, in consultation with
other teams. The Zenith team also makes decorative mazes around
the two gates, and in any spaces between the spirals.

Tactics
The Lion team and the Eagle team draw their plans onto the Art
Arena grid in chalk and write in the names of the colours to be mixed,
(a) where the two teams overlap, and (b) where the spirits of the
temple influence the colours (i.e. between the diagonals of the temple
plan). The Zenith team explain their colour influences to the other
teams, and help to mark them in. This team may also help to mix
the paint and regulate the colours in consultation with other teams.

South influence is YELLOW and the background ORANGE:
It represents the spirit of discovery.
North influence is BLUE and the background GREEN:
It represents the spirit of kindness.
East influence is WHITE and the background BLUE:
It represents the spirit of mystery.
West influence is RED and the background PURPLE:
It represents the power of good.

There is more to 'Lotus' than meets the eye. The game preserves the correct orientations according to their symbolism, without becoming too esoteric by using the Indian names. Some organizers might prefer to direct north upwards according to Western convention, rather than to the right, according to the tradition of the yantra. On the other hand, it would be valuable for fourth- and fifth-form players, as part of religious education classes, for example, to use the Indian orientations and to learn more about cultural differences and the philosophical basis of the game. That's not to say that younger players may not enjoy breaking with Western traditions and experimenting with others. When we played it with eleven-year-olds they had great fun getting their tongues round the Indian names of the Dhyani Buddhas (east = Aksobhya, south = Ratnasambhava, west = Amitabha, north = Amoghasiddhi) who become the Zenith team of friendly spirits in the game. And of course the game may particularly interest immigrant children of Indian origin.

This game leads to the consideration of an abstract aesthetic form of a very high order, more advanced than anything of a similar nature that can be found in the West. Interestingly, the game target requires a discussion about morality at the end.

'PROPHECY'

'Prophecy' is based on the 'I Ching', the Chinese divinatory method supposed to have been devised by the legendary Emperor Fu-hsi around 2852 B.C. In the game 'Prophecy' one throws three coins as if one were going to consult the 'I Ching', the 'Book of Changes'; but instead, one is given keys to the creation of a group-generated 'prophetic' painting, intended to answer all the questions asked by the players when throwing the coins.

Prophecy A painting game based on the 'I Ching'

Duration – 2½ hours or five ½-hour periods
Players – Between 4 and 16 players aged 11 +

Scenario
The 'Unknown'

Target
To create a vision of the past, the present and the future, through individual and collective divination from the work (the picture and thought processes that make it).

Teams
Each player belongs to two teams, an earthly one and spiritual one. The teams are:

			Trigram	
Spiritual	CH'IEN	(Constructiveness)	☰	
	CHEN	(Thundering dragon)		☳
	KAN	(Deep water)	☵	
	KEN	(Mountainous obstacle)		☶
Earthly	K'UN	(The good earth)	☷	
	SUN	(Wind, fresh and gentle)		☴
	LI	(Fire, bright and beautiful)	☲	
	TUI	(Lake, rich and marshy)		☱

To find which team you are throw a set of three coins three times and then three times again. The coins represent the ancient Chinese coins used in the 'I Ching', where one side has a value of 2 and the reverse a value of 3. Each time ask what the future will bring: and each time count the values on the coins as follows:

At each throw a result adding to 7 or 9 is Yang (———)
,, ,, ,, ,, ,, ,, 6 or 8 is Yin (— —)
 Then construct the result as follows, and this will also provide your strategy:

Strategy

Make a hexagram beginning at the bottom line, e.g. ▤
At this point you could well consult the meaning of the hexagram in the 'I Ching'. In addition the following adaptation may be used to provide your strategy:

(Top) line 6 gives the hue	Yang = warm	Yin = cold
,, 5 ,, ,, intensity	Yang = bright	Yin = greyed
,, 4 ,, ,, tone	Yang = light	Yin = dark
,, 3 ,, ,, line	Yang = straight	Yin = curved
,, 2 ,, ,, quality	Yang = harsh	Yin = delicate
,, 1 ,, ,, complexity	Yang = simple	Yin = complex

Tactics

In painting the prophecy act as the powers you possess would normally operate in the ebb and flow of the forces in the natural environment.

Note

When we played the game it was just before the summer holidays, and most of the children seemed to ask about the coming holiday and the weather. The finished painting looked unmistakably Chinese, which was interesting as there was nothing representational in it; though it did, I thought, also convey something of the feeling of a sandy beach with lots of sun as well as plenty of storm clouds. Maybe any painting would have at that time of year! Anyway, the players seemed to make their own judgements about its prophetic value. Moreover, they had now been introduced to Taoism, yin and yang, and the hexagrams of the 'I Ching' – and found it all intriguing and fun.

Carnival and pageant games

It was never our intention that the games should remain two-dimensional. From the beginning ideas had been put forward for centring them in three-dimensional work and movement patterns. What we needed for this was our own area which would give the greatest possible chance for every kind of cultural activity within the unfolding action of the game. Space was short, but we were unexpectedly lucky when the demolition of some ladies' loos provided a site which was adapted to become the Art Arena workshop.

GAMES OF MOVEMENT

The suggestion was put forward by the designer of 'Lotus' and 'Prophecy' that perhaps a human machine could be created (something like Mme Gabrielle Madier's demonstrated in Paris in 1975, but in this case with a cosmological basis). Players would move clockwise using brushes mounted on broomsticks to cover the upper zones, and anti-clockwise below using smaller brushes and moving closer to the wall. Zones were created when sets of concentric circles of influence were drawn in advance on the walls and floor. It was decided that some of the characters of the Tarot might give game strategies: the Juggler (clockwise, the showman/anti-clockwise, the trickster); the Emperor (clockwise, the autocrat/anti-clockwise, the despot); the King of Cups (clockwise, the sage/anti-clockwise, the pedant); or the Hierophant (clockwise, the visionary/anti-clockwise, the occult). The rhythm of movement, too, was brought in here, under the influence of the planets: Venus producing an irregular beat that varied from strong to weak, Mars – irregular and strong, Saturn – regular and strong, and the Moon – regular and weak. Players had to respond to their rhythms according to their timbres sounded on a variety of different instruments. The rhythmical emphasis and the timbre had to be reflected in the painting and the target of an ideally balanced and fertile universe.

Few schools will have facilities for such a game as 'Tarot Rhythms'. Easier movement games to play are those which are plotted on the floor. In 'Force-Field', for example, one player is gently suspended by the other players so that the human pendulum is able to hold a sponge (not a brush as this might be dangerous) and paint onto a large area of paper covering the floor. If all goes well this produces harmonic patterns of lines like a magnetic force field. Each team uses a different

colour and may concentrate on, for example, three different areas of focal emphasis in order of importance. Our teams gave themselves names like Batman, Superman or Spiderman.

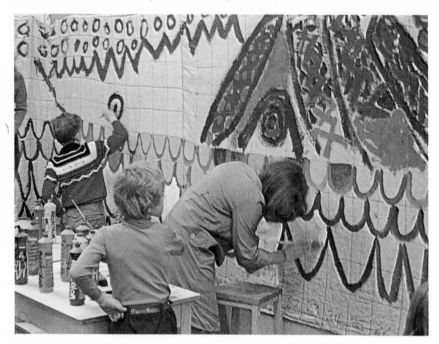

Painting the dragon's skin

'DRAGON'

The game I am leading up to, however, is much more traditional, and well tried and tested. This is a dragon-making game, developed by one of our team (Ken Beagley, a sculptor and local community worker) for the Spring Festival.

Dragon A carnival game

Duration – 3 hours
Players – 12 ± 3 players aged 8 + with an art teacher

Scenario
A Spring Festival requiring a Chinese dragon.

Target
To build and become a single dragon, which is both Yin and Yang, and to stalk down to the Spring Festival.

Teams
YIN, YANG

Strategies
Yin An icy-cold lizard type of amphibian. It has scales, or armour-plating with pyramid whorls.
Yang Fiery, with feathery wings, a crest and horns. It has short feathers all over with peacock eyes in them, and vanes along its backbone.

Tactics
The teams divide into body-making and head-making groups:
Body The dragon's skin is made of old sheeting squared up and stretched over the wall (more than one if necessary) to about 18 feet long. The backbone is a horizontal line across the middle of the sheeting. Above this line is Yang and below is Yin. Each team works out a design on its plan blank, using two if necessary. This is transferred to the skin on the wall by calling.
Head The Yin and Yang teams work out a design for one side of the head each. This is done on a plan blank. The cardboard is then squared up and the head design transferred to the card, which can be stapled onto the sides of a cardboard box to give a firm base. The Yin and Yang sides of the head will have to work together quite closely to make sure that the different sides of the head join up.

84 Art-based games

Special materials

In addition to the normal requirements of Art Arena games you will need: a piece of joined or continuous sheeting about 8 feet wide and 18 or 20 feet long; two A1 sheets of cardboard; and a cardboard box just large enough to fit over the biggest player's head.

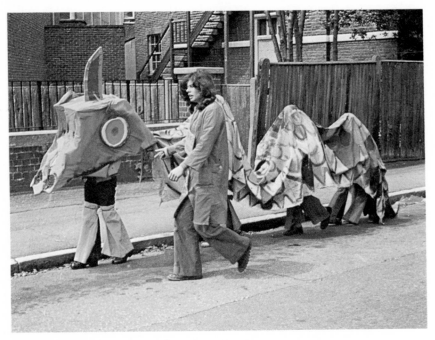

The dragon on the way to the Spring Festival

'BIONIC BATTLE'

This game does not use a wall – the action is focused entirely on the players themselves. If parents can supply suitable coloured garments 'Bionic Battle' becomes a beautiful ritual dance-like spectacle.

Bionic Battle An adventure playground game

Duration – 30–40 minutes
Players – About 30 or more players aged 7–15

Scenario
Ancient, medieval, science fiction or oriental warfare (e.g. the armies of KAO CHIU against LIN CHUNG and the bandits of LIAN SHAN PO).

Target
To produce a spectacle for video, ciné or photography.

Teams
YELLOW team and BLUE team
GHOSTS, a couple would do to begin with

Strategies
The Yellow and Blue teams line up in phalanxes at opposite ends of the playground. On the command 'Charge!' both teams advance to a drum beat of increasing tempo. As soon as both armies reach the area marked off as the battle arena, there is an ear-splitting blast of a trumpet or siren and the drum beat drops its tempo to a dead march. Yellow shields are turned over to reveal purple, blue shields to reveal red, and all movement becomes 'bionic' – in slow motion so that wild ritual gestures can be made. This continues until the two armies have made their way to the opposite ends of the play-ground battle-field. Then the ranks re-form and battle begins again.

No one may touch anyone else or they join the Ghosts, who wander *backwards* and partially blindfolded to and fro across the arena battlefield, gliding in slow but unexpected motion. Anyone touching or touched by a Ghost becomes a Ghost. After several charges most warriors will have become Ghosts.

At each Trump of Doom everyone freezes, and a Ghost who moves becomes a spectator. A warrior who moves becomes a Ghost. After the Trumps of Doom, action begins again with the drumbeat.

The whole encounter ends either when all warriors have become Ghosts or at the sounding of a double or treble Trump of Doom, when all remaining warriors become Ghosts.

Special props
Shields with reversible colours, yellow/purple or blue/red. A drum, expanded polystyrene swords, a trumpet or siren, lots of 'see-through' blindfolds (for acting blind), something to make two lines across the playground or field, marking the beginning and the end of the 'bionic' battlefield.

Simulations

More important than the games included in the ten favourites described in this chapter are certain games, sometimes described as simulations, which have become models for the invention of many other games. These are followed in detail in the next chapter.

The term simulation has been used because in a limited sense these games can certainly be thought of as simulations, and so enjoy the academic respectability which the term provides. Essentially, however, they are something more important. They are creative projects in their own right, through which a group produces art. Because the process is fast and enjoyable – and uses game processes – it can also rightly also be called a game.

A simulation is an imitation, copy, caricature, or a model of something else. Many of our games have included an element of simulation, and have been no less enjoyable for this ('Spaghetti Junction', 'Customized Connoisseur', 'Copyright', etc). But if the art-production and the enjoyment are to be thought of as less important than the learning – whether from simulation or scenario data – the whole impetus of the project as a game is likely to be lost – and then the learning too may fail.

In a pure simulation the art content is likely to be the art of illusion – *trompe l'oeil* painting, shop-window dressing, stage sets, graphics and display to ease data retrieval, etc. It can be vital for many players that the simulation conjures up an image sufficiently strong to engage their interests and provides a flag and banner to campaign under. Without it the player who thinks visually is likely to lose his enthusiasm.

Unless a simulation is played by well-motivated specialist groups it is doubtful whether it can be wholly successful unless the organizer has some sense of artistry and display. The visual field needs to be subjected

to the same nicety of selection as is applied to the topic or discipline from which a game-content is developed. In most A Ag games, however, the visual and other content is inseparable. Indeed, A Ag games are probably best run by organizers who are artists – not so much because an artist will have many more answers to question of 'How?' but because he is less likely to say 'Don't do that!' (subject to the observance of safety precautions and a respect for human dignity).

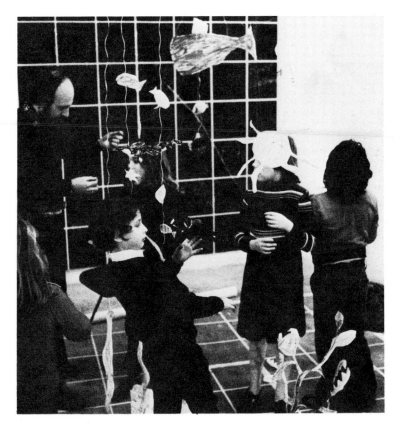

An AAg game involving 3-D space and movement at the Museum of Modern Art, Oxford

7 Model games

Two model examples from the rapidly growing list of games are described here in detail. In the first, 'Psychon', the stress lies upon the possible diversity of tactics – of experiments with media – in creating a considerable variety of effects in one painting. The second game, 'Road Blocks', is a game of considerable strategical complexity, providing rich opportunities for learning about the control and mixing of colours. Both games have been played with great gusto by children, but versions have also been devised for degree students, and have been used as instruments of research. As 'Icon 1' and 'Icon 2', i.e. in their more advanced versions, they figure amongst the most frequently played games in our repertoire. They are particularly suited to the upper forms in a senior school, the fourth-, fifth- and sixth-forms. In fact, if the technical terms were dropped they would also work well in the lower school. It is important, however, that they are supervised by an artist or artist-teacher.

A game paradigm

The model game 'Psychon', which is described in detail in this section, was at first a stopgap based on a game neither my colleague Michael Challinor nor I could understand – one devised by a fourteen-year-old, Owen Tudor. His game was called 'Lens' and was very complicated, covering several pages of typescript with many charts and tables. To gain time I substituted a much simplified game based on his idea but with a different structure. Eventually we decided to try out Owen's game in its original form with his group enlisted from the National Association for Gifted Children, assuming that these children might understand it better than we did. There were some long delays before players unravelled innumerable hidden clues but after taking one or two short cuts the resulting painting was quite commendable,

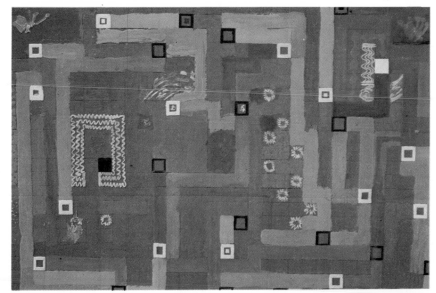

'Lens' – a science fiction game with puzzles and hazards

although the young games-inventor was disappointed in his friends' performance. It was his initiative in 'Lens' that resulted in our most-played game, 'Psychon', a game with many versions and developments. One of these, 'Icon 1', has become a standard game in teaching design and communications to degree students. Further developments are followed in 'Road Blocks' and 'Icon 2'.

PSYCHON

The game of 'Psychon' may at first reading seem complex, too complex for ordinary middle-school kids. Nevertheless, I have used it with several groups of such children and it worked well. That is not to say one doesn't meet snags. What I shall do first is describe it as if carried out with an ideal group of keenly interested children (and most groups become keenly motivated when they are playing). Later, I shall point out some of the problems and talk about ways of getting round them.

'Psychon' begins as players enter the games workshop, and are asked to choose a colour from a swatch of four sets of coloured cards: red, yellow, green and blue, each a little longer and narrower than a traditional playing card. Holding the card, each player is directed according to its colour to a seat at one of four tables. The game accommodates a maximum of sixteen players, four to a team. Each

'Think me to your citadel' – a binary version of 'Psychon' (age 9–14)

team is allocated a colour, and has its own table or Headquarters. As soon as players are seated the scenario of the game is explained; it is both science fiction and a venture into inner space: 'You are an islander in a cosmic mind in deep space. There are four islands of consciousness. Each island is inhabited by a different race, the Dyno (red), the Splat (yellow), the Logica (green) and the Esoterica (blue).'

Strategies

The strategies of the four teams in this game span the greatest range of expression available in any game mentioned so far. For example, the Splat are an island people who act on the spur of the moment with flashes of inspiration. They are recommended to use the most spontaneous techniques of application they can invent: printing, splashing, quick brushwork; in high intensity colours, with sharp, hard-edge effects, random broken and splintered shapes, radiating lines and so on.

The Dyno are a people with strong wills and a sense of power and authority. They are recommended to use large-scale, geometrical and especially orthogonal shapes in hot colours such as red and orange. Theirs must be a dynamic and powerful contribution in shapes that are huge and majestic.

The Logica are an ingenious people with a facility for creating systems and networks. They are geometricians, well able to make patterns or repeating and interlocking modules in colours austere and astringent, e.g. blues and greens, with black if necessary.

The fourth group of islanders are the Esoterica, mystics who see visions and dream dreams. They paint as if through a glass darkly, using atmospheric and nebulous or curvilinear effects in soft-edged retiring colours such as blues, or gentle, low intensity nuances of any hue.

The game can still be played successfully with as few as four players, but it does help if the green team (Logica) has more than one player in it, as this team usually has the most work to do. On the other hand, it is best for the yellow team to be the smallest, as its contribution usually takes least preparation.

After the strategies have been explained some players have been known to ask if they could change places, which is perfectly legitimate. But if no one wants to swap, then the player is allowed to assume either the colour types or the shapes allocated to the other team, while retaining the other characteristics of his own team. Normally a player who has strong views about the form of the game will be an asset, provided he can be persuaded to make constructive suggestions which are accepted by the rest of the group. A change believed in by everyone is likely to be a change for the better.

The game begins

If the players are not used to art-based gaming projects you may wonder why they don't begin. They will be waiting for the word 'Go' or a whistle. It's best to say 'Begin when you like and rough out an idea on your scrap paper, or work straight into your plan blanks. You can work at any speed you like. There is no alternation of moves.' Diagram examples of possible answers should be available for anyone who wants to see them, although many players will prefer to complete at least a rough design before looking at the diagram examples.

As might be imagined, the first drawing a player does on his plan blank is usually done without reference to the rest of his team. Once all a team's plans have been completed it will be necessary for the players to look at them carefully, for each plan is a design for the whole of the prepared wall. A team needs to find out how strongly each player feels about each part of his design, so that features may

'Psychon' – played by Japanese art teachers

be selected and recomposed into a single, uncomplicated masterplan for that team. Although this process simplifies the selection, the organizer or umpire should be careful that a really good answer is not lost in this way. Some members may generously withdraw their plans from consideration for inclusion in the masterplan, but some effort should be made to preserve something of them, even if it is only a colour or texture. There are many ways of incoporating a motif without cluttering up the final effect, for example by superimposing, fusing or interweaving.

While the masterplans are being prepared there may be players who are not fully occupied. These players can be asked to carry in their minds as best they can some image of their team's masterplan as it will look when it is finished. With this in mind they will be able to glance around the workshop at other teams' masterplans as they develop. Soon, a similar cooperation job will have to be done with all four teams' masterplans, and these observers will be in a position to lead the new discussion. Part of the fun of the game is the attempt to visualize what is going to happen when the strategies or masterplans are mapped upon each other. Some of the biggest conflicts can easily be avoided by foresight at this stage, whereas later in the game the structural alterations that might be needed to do this

would be almost impossible. While still in the planning stage it is easy
to move a motif one way or another. Some teams like to take a lot
of trouble sorting out the main coincidences of motifs, so that there
will be minimum confusion when the plans are drawn up on the wall.
A useful way of doing this is superimposing the plans on an illuminated
slide viewing table or an overhead projector (without projection).

In other games teams might prefer not only to try not to see other
teams' masterplans, but even to bypass the chalking up process and to
paint directly onto the wall, enjoying the surprises of the interplay –
continually making and negotiating territorial claims. This makes a fast
and furious game with lots of noise and bluster, and several halts for
conferences to check that no one is being left out. However, before any
painting takes place at all, it is vital for teams to give each other some
idea of what they are going to do, and for Logica, the most vulnerable
team, to have an understanding with the other teams as to any repeat-
ing units which require clarity and precision of rendering.

A decision to work straight onto the wall with no drawing is
exceptional. Normally, as soon as the masterplans are completed, they
are called square by square to the wall and drawn in with coloured
chalks, one colour for each team. Esoterica usually calls the coordinates
for clusters of squares, and the centres for any circles that have to be
constructed with string and a drawing pin. Splat is also likely to call
square clusters. Up to this time, each team will have drawn upon the
wall as if planning to use the whole wall, drawing over and through
other players' drawings.

Unscrambling

When all the mappings in chalk have been finished an unscrambling
conference is held to decide upon the tactics to adopt where drawings
interpenetrate. One after another teams explain which areas or features
they are determined to preserve and point out others they don't mind
losing or compromising over. There is always plenty of bargaining
power and there are plenty of ways of negotiating if challenged: there
will be shapes and motifs elsewhere with which one can barter, or
the offending shape can be modified in some way. When all else fails
it is usually possible to suggest changing the colour of the motif over-
lapping the cherished shape. It may be possible to mix one's colour
slightly nearer to the colour used by one's challenger; or, in really

difficult negotiations, one may have to be satisfied with a colour almost identical with that of the challenger's motif.

After the unscrambling other players sometimes allow Esoterica to sponge in some thin washes which allow the chalk lines to show through. But unless there is enough time for the washes to dry off a bit, it is usually best not to allow any painting over large areas as preparation and base for other colours.

The middle game – tactics

Now the middle game begins, and as the painting starts there is a complex interplay of busy figures balancing palettes in one hand and with the other wielding anything from a very large distemper brush to an improvised 'secret painting weapon'. It is a considerable asset to have a trained artist or designer directing the proceedings, who can explain how to create counter-change, interchange, and interpenetration of one colour by another, though the potential of the many discoveries that can be made by a group working sensitively, even on its own, should never be underestimated. At the first sign of conflict a conference, or Court of Appeal, is called, and players are reminded that the end product has to be a balance of interests of the different teams, or the game will be lost for everybody. Everyone must flourish according to their specified characters, although at this stage it may still be a mystery to the uninitiated how on earth there can be room for everyone.

The characteristics of each team should be emphasized: Splat must seem to be spontaneous and radiating, Dyno must be huge and powerful, Logica must be ingenious, and Esoterica vague and mysterious; as must be the importance of balanced representation. As long as these requirements are understood the conference negotiations can go ahead. If there is deadlock – though the potentialities in all directions are immense – as a last resort the very game-requirements themselves can be changed provided all the players agree.

The final conference

As a game draws towards a close and all the white areas of paper are claimed, it is usual to call a final conference, especially if it has been a quiet game with no conflicts. This is a grand strategy review, and consists of short explanations from each team, setting out their plans for finishing and describing what they hope to achieve. At this stage,

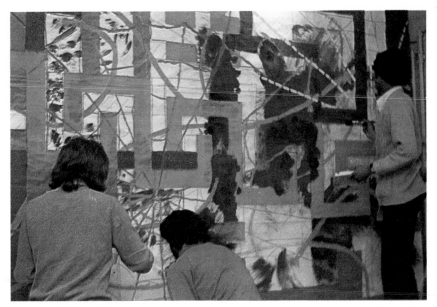

Students of electronic engineering playing 'Psychon'

the group, if new to the game, will begin to realize that the painting still offers many opportunities for further development, and they may even realize that it could be continued over several days (as some, in fact, have). The model group we are following must finish in five minutes flat, and now comes the last burst of energy as all the final finishing touches are added to ensure 'dynamic' equilibrium, a tension between the balancing forces.

Tables and stools are cleared to one side, and players sit down anywhere where they have a good view of the wall. The work is given a dispassionate appraisal by the organizer, and emphasis will be laid on the positive achievement of the painting as a piece of decoration or work of art. Again, it is stressed that what was wanted was not an equal division of area for the team territories but an effective balance of team contributions, and a technical comment on how the balance has been achieved may be useful. A large area of low-intensity colour is balanced, for example, against a small focus of piercing colour.

Some thought may be given to the painting's suitability as a cartoon (i.e. working drawing) for a tapestry, fresco, stained glass window or tempera painting. This will lead into a discussion of the value of the project – what, in simulations exercises, is called debriefing.

Evaluation

Finally, the players are asked to vote out of ten in answer to the following six questions:

1 To what extent does your painting satisfy the needs of the scenario? (How well does it give the impression of being science fiction?)
2 How effective was your strategy? (How well did all your master-plans help in the painting?)
3 How well did you get on with other players (in your *and* other teams) in negotiating, communicating and cooperating?
4 How skilful was everyone in handling the medium (paint, etc.) on the wall surface while confronting and negotiating with players from other teams?
5 How well balanced are all the different teams' interests and contributions in the painting? (Are all teams properly represented or has anyone been smothered?)
6 How much pleasure has the whole project given you personally?

So that there is no mistake, the meanings of the numbers should be explained before voting:

0 = Objectionable
1 = Feeble
2 = Poor/weak
3 = Not quite satisfactory
4 = Only just satisfactory
5 = Satisfactory
6 = Quite good
7 = Good
8 = Very good
9 = Excellent
10 = Fantastic/beyond excellence

If any of the replies in the 'Enjoyment' column fall below 5 out of 10, this suggests that the project has not been acceptable, and it might be wise to find out the reasons for this. It is also a good idea to ask players how well they think they did individually. Such a self-assessment may shed light on their criteria. In addition, it can also be valuable to the group on some occasions to find out to what extent they agree with individuals' self-assessments. This can be done by asking for each strong reaction to be registered as a plus (+) or a minus(−). For

example, if three players feel that a player did better than his estimate one might record in the 'Moderation' column ' + (3)' and if two players thought he did worse, '– (2)'. Exceptionally strong feelings might even be indicated by a double or even treble plus or minus. In school contexts importance may well be given to the teacher's moderation, in which case a plus may be given a value such as 5 or 10 per cent.

Precautions and practicalities

In the heat of the painting, normal safety precautions should not be neglected. Players will be wearing overalls or their oldest clothes. If the painting requires players to stand on tables in order to reach to the top, then the same tables shouldn't be used for mixing on; and paint spilled on the tables should be wiped up immediately in case someone slips on it. Naturally, paint shouldn't be spattered towards anyone, and painters working low on the wall should wear the traditional paper hats, folded out of newspaper, as worn by Italian artists.

After the general discussion, players should, as always, clean brushes, palettes and bowls, and set the furniture back in place.

A mural design simulation I

When we introduced art-based gaming into the teaching of design and communication, 'Psychon' seemed the most suitable model. It worked well as a game, so we felt we could do away with its science fiction trappings and use the game-structure more directly in presenting a straightforward problem in design. In one sense, this made the game into a simulation. Its scenario become a realistic one – that of a research committee requiring a mural for its committee room. The teams, too, were given the realistic job of devising motifs to satisfy specifically identified parties on the committee. In another sense, however, the project need not be thought of as a simulation at all. The outcome was likely to be able to stand up in its own right as a group-generated mural suitable for almost any committee room.

'ICON I'

This game divides the task of creating a single mural among four teams of 'designers', where normally one professional designer might be

expected to do the whole job alone. The project is to design and paint a mural for a research and development committee. Like most committees, this one consists of members with vastly differing attitudes towards life as well as towards research, and the finished painting should present a harmonious interaction of their various view points.

Icon 1

Commission
A Research and Development Committee commissions four teams of designers to make a preliminary study in painted form for a panel which will ultimately be completed in ceramic tiles, tapestry, polymer resins, printed as a large broadsheet, or reproduced by some other suitable technique the teams may recommend.

Scenario
The members of the R & D Committee differ in their outlook and their views of reality. The mural has to represent the emergence of a unity from their initial diversity.

Teams
STOCHASTIC, HOLISTIC, REDUCTIONIST, METAPHYSICAL

The teams have been selected so that they may reflect the characteristic outlooks of the main cliques on the Committee. These are not easy to describe, but the Committee have agreed that they may be described as follows:

Stochastic See natural phenomena as fleeting, quasi-random events moving sporadically and indeterminately
Holistic Perceive the universe as a set of power groupings
Reductionist Aware of patterns and networks in everything
Metaphysicals Always conscious of the element of mystery underlying natural phenomena

Strategies
Members of the Stochastic team have been chosen because they are believed to be capable of working freely and spontaneously, with

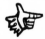

flashes of inspiration, and it is thought that this might reflect something of the stochastic outlook. They are recommended to use sharp, angular and radiating lines and shapes, techniques that look freely executed, and piercing intensities of colour.

Members of the Holistic team have been chosen because it is believed they are capable of expressing a power complex. They are recommended to use forms and colours which command and challenge, hot colours, and large-scale, hard-edge and orthogonal shapes.

The Reductionist team has been selected because it is believed that its members are precise, ingenious and logical thinkers, and will be able to use forms and colours that communicate with precision, e.g. accurately painted interlocking repeating units, perhaps using whole squares of the grid.

The Metaphysicals are visionary. They may see colours that are hardly more than tinted greys, light, mid, or dark. Delicate nuances of colour would be appropriate. Alternatively, they may assume the sharpness of vision of some of the Surrealists, concentrating on incongruous juxtapositions.

Roles
Where there are a sufficient number of members in a team, it will be possible to have a planner/stabilizer, callers, designers, and artist/painters.

Tactics
Teams need to realize that the motifs they develop need to be relatively simple, so that the interpenetrations of the four masterplans will combine effectively and not create total chaos. In order to operate successfully each member of a team has to come to terms with the differing perceptions and attitudes of colleagues. During the process of working together teams will have to be able to achieve a degree of unity in their thinking and designing, which will enable them to produce a work which has a unified corporate image.

Target
A unified 'icon' of the group mind, showing a harmonious interaction of components appropriately represented and balanced according to their team characteristics.

The development of the mural follows precisely the same stages as in 'Psychon'. The debriefing at the end is replaced by a discussion on the appropriateness of the teams' efforts in the preparatory full-scale mock-up for a mural in a particular medium such as enamel, poly-urethane resin, tapestry, ceramics, or in one of the various painting techniques: tempera, oil, fresco, etc.

The game as a ceramic mural – *by* POLLY BINNS

'Icon 1' has, in fact, been taken further by several student groups and carried out in several of the media mentioned in the last section. Polly Binns, a ceramic artist and teacher, describes below one of the most effective versions of the game.

Work on the ceramic mural is carried out as a group, as with the painted version; and as before, each player has to explore the different ways of achieving the effects the different members of the committee want – spontaneous, powerful, systematic, and mysterious. But this time, before working in the group, a player will try working at each of these effects in clay. The different qualities suggest various technical processes:

1 Coiling, incising and gouging (spontaneous techniques)
2 Block- and slab-building (power effects)
3 Pressed, cut and sliced shapes (repeating units)
4 Pinching, smoothing and tearing (soft and subtle effects)

At first each person has to become accustomed to working in clay, and needs to work independently, until finally every member of the group has produced at least one example of each category numbered above. During the session, large labels are lettered ('Free' or 'Spon-taneous', 'Powerful', 'Systematic' and 'Mysterious') and laid out on a clear surface to one side of the working area. As soon as examples have been made, they are put next to the appropriate labels. A minimum of two hours is needed for this part of the work, longer perhaps with adults. It is a good idea to have a great variety of implements of all kinds, not necessarily tools designed to be used with clay, e.g. nuts and bolts, toothbrushes, surforms, wire, twigs, leaves, sacking, reamers, cog-wheels, pastry cutters, and so on, the more the better.

Eventually, players will decide on the mode in which they would like to work. This is like choosing the colours at the beginning of the

painting game. One, several or a composite motif can be chosen by each team. When everyone is ready the plan of the mural is mapped out onto a large sheet of paper the size of the finished art-work – the size depends upon the area and time available, as well as on the number of players.

Players who haven't 'played' the painting mural take much longer discussing the planning of the mood motifs on the paper, as they haven't yet developed a sense of positioning. It is useful if these are drawn in with coloured chalks, using the same four colours as before to represent the different components (yellow for spontaneity, red for power, green for repeating units and blue for mysterious). It is usually decided that the 'power' element will remain more or less self-contained while the others do the interpenetrating. As in the painted mural, it is often the spontaneous element that is developed last, and works over the other motifs.

The purpose of the working drawing, or cartoon, is mainly to jog the memory about the basic decisions, so easy to forget in the excitement of the interplay in which players meet each other working with the clay. The cartoon can be pinned on the wall for players to refer to.

It is important that both organizer and players remember that because of the nature of the material the next stage, the making of the mural itself, has to be done in one continuous session lasting at least two hours. (A group of ten teenagers can make a mural of about five feet square in this time – and after two hours even the toughest teenager will be exhausted. Allowance should therefore be made for the smaller hands and lesser energies of younger children.) Players should also consider that the finished art-work will be a *mural*, i.e. on a vertical plane, although it is being worked on the horizontal. No part of the work, therefore, should rise above about five inches.

The mural is made on an absorbent wooden table such as it is customary to have in ceramic workshops, not onto hardboard. The boundaries of the main motifs are drawn onto this with chalk. The first move made depends on the design. Some groups put their 'power' elements on the surface straight away, and then interlace the other elements around them. Other groups put a basic all-over layer down, on which they develop the 'power' elements. This is a decision to be made by the group when the design has been formulated. If some of the players have more precise things to make, they can concentrate on these, while the rest get the all-over area down. It is useful and speeds up the design process if some people are quite happy to stand on the

sidelines preparing various pieces, e.g. lots of coils or tiny blocks of clay. They need not necessarily have taken part in the mural design itself.

Of course, it goes without saying that the experimental pieces made earlier at another session and now taken as models should not be used in the mural itself – all the clay needs to be of the same consistency to prevent uneven shrinking.

The finished clay mural is cut up into regular sections according to the shelf-size of the kiln. It is a good idea to ask players who have cameras to bring them, or to have photographic provision laid on, in case the result is not suitable for firing.

It is best to work with a white earthenware clay if the colours are to be taken through to final glazing (e.g. Podmore's P.1024 – a 5 foot square takes about 50 kilos), and if you want to glaze the finished result it is best to use a low soluble transparent glaze (e.g. Seger cones 03a). Pour out three batches of glaze, leaving the remainder transparent to achieve a white effect, which will be useful for the 'free and spontaneous' group. The other three batches each need a different percentage of oxide in them. The 'power' group might add 5 per cent of red iron. The 'systematic' group could add 5 per cent copper carbonate and the 'mystery' group 3 per cent cobalt oxide. The glazes will have to be brushed on rather than dipped. After they have been fired again the mural tiles can be fixed in position using cement and pegs.

A territorial game

'Road Blocks' is a game of high strategy involving a more complex interweaving and interpenetration of shapes than any other AAg game. It was originally designed to test the spatial abilities of a group of children from the NAGC (National Association for Gifted Children), and was based on another aspect of the tantalizing 'Lens' game designed by Owen Tudor (see p. 88). However, the complexities of 'Road Blocks' are even greater than those of 'Lens', even though they are solely visual. They went beyond the capabilities of the NAGC children, whose attempts to solve it resulted in something looking like a confusion of tinted mushrooms, macaroni cheese and coloured seaweed. Nevertheless, when we tried the game out with older players it worked well.

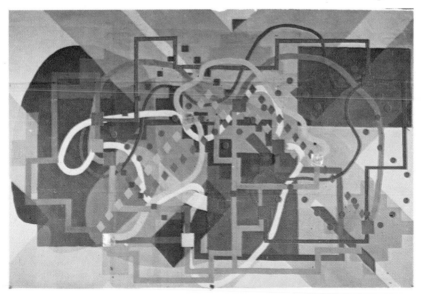

'Road Blocks' – played by students of civil engineering

'ROAD BLOCKS'

The game is a further development of 'Psychon' in that it is again about the four science fiction nations, Splat, Dyno, Logica and Esoterica. The scenario is now one of an inter-stellar city in which four anti-pathetic nations hold most of the territory in joint ownership although each has its own specific areas; they must attempt to flourish in harmony with each other.

The problem, as before, is that when all these zones are transferred from masterplans to the same mural grid on the Art Arena surface there will have to be complex mappings of zones one over another. Where territories overlap the colour of each must be included in the mixture of the final colour of the overlap area. The exact character of the mixture, how much, that is to say, of each colour goes into the mix and how light or dark it should be, has to be determined aesthetically. The unscrambling process is a long one in this game, and each overlap has to be labelled with the colours in the mix. It was in fact the game of 'Road Blocks' which introduced the idea of the unscrambling conference, which is an integral part of most A Ag games. The formal/expressionistic character of a game outcome depends very much on the amount of time devoted to this.

'Road Blocks' is further complicated by the addition of a centre to each zone and two main roads from each centre joining it to the centres of the team's other two zones. Each centre occupies one square on the grid, and it cannot be changed by overlay. The game is virtually impossible to play if the zones are not drawn and painted in before the roads are mapped out on the wall. In the game as first played it was ruled that any roads crossed an odd number of times would be blown up by terrorists. However, the only players to get as far as this were a team of civil engineering students, who promptly reframed the whole game as a civil engineering simulation, with building foundations (Dyno), sewage conduits (Splat), services (Logica), and environmental data (Esoterica).

Road Blocks

Scenario

You are one of four teams of science fiction town planners, each of which has to build a city for one of four different races. The four races do not want to mix, but they do happen to exist at the same time and occupy the same area. However, their lands are different shapes, and have different frontiers (see Strategies).

Teams (races)

SPLAT, DYNO, LOGICA, ESOTERICA

Nubs and zones

Each city has three main zones with a centre (nub) in each zone. Each nub is joined to its fellow nubs by roads.

 The different races' territories and highways will sometimes flow in and out of each other. It is desirable to have plenty of overlap and crossings, so that the races can be encouraged to mix and appreciate each other better. Overlapping areas must be shared by mixing together the colours of the two or more parties concerned. The same applies to the roads. Even your own roads crossing each other must mix colours over the area shared.

 No race may claim to be the sole possessor of any territory marked on the masterplan of another race.

Target
Design in the Art Arena the grand masterplan for the 4-race super-city called PSYCHON.

Strategies

SPLAT

Nubs Place three silver squares well-spaced over your masterplan. These are:
1 a fast-travel centre;
2 a sports stadium;
3 a rocket launch site;
and are the nubs of your zones.

Zones Light grey, bounded by oblique lines.

Roads Each zone has three roads joining the three nubs:
a) diagonal in diamonds – yellow
b) orthogonal – lime-green
c) curvilinear in small arcs – light blue

DYNO

Nubs Place three red squares well-spaced over your masterplan. These are:
1 a military arsenal;
2 a Hall of Justice;
3 a power-house;
and are the nubs of your zones.

Zones You have three large rectangles or squares, to be coloured light red-brown.

Roads Each zone has three roads joining the three nubs:
a) orthogonal – red
b) curvilinear – red + light grey (white + a little black)
c) diagonal in diamonds – orange

LOGICA

Nubs Place three green squares well-spaced over your masterplan. These are:
1 a communications centre;
2 an information terminal;
3 a bank;
and are the nubs of your zones.

> Zones You have tree large stepped diamonds, to be coloured grey-green.
>
> Roads Each zone has three roads joining the three nubs:
> a) diagonal in diamonds – green
> b) orthogonal – green + light grey
> c) curvilinear – citrine (yellow + a little black)
>
> ESOTERICA
>
> Nubs Place three squares well-spaced over your masterplan: one white, one blue-purple and one light blue. These are:
> 1 a museum and art gallery;
> 2 a temple;
> 3 a library;
> and are the nubs of your zones.
>
> Zones You have three curvilinear-shaped zones, to be coloured light blue-violet (blue, purple + white).
>
> Roads Each zone has three roads joining the three nubs:
> a) curvilinear – white
> b) diagonal in diamonds – blue-purple
> c) orthogonal – light grey or silver
>
> NOTE: All the above designated territory belongs to each team as planned where it is not also marked on another city's masterplan. Land that is marked on more than one team's masterplan must be shared.

A mural design simulation II

'Road Blocks' was revised as 'Icon 2' and given a scenario similar to 'Icon 1'.

'ICON 2'

Scenario

A mural is commissioned by an industrial organization which wishes to symbolize its progress in expansion. The organization has four main departments, and each is to be represented in the mural by a design team.

Teams and strategies

The first area is *advertising and publicity*, which has three zones bounded by oblique lines and slatted yellow in horizontal bands. The second area is *management*, with three red orthogonal zones. The third is *accountancy and computing*, with three green stepped diamond zones, and the fourth is *forecasting and project-design*, with three blue curvilinear zones. As before, each team's zones have centres (now called 'information centres') and each centre has two channels connecting it to two other centres. The centres and channels are: silver/oblique (advertising); magenta/orthogonal (management); lime green/orthogonal with a diagonal displacement of one square where directions are changed (accountancy); and purple/curvilinear (forecasting). Channel colours are open to choice.

Tactics

Tactical stages are (1) the unscrambling process, including writing into each overlapped territory the colours to be mixed, and (2) painting in all zones before marking in and painting the communicating channels.

The whole project can be equally effective restricted to three teams using the subtractive primaries for their zones (magenta, yellow and cyan), or as an exercise in classical colour mixing using the Greek palette, red ochre, yellow ochre, black and white, introducing more intense hues for the centres and channels.

Perhaps the players most perplexed by this project were pupils of computer studies, who, after attempting a systematic approach to unravelling the permutations of colour mixings, decided in the end that perhaps it was best to make the mixtures by intuition and sensibility!

The operation and results of 'Icon 1' and '2' used as research games show that 'Icon 1' (and 'Psychon') produce considerable *tactical* variety of expression in the use of visual media, while 'Icon 2' (and 'Road Blocks') produce a greater variety in formal policy-making decisions at *strategy* level. 'Icon 1' never looks the same even when it is repeated by the same players. 'Icon 2' is always somehow identifiable, expressing something of the thoughtful composure of an experiment in crystallography.

NOTE: For simplified versions of 'Psychon' (particularly suitable for handicapped players) see index under 'Psychon' progeny.

8 The invention of art-based games

This chapter gives various people's accounts of the process of devising games, with examples of the games they have invented. Thinking up a game may seem difficult. In fact, it is less difficult than it appears. At first we (the organizers) invented all the games ourselves, but by the end of the first term the children were demanding to take part in the games invention. From that time onwards the process has been shared between players and organizers. We used to hold a games-invention session at the beginning of each new term, but recently there has been no need, as the children automatically turn up with games already worked out; although while all the children have had a go at inventing games, some of them have shown particular aptitude.

How does one set about inventing a game? We found that even the most imaginative inventors were not always able to remember all the factors involved, and we overcame this problem by designing a simple form to fill in (see Fig. 9). The games invention form is not so much a questionnaire as a memory jogger, providing minimum space and the fewest possible headings so that it is not too daunting for children to fill in.

There is no one way of devising art-games. A systematic and thoroughly serviceable method is to start with one of the main aspects of the game, preferably beginning with the scenario (the game's topic and story line) and strategy (the theoretical opportunities open to teams in planning their campaigns), teamwork (opportunities for inter-team judgement) and tactics (the moves of the game) – or indeed, starting from the other end, a target, and working backwards to the scenario. In this systematic thought-process, the ideas flow forward or backwards through the consecutive stages of the game. The systematic approach is a good one and will yield a sound and workable game for almost any topic you like to think of. Alternatively, one may have a flash of insight,

Eco Machine
(Game title)

Art Arena game devised by

Howard Rich (12yrs)

Duration 2½ hrs

Date 9·4·1978

Number of players: 9 ± 7

Group **Juniors**

Ecology
(Topic subject)

SCENARIO A company has decided to make a machine which harnesses natural power and is easily transportable.

TEAMS 1 Earth 2 Air 3 Fire 4 Water

STRATEGIES

	Colours	Shapes	Effects
1 Earth	Brown & Grey	Block shaped	Heavy.
2 Air	Light Blue & White	Triangles & Diamonds	Airy
3 Fire	Orange, Red & Yellow	Cubic & rectangular prisms plus parralled space frames	Structural & Furnace like.
4 Water	Dark Blue & Green	Curved & cylindrical, with pipes	Spherical, ball-like or globular.

TACTICS

EARTH must harness gravity.
AIR " " wind or blown air.
FIRE " " sun & fire.
WATER " " flood & hydro power.

ROLES Planners ✔ Callers ✔ Designers ✔ Artists ✔

TARGET

To make a machine which will make use of the energies of nature released in natural and unnatural disasters and convert them to constructive use in the disaster area. Each team should be properly represented.

Fig. 9 Invention form filled in by a young game-inventor

like the inventors of 'Spaghetti Junction' (see p. 115) and 'Pulsar' – a game which was 'seen' complete as the inventor stepped off a bus.

Much depends upon what you want to get out of a game. If you have a special interest in drama, movement, ethics or morality, you will enter the circuit at teamwork, and perhaps stay with it. If you like spontaneity, randomness and chance, you might enter at tactics, and very likely begin and end with tactics without introducing any of the other main aspects of the art-based game.

An inventor who concentrates solely on the scenario and story-line is likely to make a simulation. This may have a non-visual origin (e.g. 'Intellect 1 & 2', based on the brain – see p. 130) or be entirely visual like 'Crystals'. Anyone who wants good painting or interesting art will concentrate on visual strategy and tactics, and an aesthetic target.

Fig. 10 shows the processes of the systematic creation of an art-based game. The simplest games invented have been based on the contrast of opposites, e.g. Sunshine against Storm (described on p. 55).

One of our most effective and simple games is 'The Blend', invented by nine-year-old Nicholas Richardson, who saw the collision of a space-ship and a space rocket as producing a fusion of the two and new properties neither had before. The most sophisticated of the juniors' game inventions is perhaps David Priestland's 'Prophecy' (described on pp. 78–80). Students have invented games ranging from 'Genesis', a simple clash of archetypal forces – Lava, Gases, and Electric Storm – by geology students, to a complex game within a game by student of electronic engineering (see pp. 129ff.).

While students have contributed a high degree of skill in the execution of the art-work, the children have excelled in the invention of the games. However, it hasn't happened overnight. The process has been a slow and steady one, and it might be helpful at this stage to include accounts by some of the games inventors. The first game was the conception of a ten-year-old, the second one of the twelve-year-olds. The games accounts are, as with all children's writing for the games, a cooperative exercise with parents or organizer, and have been edited and simplified so that the games work smoothly and the ideas can be understood.

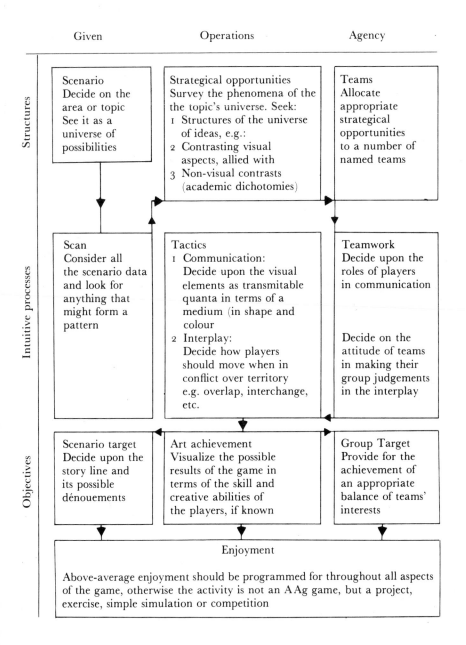

	Given	Operations	Agency
Structures	Scenario Decide on the area or topic See it as a universe of possibilities	Strategical opportunities Survey the phenomena of the the topic's universe. Seek: 1 Structures of the universe of ideas, e.g.: 2 Contrasting visual aspects, allied with 3 Non-visual contrasts (academic dichotomies)	Teams Allocate appropriate strategical opportunities to a number of named teams
Intuitive processes	Scan Consider all the scenario data and look for anything that might form a pattern	Tactics 1 Communication: Decide upon the visual elements as transmitable quanta in terms of a medium (in shape and colour 2 Interplay: Decide how players should move when in conflict over territory e.g. overlap, interchange, etc.	Teamwork Decide upon the roles of players in communication Decide on the attitude of teams in making their group judgements in the interplay
Objectives	Scenario target Decide upon the story line and its possible dénouements	Art achievement Visualize the possible results of the game in terms of the skill and creative abilities of the players, if known	Group Target Provide for the achievement of an appropriate balance of teams' interests

Enjoyment

Above-average enjoyment should be programmed for throughout all aspects of the game, otherwise the activity is not an A Ag game, but a project, exercise, simple simulation or competition

Fig. 10 A systematic way of inventing art-based games
All aspects of the game are inter-related, and there is no reason why you should not jump from one box to any other.

My way of inventing games – *by* NICHOLAS RICHARDSON

I think art arena is about making a blend of things so the first game I invented a year ago was called the Blend and it was to fly a space ship (one team) into a robot (the other team) to make a space robot. When I invent games I jot down what its all going to be about in pictures. With star wars I used the latest craze and saw the film quite a lot of times and set it out in my mind how Im going to do it. I drew drawings and plans to see that theyll look right when they all go together. To begin with the dark lord darth vader was a giant painting to the top of the wall, then I thought the dark lord has got to be stopped but if the teams cover him up completely with all their paintings you wont know if hes escaped, so youve got to let some bits of him stay and show through all the teams drawings. I wanted four teams but I didnt use the main people such as luke skywalker and the princess because they wouldnt look as good as the robots C3PO, R2D2, the wookey and the jawas. Each team had a bit of darth vader to do some show-through drawing and painting over. Every kid in our lot likes to have a bit of a painting he can have as his own without being a blend so in this game I said that the scene is in a laboratory and behind darth vader is a whole wall of tv screens and instrument panels and each person or team could do a picture in a tv screen of the best thing that happened in his part of the story. I called the game the Force but I think now it might have been better to use the Force to change darth vader into a good person by teaching him a lesson instead of just trapping him prisoner for ever.

The Force A game based on 'Star Wars'

Scenario
The good rebels must blot out the dark lord, but not let him escape.
Enough of him must be left to be held prisoner.

Teams
R2D2, C3PO, CHEWBACCA, JAWAS

Strategies

R2D2	has the RIGHT EYE of the dark lord and the TOP RIGHT of his Body together with two television screens
C3PO	has the LEFT EYE of the dark lord and the TOP LEFT of his Body together with 2 television screens
Chewbacca	has the LOWER LEFT face of the dark lord & LOWER RIGHT of his Body together with two television screens
Jawas	has the LOWER RIGHT of the face of the dark lord and LOWER LEFT of his Body, together with 2 television screens

Tactics
The shape of the dark lord is drawn straight onto the wall grid from
the example. This is drawn in first by a player chosen by the team,
who also has a television screen. The television pictures show scenes
or characters from the star wars. Any areas left over can be used
up anyhow the group wants. Paint yourself over darth vader.

Target
Equal shares for all in the capture of the dark lord, showing your
best scenes on your television screen.

How I invent games – *by* DAVID PRIESTLAND

You'd probably have thought it impossible to invent any new games, as you'd think all the ideas had been exhausted. When I had the chance to take part in the Art Arena project I found that it was surprisingly simple.

First I become interested in a subject, talk to people about it, and browse through books for illustrations and information. I list the forces involved, and work out both colour and design, fitting them to teams and story-line. I try to see the game in my mind as it would actually be played, and figure out in diagrams if it would work. Then, I sketch patterns on a piece of paper to see what the end result might be like, and that's about *it*!

Another way I invent games is to have a flash of inspiration. That's how my game called 'Spaghetti Junction' was invented. At the time I had very strong ideas about Politics and wanted to become a politician – though I don't now.

It was different again with some of the historical games I invented – 'Prophecy' based on the 'I Ching' and 'The Jewel in the Lotus' based on Indian Yantra. I found out the forces involved and then tried to make them work together to produce a 'meditation' pattern.

The most interesting of my contemporary games was my first, 'Spaghetti Junction', in which there are five teams – Conservationists, Road Builders, Railway Builders, House Builders, and the Town Council. Builders had to obtain licences from the Council, who never actually saw what was going on in the locality – the game mural. In fact, one group playing this game started giving bribes of toffees to the Mayor, who was found to be so corrupt that he was soon voted out of office. However, with a more worthy Mayor the game collapsed and the former corrupt Mayor was reinstated. He reformed his ways and showed so great skill in managing the town that the players put up a statue in his honour.

Once you've started on inventing games the desire to invent grows and grows. Its rather like a mania. Once you've invented a game one way, you try it another way, and you want to keep on experimenting. You don't have to restrict it to the usual package of components such as dice and counters; and you don't have to adapt your original ideas to fit on a small surface such as a board like the commercial games manufacturers do.

I usually research my games during the weekends, and it is amazing

how much information can be discovered in the process of looking into new subjects. Themes of games I have invented vary from Alchemy and the Qabalah to the exploitations of a patents office and science fiction. 'Lodestar' is about the conjunction of two planets. My best game is as follows:

Spaghetti Junction A town planning game

Duration – $2\frac{1}{2}$ hours or five $\frac{1}{2}$-hour periods
Players – 10 ± 5 players aged 10–17

Scenario
A town is rapidly becoming full.

Teams and Strategies
TOWN PLANNING COMMITTEE Issues permits to the other teams to use certain areas of the Art Arena town-plan for particular purposes. The Committee, however, is not able to see what is actually happening on the Art Arena. They may keep a record of permits issued, and they should be able to judge from this which permits to grant. But as they cannot see the reality of the situation they may be influenced by the way in which a case is presented by the applicant.

BUILDER-ARCHITECTS All building is to be in rectilinear purple blocks at right angles to each other.

CONSERVATIONISTS Everywhere possible should be conserved as green parkland, green belt, village green, or as ponds and lakes, rivers and reservoirs. A forest would be a particularly desirable asset.

RAILWAY CONSTRUCTORS Railway tracks should be represented by orange lines 2 inches thick, at different angles across the Art Arena, none vertical or horizontal. They will end in stations or termini. No curved lines will be permitted in this town, so the tracks will have to zig-zag across the town according to the density of the population and the need for rail transport.

> ROAD BUILDERS All roads should be curvilinear and white. Serious thought should be given to one-way traffic through the centre of the town. There should also be main and service roads, and perhaps a ring road and flyover.
>
> *Tactics*
> When your plan is provisionally sketched in and agreed upon by your team you may apply to the Town Council for a permit to develop up to FOUR squares at a time in any direction. No more may be claimed at a time. While you are waiting for your application to be approved you may find that other areas that you were going to claim have already been acquired. So your masterplan may have to be changed continually to adapt it to new circumstances. Also give the Council some idea of your development plan.
>
> All tactical moves within the Art Areana will be done with paint or collage.
>
> *Group target*
> The game will be won if teams succeed in bringing about a good and fair distribution of interests and facilities.

The second account is by a teacher.

Everything is potential game material –
by BEVERLEY RICHARDS A'COURT

Playing and inventing art-games is infectious. After playing for the first time every mundane detail of my journey home appeared in a new light as potential art-game material. I suspect this is a fairly common experience, judging by the typically brief time-lapse between first playing a game and inventing one's own. After more games and more thought about them I am convinced that the art-game format provides an evolving framework through which to explore, understand or simply become familiar with a few basic concepts about virtually any object or body of information from bricks to the binary system.

The non-competitive emphasis of the art-game, 'winning without losers', has two important consequences for the invention of games; firstly, it makes inventing art-games much easier than inventing

traditional-type games. It is much simpler to take a whole image or theme and divide it into component, cooperatively contributing parts and roles, than to devise strategic rules to ensure that each creative contribution to the game simultaneously subtracts from or hinders another player's contribution.

This is related to the second consequence of non-competition which is that the games and the art-works they result in are in a very real sense 'larger than life' and greater than the sum of their parts. The relatively open-ended strategy-rules, and the fact that all additions to the game, including negotiated changes in the rules, and all experiences of the game at the level of human interaction whether amusing, exciting or upsetting, are positive contributions to the game as an event. Nothing is simply negated as not being 'in the rules', so the final outcome is unpredictable and there is never only a single possible solution.

To draw an analogy with musical composition, the art-game has to be played in order for its outcome to be experienced by the players, including the 'composer'. Individual games vary in the extent to which they employ a fairly straightforward 'addition' of elements to make the whole or 'multiply' team's designs in more complex ways. In my experience the latter type involves more areas of negotiation and provokes more interaction among players.

There are two very different ways of inventing games, the first being the one I unconsciously seemed to be using when I invented my first game, and the second arising out of the subsequent feeling that other people, perhaps most notably the younger players, may design games in very different ways.

The first method, much of which is probably implicit in what has been said, is to start with an overall pictorial image of the completed game and to break it down into articulating parts, working backwards from a picture of the solution to the teams and strategy-rules that would generate such a solution. As the characteristics of the teams and the details of the strategy-rules are worked out in more detail the completed mental image suffers many transformations, becoming more elaborate yet less distinct. Eventually one loses all idea of what the final outcome might look like, and waits to find out how a group of people will create it. If the rules are inadequate, giving some players plenty of scope and others a raw deal, the players themselves can alter them. (See the 'Landscanner' brief at the end of this account.)

While inventing 'Landscanner' I felt a degree of frustration: perhaps by beginning with a preconceived whole image and then breaking it

down into parts I was limiting the game's possibilities and using a rather 'closed mind'. One could, on the contrary, invent in an almost opposite way. For example, teams and strategy-rules could be devised on the basis of a set of theoretical hypotheses, such as statements about the notion of the planets according to knowledge available in the mid-nineteenth century, or immediately prior to the discovery of Pluto. The game could then be played in an open-ended way, each planet-team following a set of coordinates in order to discover its orbit route. An archaeological game, for example, might involve devising strategy-rules that would describe a series of situations or events leading up to and accounting for the layout of ruins described in the scenario. The teams might, for example, represent the eroding and changing terrain, a community of Iron Age farmers, subsequent users such as seventeeth-century sheep farmers and nineteenth-century conservationists and restorers. This sort of game resembles the de Bono lateral thinking method of generating alternative hypotheses about the origins of a particular situation depicted in the scenario, an archaeological land-scape, for example.

One educationist[1] has identified a number of characteristics of traditional and more 'open' or 'integrated' teaching systems. The former, in which information is imparted in clearly distinct subject categories, he suggests tend to foster and rely upon: (a) the view of knowledge as the private property of individuals; (b) the child's learning to work within a received 'frame', aware of what questions may be asked and when; and (c) socializing the child into 'knowledge frames' which discourage connections from being made with the child's personal and everyday reality.

Inventing art-games provides an opportunity for knowledge to be shared and extended by the interaction of what each child brings to the group, for questions beyond the usual subject frame to be explored, and for the child to draw on and incorporate images from his or her own experience when trying to make sense of a body of information.

A final important concomitant of traditional subject-bound educa-tion is that 'the ultimate mystery of the subject is revealed very late in the educational life', that is, the perception that the knowledge is essentially 'permeable'. Art-games, in my view, are capable of impart-ing simple, basic information in a subject category and presenting it as relevant and accessible.

The following is one of Beverley's games.

Landscanner A game drawing upon geography and meteorology

Duration – 2½ hours
Players – 8 ± 4 players over 10

Scenario
An outcome of the US space programme has been the development of a new computer for scanning and presenting in coded display the following:

Teams

CONTOUR SCAN	Forms and surface contours
W-STRATUS	Weather drifts
THERMO-G	Surfaces underlying the thermal zones
TEXGRAM	Surface texture patterns

Target
Each team plays the part of one of the above four processors, and each creates a scan-map of the given area (see the map provided). The processed and coded scan maps have to be combined to build up a complete 'landscan'.

Strategies

Contour Scan	A continuous line half a square wide traces around the main contours of the landscape, as if from an aerial view. Any light bright colour (e.g. red, yellow, blue, white).
W-Stratus	Wide and narrow bands of parallel stripes of colour represent moving weather densities (mainly wind and moisture) at about 2,000 feet. Close stripes indicate highly changeable weather zones, e.g. over mountains and hills. Long stripes wide apart indicate more stable weather, e.g. over flatter areas. Overlapping bands indicate different weather types

	at different levels. Colours: blue and green = cold air; red and orange = warm air.
Thermo-G	Large simple shaped blocks of pure colours indicating different temperature zones. Hot colours for human settlements, and flowing underground rivers, cold colours for icy areas, mixed colours for overlapping hot and cold zones.
Texgram	Works in pattern and texture, and consists of very simple small 'computerized' shapes not larger than one quarter of a grid square on the wall. These shapes should be drawn (but not filled in) with paint lines onto dry or wet paint – or scratched into wet – over the colours of Thermo-G. This texture of symbols should indicate: industrial areas, settlements, pasture lands, unused land, sandy areas, any small-scale changes on the surface, and patterns of surface texture. The repeated symbol-shapes should be lighter or darker than the surface they are on, or an opposite colour.

Tactics

Thermo-G must be painted in first, the other teams helping. After their areas have been painted Thermo-G should transfer to Texgram's team, as Thermo-G's zones are the only areas that Texgram may work over. Contour Scan and W-Stratus may intervene or interpenetrate the work of other teams in any way that seems to convey the most information, according to a consensus of opinion.

Note

When this game was played by eleven- and twelve-year-olds the map we used was of Northern India and Afghanistan. W-Stratus used oblique straight lines which were cut out of white and coloured paper and stuck on the painting as collage, otherwise the painting would have taken very much longer.

The third account of games invention is by Michael Challinor, research assistant to the project 'The use of games in education through art'.

Games with a mathematical base – *by* MICHAEL CHALLINOR

Children playing art-based games have shown a special liking for scientific scenarios, be they fictional or factually based. Often this can lead them into using mathematics almost unawares. 'Pulsar', for example, was a mathematical game I devised whose players did not, in fact, realize they were 'doing' maths.

So often the mathematical language of the physical sciences is itself a barrier to understanding. 'Pulsar' presented the problem of introducing concepts derived from mathematical theory of probability to eight- to twelve-year-olds. It is a game based on Markov Chains. But what are they? A textbook might explain: *Given that an event* (i) *having the probability* $P(i)$ *is followed by an event* j *having the probability* $P(j)$, *the probability of occurrence of* j *given that* i *has occurred is* $P(i, j)$, *and it follows that*. . . . This disguises the fact that a Markov Chain is a type of random behaviour in which the likelihood of something happening is determined by what has taken place previously.

Markov Chains (and other 'non-stationary stochastic processes') are encountered in physics and chemistry. We use them to describe the movements of great populations in cities, or in mass transit systems. They are of importance in communications engineering, and in anthropological studies of natural language.

'PULSAR'

In 'Pulsar' all the Greek characters, brackets, operator signs and abstruse English prose which abound in any maths textbook were replaced by simple procedures which the players enacted. They used 'stochastic matrices' in which 'transition probabilities' were identified by colours rather than numbers; and they operated improvized roulette wheel type randomizers. Using these devices the players produced outputs in the form of colour sequences, and soon noticed that whereas one of the four teams changed its colours very rapidly, another team would stay in the same 'colour state' for a long time before suddenly changing to another.

Gradually the idea of prediction (in a scientific sense) began to grow in them. They soon realized that trying to guess the next appearing colour as though it was a playing card being drawn from a shuffled pack was futile. They discovered that the appearance of new colours in the mural had something to do with the colours that were already

there. Eventually they determined that the real key to the structure of the painting lay in those enigmatic stochastic matrices. Having seen the mural developing the players become able to make informed and accurate guesses about its future evolution. It was finally understood that, knowing what had gone before, consulting the matrix would show what was most or least likely to happen in the future. Having understood this process the children had almost realized the gamblers' paradise in being able to wager on certainties.

The game of 'Pulsar' operates on a far larger scale than the usual pencil-and-paper maths game, and results in a hectic spectacle which, at its best, becomes a massive 'pointilliste' screen. The mathematical topic is not treated as a thing in itself but as an applied concept with a scenario which is enacted by the players. Although the learning phase of the game occupies only the briefing and the first twenty minutes or so of the two- to three-hour playing time, the remaining play is by no means a wasted activity as far as mathematics teaching is concerned. Twenty minutes or so to teach higher mathematics to seven- to nine-year-olds is a very short time. The remainder of the time is a very necessary period of assimilation, in which the topic is applied, played with, and by these means reinforced.

Pulsar A science fiction game with a mathematical base

Duration – $2\frac{1}{2}$–3 hours
Players – 8–16 players over 9

Scenario
A cloud of cosmic dust has accumulated in outer space. It is exploding and becoming a bright new star. About it fly many comets and meteorites. These are the remains of stars which have exploded and which over a long period of time have taken up regular trajectories.

Target
To make a great monitoring chart of the Art Arena grid, recording the *paths* of two star-ships probing the universe of cosmic dust and the *observations* of comets and meteorites. As space-time travellers you must scan the whole of the universe before the final big explosion

or both teams will perish in it. (The time of the explosion = the time by which the game must end.)

Teams

ORIBITAL path-tracker ORBITAL meteorite-observer

CENTRIFUGAL path-tracker CENTRIFUGAL comet-observer

Strategies

Orbitals	Routes: a rectangular spiral inwards, beginning at the outermost edge of the galactic arena (top left corner) and moving clockwise in the largest spiral possible inwards square by square.
Centrifugals	Routes: a rectangular spiral outwards, beginning at the middle and moving anti-clockwise in the smallest spiral possible outwards square by square.

Tactics

Navigation through space and the observing of comets and meteorites is done as follows. Each square of a tracker team's path through space is painted a colour determined by spinning the spaceship's gyro (see below for its construction) and then processing the reading through a matrix (see below for its construction and operation). In the case of the observers the gyros and matrices determine the colour of the paper to be stuck onto a square already painted by a path-tracker: observations of meteorites and comets are registered, that is to say, by collage.

 Emergency escape plans: If it seems that the universe is not going to be spanned by teams in time, organizers can introduce measures for boosting speed, such as quadrupling the areas of squares covered by each calling, and even, if necessary, making a nebular whorl across the gap.

Tactical roles

Matrix Operators, Gyro Operators, Tracker-painters, Observer-stickers; optional coordinators, paint-mixers, cutters.

Matrix Operator Each of the four matrix operators controls a team's journey through space. This player makes the first decision which

triggers off a sequence of events determining the team's fate. All further decisions are determined by the following process:

The matrix operator's first and only *decision* is to choose any colour from those around the edge of the matrix (see Fig. 11). This colour

1. Orbital team

	Red	Orange	Yellow	Green	Purple	Black
Red			yellow	blue		red
Orange				red	blue	yellow
Yellow	red			yellow		blue
Green	red	blue				yellow
Purple		blue	red			yellow
Black	blue	yellow	red			

2. Meteorite team

	White	Silver	Grey	Blue	Turquoise	Lime-green
White	blue			red		yellow
Silver		blue		yellow	red	
Grey			blue		yellow	red
Blue	red	yellow		blue		
Turquoise	yellow	red			blue	
Lime-green	yellow		red			blue

3. Centrifugal team

	White	Grey	Lilac	Blue	Turquoise	Lime-green
White				blue	yellow	red
Grey			yellow	red	blue	
Lilac	red			yellow		blue
Blue	blue	red				yellow
Turquoise	yellow	blue	red			
Lime-green	blue	red	yellow			

4. Comet team

	Red	Orange	Yellow	Green	Purple	Black
Red	blue			red		yellow
Orange		blue		yellow	red	
Yellow			blue		yellow	red
Green	red	yellow		blue		
Purple		red	yellow		blue	
Black	yellow		red			blue

Fig. 11 'Pulsar': the matrices

Each entry within the matrix is known as an 'address', and expresses a relationship between the items at the edge.

◍ = red, representing a transition probability of 1 in 3;
⊜ = blue, representing a transition probability of 1 in 2;
☺ = yellow, representing a transition probability of 1 in 6.

These probabilities correspond to the proportions on the gyro. Thus in matrix 2, the probability of grey being followed by turquoise is 1 in 6, while it is never followed by blue.

is called to the team's tracker-painter or observer-sticker who puts it on the wall.

To discover the second and all colours afterwards:

1 Note the colours at the *left* of your matrix. Put your finger on the one that has just been put on the wall.
2 Tell the gyro operator to spin and to tell you the colour at which the gyro stops (see Figs 12 (a) and (b)).
3 From the colour your finger was on, run your finger along the row until you meet the colour called out by the gyro operator.
4 Now move your finger upwards from the gyro colour to the colour at the top of the column. Call out this colour to your painter or sticker.

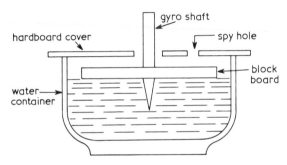

Fig. 12(a) 'Pulsar': the floating gyro

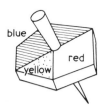

Fig. 12(b) The gyro colour coding: blue = $\frac{1}{2}$ red = $\frac{1}{3}$ yellow = $\frac{1}{6}$

The gyro is a randomizing device intended, when used like a roulette wheel, to generate random sequences. Coloured areas on the gyro correspond to the colour-coded transition probabilities in the matrix. Our gyros are floated on water to allow free spinning, and are covered except for a small inspection hole.

5 Now move your finger to the left and down the vertical column of colours until you come to the same colour as the one that has just been put on the wall.

6 As before, tell your gyro operator to spin and call the next colour appearing on the gyro. As before, run your finger along the row until you come to the colour called out by your gyro operator, then move your finger upwards to the colour at the top of the column and call this colour to your painter or sticker, and so on.

Gyro Operator. This player spins the gyro with his fingers (see Fig. 12). To save time it may be stopped sharply, and if it is a home-made gyro as described above it should be lifted gently so that the water in the bowl does not spill. The colour appearing in the small hole in the cover should be called to the matrix operator. There are usually four gyro operators, one to each team; but if numbers are short a matrix operator can manage both matrix and gyro.

Tracker-painters. The Orbital team's painter starts on square A1 and paints one square at a time moving clockwise in a rectangular spiral inwards to the centre. The Centrifugal team's painter starts from J16 (where the wall is squared A–T, 1–32) and paints one square at a time moving outwards from the centre in an anti-clockwise rectangular spiral towards the edge of the arena.

Observer-stickers. These players follow one square behind the painters sticking paper cut-out shapes onto the wet paint. The cut-outs may be of any shape so long as they do not cover the square entirely. There are two observer-stickers, an Orbital and a Centrifugal. The colours they use are called to them by their matrix operator.

'DOUBLE STAR'

The value of the Art Arena game lies in its being an invention kit, not a statistics teaching game, a biology teaching game, etc. The users of the system must invent their own games to satisfy their own specific requirements. For the teacher, this involves a form of creative introspection, and the re-creation of subject topics as processes whose elements

may be interpolated into the formal process of a game. The following, for example, is another game with a mathematical base, but very much simpler than 'Pulsar'. 'Double Star' is an arithmetic game which gives practice in adding and multiplying.

Double Star A game giving practice in arithmetic

Duration – 2½ hours
Players – 8 ± 2 players aged 7–13

Scenario
Amazing shapes and patterns made up of particular numbers of units of things can be found almost everywhere, especially if you look at things through a microscope.

Target
To make a double star flashing with fire and ice.

Teams
FIRE-STAR, ICE-STAR

Strategy (see Fig. 13)

Both teams	1	*Fixing the position of your star*
	1.1	Choose a point where an upright and a horizontal line cross somewhere in the middle of the left- or ride-hand side of the grid. Left for Fire-star, right for Ice-Star.
	1.2	Now put 'o' in each square round it.
	1.3	Number the squares from 'o' outwards to the edges: a) to the right; b) downwards; c) to the left; d) upwards.
	2	*Making your star grow*
	2.1	Choose any two numbers across any one quadrant.
Fire-star		Add these two numbers together. Remember the sum. Divide the sum by 3 (your special number or Modulus). What is left over? Remember it. It is called a residue.

Ice-star		Multiply the two numbers across the quadrant. Divide the product by 4 (your special number or Modulus). What is left over? Remember it. It is called a residue.
Both teams	2.2	Put the residue into the square opposite the two numbers you chose.
Fire-star		Paint the residue square: Pink if the residue is 0, orange if 1, red if 2.
Ice-star		Paint the residue square: Purple if the residue is 0, lime-green if 1, light blue if 2, dark blue if 3.
Both teams	2.3	Remember the sum if you are Fire-star. Remember the product if you are Ice-star. Starting from the residue square count out the same number of squares as the sum/product, moving away from the centre vertically and horizontally in two lines of squares. Paint this 'V' shape the same colour as the residue square.
	2.4	You will now have an angle-shape like an 'L' with arms of equal length, or a 'V' with its angle a right-angle. Repeat the same right-angle shape in each quadrant, so that each quadrant is the same but a different way up. This is called symmetry.
	2.5	Repeat the whole thing again choosing two new numbers across any quadrant. Now follow the directions from (1) again.
	2.6	Keep repeating with new numbers until you think the double star is finished.

Tactics
Where one team's lines of squares cross those of another team an unscrambling decision will have to be made. The most effective idea is usually to mix the two colours together and paint the new colour into the overlap.

Both teams normally work into the same wall grid, but alternatively they may (1) both work on one team's star, or (2) work separately on different walls, at the same time or one after another.

Fig. 13 Strategies for 'Double Star'

The fourth contribution on the invention of games is by a student of electronic engineering.

Games within games? – *by* CHRISTOPHER C. KNIGHT

In creating educational games you can operate at two different levels. You can arrange for several players in a group to perform the task of producing a painting, and they can learn from one another and from the information-content of the game. Alternatively, you can raise the process to another dimension by making a game out of monitoring the group already playing. Thus, outside their game is a 'meta-game'.

An outsider can learn a great deal by observing the group reacting to its game and to each other, and by subsequently interpreting the outcome in terms of end product, enjoyment, value, etc. This second process has quite a wide field of application in sociology and psychology.

'INTELLECT 1'

Once the need for a certain kind of game is identifed, steps can be taken to design the scenario and structure of play so that the game leads towards the fulfilment of the required objectives. I designed 'Intellect 1', for instance, as an educational game in which the participants can learn the component parts of the human brain and the interconnecting patterns which make it work as a whole. In this 'first order' version of 'Intellect' the strategies involved were devised to create interest as well as to supply the basic information. The information present is, in fact, of medium density, and representative of an amount particularly easily contained within a scenario.

'INTELLECT 2'

While 'Intellect 1' is a game in itself, it also provides the basis for a more complex game, 'Intellect 2', an example of a 'second order' game in which outside observers learn about two or more groups, perhaps socially dissimilar.

For a 'first order' educational game to be successful it is essential that the information is presented in an acceptable package, in a way that maintains interest and makes the game enjoyable to play. The enjoyment factor is no less important in the sociological game. Apathy in the latter is likely to cause a biasing of the results and a reduction in the fulfilment of the game's purpose. However, there will always be a natural bias in playing any of these games; and this bias must be accounted for in terms of standard results.

Intellect 1 A game drawing upon psychology

Duration – 3 hours (minimum)
Players – 8 ± 4 players over 13

Scenario
The human brain.

Target
To create a visual analogue of the processes of the brain, in such a way that the result records specific characteristics of the group-mind of the players.

Teams
LOGIC AND RANDOM PROCESSOR GROUP, SHORT- AND LONG-TERM MEMORY, REFLEX GROUP, AFFECTS (where affects = emotions such as love, remorse, shame, envy, boredom, melancholy, rage, etc.)

Strategies

Logic	Squares of any area in a definite or logical sequence in blues and greens. Overlaps the random processes.
Random	Maze-like motif with multiple paths in blue and green. Overlaps the logic processes.
Short-term Memory	A long grid with two axes, x and y. Colour: red, light and low intensity, for the structure, which may be curvilinear or rectilinear. Spots of colour of varying intensity and hue should be placed in or on the grid to symbolize information present. Overlaps with long-term memory.
Long-term Memory	The same colours and shapes as short-term memory, but larger in content and covering the whole area available.

Reflex	Sharp triangular areas overlap to form a unit, and stand on the sensori-motor input and output paths. The triangular areas are yellow and orange; the colours of the paths should be carefully chosen.
Affects	It would normally be appropriate in a studio to expect the group mind to be relaxed, and this would balance the rather brash effects of everyday life on the rest of the brain. Amorphous and nebular shapes in subtle colours, particularly grey-blues, would seem right; but keep a close liaison with the memory group, especially the short term memory.

Tactics

There should be a healthy interchange of information between the teams before they start to paint the composite group mind image. The Logic group can be expected to seize upon every opportunity to rationalize and stabilize the contributions from other teams. The Reflex group may well take up and develop any directions or motifs seeming to emerge from the affects. All teams should rely heavily on the Memory group for clues as to the way in which their motifs should be developed, and every opportunity should be seized to inject imagery into the memory 'cells'. This can be done by collage or representational painting. Towards the end of the game there might well be a brainboost or redoubled effort to integrate all areas of the 'mind' by a variety of overpaintings and pictorial insertions.

Intellect 2 An extension of 'Intellect 1'

Duration – Runs parallel with 'Intellect 1'
Players – 8 ± 4 players

Scenario
While the group mind analogue (Intellect 1) is being evolved it is observed by the 'outside world' (Intellect 2), which is a game within a game.

Target
To monitor and assess the processes taking place in Intellect 1 from another viewpoint, that of Intellect 2. This critique of the group mind of Intellect 1 should take the form of another mural and be subject to the same assessment parameters. The degree of difference between the two murals is expected to show the level of harmony or incompatability between the two groups of Intellect 1 and 2.

Teams and strategies (As in Intellect 1)

Meta-Strategy
The second mural is a representation of the likes and dislikes of the group (Intellect 2) in relation to the evolving characteristics of Intellect 1's painting. Intellect 2 may adopt parameters relevant to the outside world, e.g. political, musical, etc.

Tactics
Basic design elements (e.g. hue, tone, and intensity of colour, curvilinear and rectilinear lines, hard/soft-edged shapes) are assessed and voted for by Intellect 2. Majority votes influence the designing of the new masterplans and strategies of Intellect 2 as well as influencing the tactical interaction on the field of play.

Reference

1 Bernstein, B. (1971) *Class, Codes and Control*, London: Routledge & Kegan Paul.

9 Evaluating the games

Finding a system – *by* MICHAEL CHALLINOR

As a game, Art Arena needs some kind of a scoring system: our scoring system is not one whereby players score points off each other, but one meant to reflect an unfolding pattern of play rather than merely a final result.

Apart from being a game, Art Arena is also art-making. Art is concerned with rare and fleeting events which may be unique in the lifetime of an individual. An art-assessment method must allow for the non-repeating nature of the art-making process. Further, art studio activities differ in a marked way from other educational activities. Art is not generally a learning process *per se*, and the modes of curriculum evaluation and pupil assessment which apply in other aspects of education do not necessarily apply to art studio work. What are we left with which might serve as a basis for an art-assessment system?

Two main factors are of overriding importance:

1 The art-work seen as a concrete record of certain processes and activities; and
2 The art-makers' attitudes to their own work.

An assessment procedure must look not only at the art-work as a physical object but also at the varied intentions, motivations and feelings of the art producers. Thus two distinct types of assessment, and two types of measurement must be incorporated into our evaluation system.

When we began this difficult task we were still uncertain of its potential value. When we began we introduced a rough-and-ready check-back to see how the game went from the point of view of the organizers as umpires; and we found ourselves trying to make up our minds how players had got on. When we asked the players, however,

they clamoured eagerly to tell us. We soon realized that we were getting more useful information from the players than from the umpires, so we looked around for a technique which would give us as much feedback as possible from the players. We were looking in particular for data that would help us in devising new games; but neither conventional art-assessment nor game-scoring procedures were very helpful.

Eventually we developed an approach which supplied the sort of information we needed – information about, for example, the success or failure of the game in stirring the imagination, inviting puzzle-solving, in firing the group spirit, and in stimulating sensibility in some kind of active performance. The method we settled on did all this and clearly recorded all-round successess and failures; it also showed which games, in the players' experience, were not so successful as we thought, and which of those games we had considered a write-off seemed to the players to give quite good opportunities for doing things they might not otherwise have thought of. The new approach took the form of a voting and discussion session and worked well. The children so enjoyed talking about and assessing what they had done that they pressed for more and more categories to vote for. Finally, we drew the line at seven categories, adding to the basic four (1 – *scenario*, 2 – *strategy*, 3 – *teamwork*, and 4 – *tactics*) the actual *target* (5), concerned with the success of the group's composite achievement, the overall *enjoyment* (6) experienced in playing, and the general sense of success or failure of the individual player in a *self-assessment* (7(a) and (b)). These categories are shown in Fig. 14.

Voting on this system gives the players a chance to stand back and look appreciatively and critically at what has been done; and their voted scores give valuable cues to both promoters and inventors of games. Firstly, they give a picture of how acceptable or unacceptable to a particular group a game is as a whole, including any academic learning content (6 – enjoyment). Second, they give a clear indication of the group's sense of cohesion and players' capabilities of working together in an art or design workshop (3 – teamwork, and 5 – target). Third, they give an insight into the group's balance of aptitudes: (1) imagination, (2) systematic thinking, (3) teamwork, and (4) sensibility in handling materials. Each group has its own 'centre of gravity', some showing a liking for simulations, others more for design and invention, while others again will be preoccupied with all the different ways of treating paint and media. Fourth, the votes give a good idea of the

ART ARENA

Project **Treasure Trail** Group **Juniors** Date **Jan. 28** ...

Names	Team symbols	Group achievement				Success-rating		Individual achievement	
		1 SCENARIO	2 STRATEGY	3 TEAMWORK	4 TACTICS	5 TARGET	6 ENJOYMENT	SELF-ASSESSMENT	MODERATION by group &/or observer.
SCORE CHART		How well have its needs been satisfied?	How effective were, e.g., master-plans?	How well did all work together?	How much artistry shown by all in the interplay?	How well were all teams' interests balanced?	How acceptable was the whole project?	How well do you think You did? %	Do you agree? + = more − = less √ = yes
Adrian	R	9	8	8	7	6	10	7 + (3)	
Amanda	H	10	10	10	8	10	10	6 + (3)	
Billy	F	6	3	10	6	2	3	5 + (3)	
Cristopher	R	10	9	8	9	4	10	6 + (3)	
David	H	7	5	8	5	5	8	6 + (3)	
Flora	T	9	9	10	10	10	10	4 + (3)	
Howard	T	8	7	8	7	6	9	6 + (3)	
John	H	8	7	6	6	5	7	6 + (3)	
Lindsay	T	8	6	7	5	5	7	4 + (3)	
Matthew	R	6	10	10	10	10	10	4 + (3)	
Nicholas	F	5	2	8	9	2	10	2 + (3)	
Patrick	F	8	8	8	9	7	8	7 + 2	
Rebecca	H	8	7	10	4	9	5	8 + (3) −(2)	
Richard	F	9	9	10	9	6	10	7 + (3)	
Yinka	T	10	9	10	6	2	8	3 + (3)	
Totals		121	109	131	115	89	125	81	
Mean		8·07	7·27	8·73	7·67	5·93	8·33	54%	

Recorder... **Rebeca** Success-rating columns 5 & 6 **71·3** % 45% + = Success

Commentator **Nicholas**
Announcer **Christoper**

Fig. 14 The Score Chart entered

quality of a player's own feelings and efforts (1–4) in playing the game, and his or her progressive achievement in the game's activities (1, 5 and 7).

The voted scores, however, relate entirely to the art-makers' subjective and often relatively immature attitudes to their own work, so there also needs to be some recognition of the art-work from the more objective viewpoint of the art-trained observer. However, A Ag is a loose framework of procedures intended to encourage artistic creativity without pushing the activity towards a predetermined goal. Player performance should not be seen as motivated by the need to attain an academic aesthetic standard. The traditional ideal of the pursuit of excellence when applied to art curricula requires reference to external criteria (cultural, fashionable, etc.), which are arbitrary and variable. The best-games, moreover, produce all-round high voting, signifying a rich quality of experience. We really wanted to be able to monitor changes in a player's ability in the practice of art and a player's aesthetic learning progress from game to game.

Early in the games I noticed that some players and teams of players were better able than others to make imaginative and yet feasible departures from the given 'examples' of game strategy. And it was by no means difficult to see their efforts as classifiable on varying levels of originality. This, I felt, was the really significant factor, apart from mere skill in handling, which characterized an important and easily measurable development from the mindless copier to the mature and capable artist-designer.

THE VOTED SCORES

The players' voted response at the end of the game was at first called the 'index of performance' (here the term 'index' has no statistical meaning). It was borrowed from a performance evaluation system employed for many years in motor sport, and refers to a method of combining differing mensural units into a single formula. At a later stage we translated the index of performance into a descriptive model known as the 'crystal' (see Figs 15 (a), (b) and (c)); using this 'three-dimensional' method of notating evaluation, organizers can carry in their mind's eye the essential characteristics of the whole range of games they have played.

Crystal or voted scores (V) are arrived at as follows:

The players are asked for a vote between zero and ten inclusive

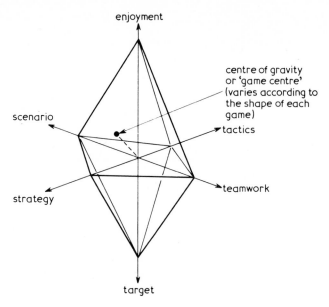

Fig. 15(a) The 'crystal' assessment model: axes represent players' votes for the named categories

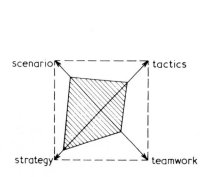

Fig. 15(b) Horizontal section through the crystal

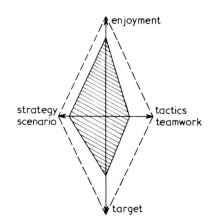

Fig. 15(c) Vertical section through the crystal

for each of the main categories of the game. The votes are entered onto a questionnaire, and the group mean is worked out for each of the six categories. When these are put together in the form of a crystal the interrelation of all the factors can be seen.

The scores are marked along the axes of the figure, the volume of the resulting octahedron being the players' score in the game. The crystal shows the 'shape of play', and the 'game centre' indicates a bias in the voting towards particular aspects of the game. A V score is to be expressed as a percentage of the volume of the largest possible crystal, i.e. when all voting categories have a group average score of ten. The chief advantages of this system are:

1 A quantitative representation of the game which has some recognizable correspondence with the real event.
2 The scoring system is simple to organize. There is seldom sufficient uniformity in art studio practice to allow a conventional statistical approach.
3 The crystal model can be used for the description of individual, as well as group performances, and personal case histories may be directly compared with the group result.

The V scores have a mid-point (5 out of 10), but the custom in the UK of fixing examination pass/fail points at 40 per cent has led us to adopt a dividing line at the same level (4 out of 10).

ORIGINALITY

Teachers who want to make a serious evaluation of art-content in a game can follow two courses, according to their view of the nature of art. First, a teacher may go through the voting sequence, looking with a trained eye and awarding aesthetically biased marks for: evocation of scenario, problem-solving, balance of team contributions, and expressive handling of media. Second, teachers may prefer to follow through the *originality* of the group from its first strategical ideas in the masterplans through to their survival in the final painting.

The originality of a game can be judged by comparing the teams' masterplans with the respective 'examples' of masterplans which the teams receive with their project briefs. According to the teams' closeness or departure from the given 'example', an originality rating can be arrived at for the whole group, the originality discussed in this

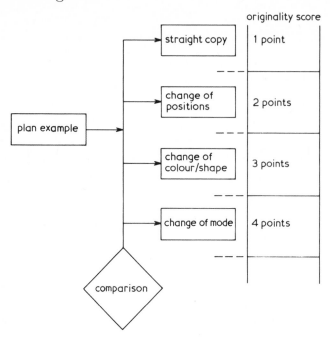

Fig. 16 Originality rating procedure

section being an attribute of the game, not necessarily of the players. Fig. 16 explains the originality scoring.

The straightforward nature of the game brief and its formal constraints allows the team strategies to be placed in one of the four water-tight classes shown in Fig. 16. Each may be given a points score: one point for a straight copy of the 'Example', two points for a change of position of a motif, and so on. The originality rating for the game as a whole is then arrived at by a simple arithmetic procedure, described in the index under assessment.

CREATIVITY

For purposes of assessment, a game's overall creativity may be expressed as a relationship between the quality of the activities of the game as voted (V scores) and originality (O rating).

In order to visualize this relationship in its simplest form, it is useful to think of the O and V scores as being either large or small,

making big generalizations about high or low quality of activity (V scores) in relation to high or low originality (O ratings). Thus a game with high scores in the V scores shows a rich level of experience and achievement for that particular group. We have called it the accomplished game (high V or \underline{V}). The best one can say of a game with low votes (\overline{V}) is that it is an amateur game. On the other hand, a high O rating is a sign of the innovatory game (\underline{O}) and a low one shows a relatively imitative or eclectic game (\overline{O}).

High quality or art experience and activity (\underline{V}) combines with high originality (\underline{O}) to yield the highest calibre of game, which we have called the creative game (\underline{OV}). Conversely, the game which is both amateur (\overline{V}) and imitative or eclectic (\overline{O}) is best described as the embryonic game (\overline{OV}).

These crude groupings described above (\underline{OV} and \overline{OV}) comprise the extreme ends of a gradient, using scores which are seen as simply being above or below their respective mid-points. The series can be completed by adding intermediate grades at which one factor is high and the other low; \overline{O} and \underline{V} becomes $\dfrac{V}{O}$, the academic or pastiche game. Then \underline{O} and \overline{V} becomes $\dfrac{O}{V}$, the eccentric game. The various crystal models are shown in Fig. 19, and different kinds of game are described in the next section.

The character of the games-play

Games played by different groups vary in the same way as the performances of individual players. The following are some examples.

TOPIC ENTHUSIASTS' GAME

Players who pay special attention to the scenario, and correspondingly less to the other main divisions of the art-game, are special enthusiasts of the game's topic and are often able to bring an understanding and appreciation to the game which is shown in the final painting. This was noticeable, for example, in a game of 'Virus' played by a group of players which included a few children who had started learning about biology. The coincidence of knowledge and interest made the game especially exciting for everyone. Conversely, one high-IQ group

produced some of the least imaginative and sensitive work in games where the topic was not to their liking; once they had lost interest, nothing – neither team-spirit nor sense of achievement – could bring them back again from their independent personal 'fugues' (to use the psychological term), which might run parallel with the game without ever making a contribution.

THE PUZZLE FANCIER'S GAME

Amongst the groups of players who got most out of the strategies of the game are individuals who like doing puzzles and enjoy technical subjects. Some of the less able pieces of strategy came from players good at naturalistic drawing but with less of an eye for pattern.

IN-GROUP AND GANG PLAY

Many groups do well in their teamwork, both in teams and between teams. Some proceed with gusto and rumbustiousness, but do well only within, not between teams. We found this with the first local children's eight- to fourteen-year-old group, for example, and most children of the six to eight age-group, with notable exceptions. Among older age-groups some seem able to work in silence, exercising a kind of telepathy in their communications. Others – more extravert groups – can behave just like small children, complaining bitterly if part of their territory is inadvertently appropriated.

GAMES, WILD AND FREE

Among groups making outstanding use of tactical work with paint has been a small group of delinquent children in the eleven to twelve age-range, showing high impulsiveness but also special sensibility, though what they did probably looked rather wild and abandoned to an untrained eye.

Good results have been achieved by rowdy groups newly arrived at our workshop and anxious to break the system by following it implicitly and literally. 'You want large shapes. How's this, then!' – lunging out as far as the human frame would allow, making quite large and free motifs where the player had probably never drawn anything larger than a postcard before.

While the unbridled groups benefit from the discipline that comes

with the use of a matrix and communications relay, some more reserved children have to be encouraged to become bolder – for example, to make sweeping gestures with the brush so they can appreciate a larger view of things.

GROWTH OF THE RESPONSIBLE GAME

Of groups concerned more especially with what we have called the target, the balance of interests of the different parties involved, some of the most responsible and mature have been those local groups of children who have attended regularly, and have found at length that they have been able to discuss the work in depth, exploring many aspects of aesthetic as against quantitative balance measured in numbers of squares. A few have realized that an unbalanced result might in some contexts be better art, and have opted for that. In this case, such a group will have set itself a different and potentially better task than the strictly 'equal' one they were commissioned to undertake. It is better, too, than the 'juggled' game in which the target has been arrived at with no regard to the other categories of the game, merely by balancing out non-interactive motifs, as in many kinds of collective mural painting (see Fig. 17).

THE GOOD MIX

Some of the most enjoyable games are those in which age-groups and abilities are evenly distributed. One Norwich 'youth' club plays the games with an age-range of eight to eighty in the same game.

Some of the least happy results are from games in which the un-scrambling conference is skimped, when aggressive teams are allowed to go on a territorial rampage. This is likely to happen especially in games in which older and younger players, or girls and boys, find themselves in competition with each other, or in games in which there has been a free choice of partners – when, for example, enclaves of friends gather into separate teams.

Experienced players sometimes have a run of games in which voting becomes euphoric and marked by uncritical abandon, in spite of strictures to be more critical from those officiating. Fig. 17 shows the game characteristics in the crystal model.

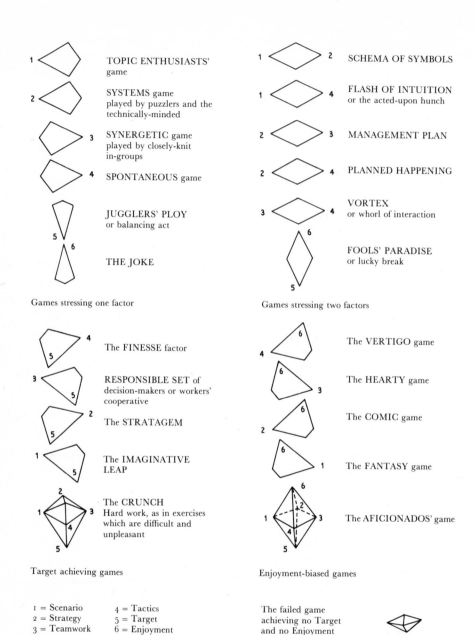

1	TOPIC ENTHUSIASTS' game
2	SYSTEMS game played by puzzlers and the technically-minded
3	SYNERGETIC game played by closely-knit in-groups
4	SPONTANEOUS game
5	JUGGLERS' PLOY or balancing act
6	THE JOKE

Games stressing one factor

1 2	SCHEMA OF SYMBOLS
1 4	FLASH OF INTUITION or the acted-upon hunch
2 3	MANAGEMENT PLAN
2 4	PLANNED HAPPENING
3 4	VORTEX or whorl of interaction
5 6	FOOLS' PARADISE or lucky break

Games stressing two factors

4 5	The FINESSE factor
3 5	RESPONSIBLE SET of decision-makers or workers' cooperative
2 5	The STRATAGEM
1 5	The IMAGINATIVE LEAP
1 2 3 4 5	The CRUNCH Hard work, as in exercises which are difficult and unpleasant

Target achieving games

4 5 6	The VERTIGO game
3 5 6	The HEARTY game
2 5 6	The COMIC game
1 5 6	The FANTASY game
1 2 3 4 5 6	The AFICIONADOS' game

Enjoyment-biased games

1 = Scenario	4 = Tactics
2 = Strategy	5 = Target
3 = Teamwork	6 = Enjoyment

The failed game
achieving no Target
and no Enjoyment

Fig. 17 The character of the game play
The shapes above show vertical sections through the assessment crystal. Three perspective diagrams are also shown.

I O Objectives

The games are meant above all to offer a way of working in a group which is enjoyable and fulfilling. They also aim to help educate in various ways both *in* and *through* art.

First, one expects them to educate in the actual processes of creating art. Second, it is intended that the games not only promote in the players qualities such as logical thinking, breadth of judgement, executive skill and imagination, qualities which teachers of most disciplines also try to nurture but that they provide in addition a vehicle for familiarizing players with ideas and data from other subjects. This Chapter will discuss education in and through art; I hope it will provide taking-off points for new ideas in art-based gaming.

Education in art

One of the advantages of the kind of group-generated art-process we are using is that it brings out the different phases in art-making. What I mean by that is that a number of phases are followed through in the process quite naturally and automatically with little formal demarcation (see Fig. 18).

The planning stage, for example, falls into three phases: the scribble phase or warm-up, which is equivalent in professional art-production to the survey, research, and experimental studies which go into a project; the plan-making, in which players devise shapes, colours and motifs or imagery for their individual plans – equivalent to the assembling of the design ideas in professional art; and finally the masterplan phase, in which motifs and images are chosen from the individual plans and combined in the team masterplans, in some ways like the work that goes into the professional preparation of mock-ups.

The structuring stages in the middle-game have two crucial phases, which are only too rarely dealt with in depth in art education. These

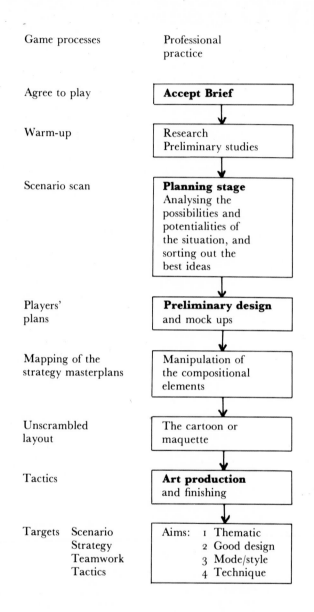

Game processes	Professional practice
Agree to play	**Accept Brief**
Warm-up	Research Preliminary studies
Scenario scan	**Planning stage** Analysing the possibilities and potentialities of the situation, and sorting out the best ideas
Players' plans	**Preliminary design** and mock ups
Mapping of the strategy masterplans	Manipulation of the compositional elements
Unscrambled layout	The cartoon or maquette
Tactics	**Art production** and finishing
Targets Scenario Strategy Teamwork Tactics	Aims: 1 Thematic 2 Good design 3 Mode/style 4 Technique

Fig. 18 Game processes compared with professional practice in art

are (1) the mapping phase, in which contrasting ideas, motifs or images are mapped onto the art-work surface; and (2) their unscrambling. In other words, the contrasting themes are knit into one unified work after all their strands have been unravelled. In the past, the drawing together of say, landscape and figures, or human form and drapes, has usually been the private concern of one artist alone, each theme worked out as a whole in itself, the one superimposed on the other, and then reworked as a corporate whole. Otherwise, one might have had Michelangelo and Leonardo collaborating on the same battle scene instead of working separately on their battles of Cascina and Anghiari respectively.

In the last stage of the games the players as artists are concerned to create a particular impact according to the nature of the scenario. This general effect will have appeared in the masterplans, and depended on decisions made about the shapes, forms and colours to be used in the final painting. Each detail has to be transferred to the new surface. The phases of transference alternate between translating from master-plan to art-work, taking in what other teams are doing, and continually adjusting and reinterpreting one's own mission in the light of the emerging vision of the whole, which if all goes well is richer and more surprising than one might have imagined. In a sense, each game is covertly an exercise in basic design: games such as 'Psychon' and 'Road blocks' make a good introduction to a design course.

STRATEGICAL OPPORTUNITIES AND THE LANGUAGE OF COLOUR, SHAPE AND TEXTURE

Teachers working in secondary schools who favour a lesson that is becoming known as Creative and Analytical Studies (CRANAL) will find theoretical aspects of A Ag especially valuable – such aspects as, for example, the specification of the strategical opportunities for the use of colour, shape, and the general effect to be achieved in each game.

The strategical opportunities lie within a range from the mind-blowing to the gentle and atmospheric, the psychedelic to the subliminal. To take only one factor, tone (the range from absolute darkness to total lightness), Fig. 19 illustrates gradients of tone-contrast at four different levels of impact.

The range (like the tonal range of a scream/shouted command/spoken word/whisper) is from high impact and/or contrast at the top of the

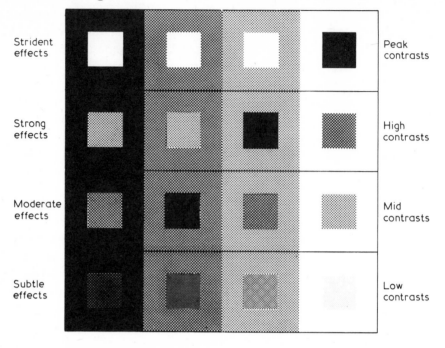

Fig. 19 A tonal-contrast gradient. From Pavey, D. (1974) Colour psychology in art and design, *J. Colour Group*, 17, 317.

gradient to low impact and/or low contrast at the lowest level. It shows, for example, how a black motif (the small black square) makes an increasingly pronounced impact as the surrounding tone is lightened. Ultimately, players need to become aware of the interaction of colours on a similar gradient, as well as shapes and textures.

In this way, players learn, for example, what to look for in the environment, how to analyse its contrasts and changing moods and interpret them in art creation. As an art lesson the art-based game introduces the learner to the basic 'language' of art, or more correctly its channels of expression and its potential sources of meaning and symbolism: colour, from dazzling contrasts to the most delicate nuances; shape and form, from geometrical to atmospheric; texture, from hard and rough to soft and insubstantial, and so on. Colour can be changed in only a limited number of ways, and a teacher who knows what these ways are and has a sense of the appropriateness of colour effects is likely to find the games particularly successful. Colour, for our purpose

particularly, can be made more intense by adding more concentrated pigment of the pure hue or more delicate by the addition of white, grey (whether light, mid- or dark) or black. It can, in fact, be changed in only three basic ways: (1) by lightening or darkening; (2) by being made colder or warmer, that is to say, moved across the spectrum towards red or blue; or (3) made more intense or less intense.

The games provide a teacher with a quick way of setting projects which explore all the different kinds of colour composition: Op art (with its peak contrasts of tone, and the highest intensities of hues opposite on the colour circle); colour blazon, of a heraldic type (strong contrasts of high intensity with hues well spaced on the colour circle); 'melodic' colour (small focuses of successively higher intensity in hue on a low intensity field); subtle nuances (analogous hues and monochromatic gradations of low intensities); colour glow effects, produced by contrasting higher intensities of hue with lower intensities of hues opposite on the colour circle; colour crescendo (low intensity hues graded over the whole field to a small focus of high intensity).

Finally, the games are no less art for being games, and the pace of the normal art class is given an unusual urgency, while the well-trained art teacher will see many other possibilities in addition to those mentioned, which he can handle in his own way. One of the most important aspects of the games for both teacher and pupil is their open-endedness.

Education through art and the processes of the game

The idea that art and game can be effective media in educating is by no means original. One of its strongest advocates was Sir Herbert Read. In his book *Education through Art*[1] he described art, interestingly for A Ag, as a form of play; but his central thesis was that 'art should be the basis of education' (p.1) – by which he meant *all* education, in that each profession requires a special mode of expression; and by 'expression' he meant

> audible or visible signs and symbols ... how to make sounds, images, movements, tools, utensils ... All faculties of thought, logic, memory, sensibility and intellect, are involved in such processes, and no aspect of education excluded in such processes. And they are all processes which involve art, for art is nothing but the good making of sounds, images, etc. The aim of education is therefore

the creation of artists – of people efficient in the various modes of expression. (p. 11)

It follows that 'the artist is not a special kind of man but that every man is a special kind of artist', as Eric Gill said, quoting a precept of the Indian philosopher Ananda Coomeraswamy.[2] Indeed, if one taught everything through art, art itself might no longer need be taught to children as a special subject. The public school district of Attleboro, Mass. has been acting on this idea for over ten years, basing its whole system on education through art. The authority introduced a 'concept-centred curriculum' of major ideas cutting across disciplines, e.g. hierarchy and complementarity, symmetry and asymmetry. The painting and sculpture then created 'visual concept models', and the 'learning-process skills' became the real basics of education. Teachers of this authority drew up, during May–June 1976, a curriculum guide listing visual, perceptual and imaging aptitudes as learning objectives of art as follows

Stage I Visual discrimination of (a) texture, (b) shape, (c) figure and ground, (d) spatial orientation and part-whole relationship.

Stage II Visual memory of (a) shapes, (b) sequences and other orders of relationship, (c) shape identities.

Stage III Drawing and constructing (a) visual-motor tracking, (b) copying figures, (c) observational drawing, (d) drawing mental images, (e) 3D construction of mental images.

Stage IV Visual completion (closure) of (a) partial two-dimensional figures, (b) partial three-dimensional figures, (c) extending incomplete series, (d) field-pattern completion, (e) improvising from incomplete drawing (aiming at creative fluency, flexibility, and originality).

Stage V Abstracting (a) reducing to visual essentials.

Stage VI Estimating and predicting (a) size-area equivalences, (b) scale/proportion, (c) imaging from other viewpoints (transformed perspective), (d) visual transformation as a consequence of new conditions.

Stage VII Visual transformation/spatialization, (a) imaginatively folding a flat pattern into a three-dimensional form, (b)

imaginative rotation of forms, (c) imaginatively transform-
ing one form into another by progressive stages.

Stage VIII Visual analogy, (a) solving a relationship by reference to
an analogous visual pattern of relationships.

Stage IX Synthesizing divergent forms.[3]

The initiator of this curriculum development, Don L. Brigham, writes
that

> Good art teachers are imaginative enough to take the rather dry,
> clinical-sounding skills named above, and convert them into
> stimulating, sensuous, media-manipulative and image-formative
> experiences for children. There is lots of *good art* being produced
> by children in Attleboro schools even though the lesson-ideas that
> underlie the art productions are often not product or art-media
> skills oriented. We have found that art *happens* when open-ended
> visualization problems are presented to children and when the
> attractive media and tools of art are made readily available and
> teachers are competent in helping children use the media and tools
> to express the vivid images that arise in their minds under the in-
> fluence of stimulating teaching.

An art teacher and research worker supporting this curriculum has
pointed out to me that the danger in such an integrated programme
is that the quality of the art object may be compromised by the need
to load it with relevant conceptual meaning, or lapsing into kitsch.

A good way of making the American art-based curriculum less dry
and clinical might well be to infuse into it some art-based gaming
structures to provide a motivational framework which would sound
a bit more inspiring and remove the need for gimmicky projects. There
are, indeed, few concepts in the list which have not been incorporated
in one or other of the A Ag games.

Art-games and the development of character and temperament

The aim of the games is to develop imagination and sensibility, and
powers of thought, communication and judgement in the players; to
extend their means of expression so they can experience, think and
act in ways which form a basis for most disciplines. The very structure

of the game-model seems related to categories described by Carl Gustav Jung as (1) intuition, (2) thinking, (3) feeling – in the sense of affective judgement, and (4) sensation. There is an even closer relationship with a development of Jungian thought which sees the four categories in terms of polarities – active-passive and autonomous-heteronomous:

1 The scenario-scan – involving apperception, incubation and inspirational awareness (ultimately leading to discovery) – as passive heteronomy.
2 Strategy – logical thinking which involves not so much deduction from rules as the recognition and manipulation of potentials and the making of systems – as passive autonomy.
3 Teamwork – operations based on value judgement and personal conviction – as active autonomy.
4 Tactics – practice based on the appropriate impulse of the moment arising either out of an immediate reaction to stimulus or the flash of insight and technical mastery – as active heteronomy.

Games such as 'Psychon' and 'Icon 1' are based squarely on these conditions, and team names such as Esoterica, Logica, Dyno and Splat are obvious personifications of these processes.

In more commonplace terms intellect is served by the scenario-scan (data assimilation) and strategy (visual thinking); the emotions by team judgements; and the physical system by the interaction of the game and the execution of the tactics. The emotions, however, should be seen to have two sides, the personal and the social. Special emphasis is placed on the social by community arts groups such as St George's, Liverpool, and Inter-Action in London.

THE HUMANITIES

Sensibility and quality of communciation, whether in the A Ag games or other projects, literary, musical and so on, figure among the prerequisites of the humanities; and the antithesis between group and individual judgement is a perennial theme in great works of literature. The A Ag model, as an art form, offers the kind of breadth and freedom that characterizes the humanities generally, and perhaps fine art in particular. If non-artists have made an unexpected success of abstract painting through playing the games, art students have also done well and excelled particularly in games requiring representational drawing

or exquisite draughtsmanship. Moreover, the games as we see them – non-compulsory and non-competitive – have an inherent concern for each participant's quality of thought, feeling and freedom of action. They aim at involving children in a process which exercises their faculties freely so that they can enjoy themselves *now*, and find the kind of excellence that they want *now*, rather than assimilate something they have to take on trust as leading to excellence and good experiences in the distant future.

MOVEMENT, MIME AND DRAMA

In an extension of the range of experience teamwork has sometimes included movement, mime and drama. One way of doing this has been to lay a floor-grid corresponding with that on the wall. Then instead of carrying out the unscrambling by pointing out territories with a stick, the floor grid can be danced over, reclined upon, stretched over, dealt with acrobatically, or even stamped upon to give the appropriate emphasis that a team needs in expressing its claim to particular areas, focuses, routes or connecting channels. This is done without words except perhaps for the calling out of coordinates as the mime unfolds. A performance like this can become an entity apart from the game – and sometimes we have continued in the gymnasium.

We have made fewer experiments with drama. In one game, 'Ethicon', alien codes of ethics were acted out to shed light on our own value systems. I should like to see an extention of fringe performances in drama, music and dance programmed with contrasting themes, planned and unscrambled by the group during the performance, so that the outcome is unpredictable and draws more completely on the creative skills of the company.

Art games and subjects other than art – conclusion

A key aspect of the educational benefit of the A Ag model is that it draws upon data and concepts from other fields than art, and so can help to develop and reinforce those concepts. For some children the visual mode is particularly important when it comes to taking in information, and the art-based game can provide an effective alternative way into a subject; it can also offer special opportunities in the experience of integrated teaching and learning, which can fit very well into the integrated approaches currently being developed.

Scenarios of many of the games are those of school subjects (see Chapter 6) reading and writing ('Treasure Trail', 'Kidnap') and arithmetic ('Toy-Test', 'Flags', 'Lace Trace') to geography ('Land-scanner', 'Isobar'), history ('Hadrian's Wall', 'Gnosis') and science ('Crystals', 'Steady State', 'Virus'). All this has been, as it were, without trying. None of our games has been invented for a school lesson, but rather for fun outside school; moreover, several of the above were invented by children.

How much data you programme into a game and how much learning you require to take place in a game will depend on your appreciation of the capabilities of the learners. Some of the details, often new to the player, will immediately become part of his world of knowledge; others may need reinforcement later on. Something which seems worthwhile and attractive is likely to be easier to remember. The player may need to make no conscious effort, and there are no anxieties attached to forgetting.

By grouping together some of the things we assess in the games, it becomes clearer how the processes we have been using are also those which permeate other aspects of learning and culture (see Figs 20 and 21).

SCIENCE AND TECHNOLOGY

Naturally, the use of the scenario, for example, results in players selecting clues which contribute towards the game outcome; but, it is precisely such selecting, imagining and visualizing that is a special feature of induction and the recognition of concepts, and ultimately of the invention of physical things and processes. This aspect of the game can lead into the area of applied science at junior level. In the primary school, as Professor Maurice Wilkins has suggested, it is difficult and indeed inadvisable to separate science from art.[4] Why not games, too? The scientist or technologist, when faced by an almost insoluble problem, resorts to gaming and stimulation techniques.

While Jerome Bruner[5] and other educationists have written about the value of games and simulations in education there is as yet little appreciation of the teaching potential of effectively devised visual experience. I have taken part in university teaching simulations in which there were hardly any visual dynamics at all. This is a mistake which contemporary industrial simulations do not make: compelling visualization and read-out displays provide instantaneous information

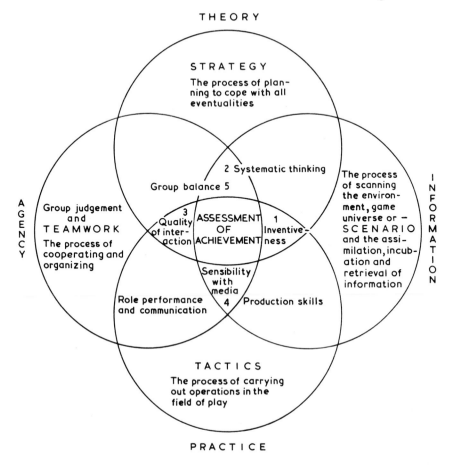

Fig. 20 Inter-relationships between factors assessed in the playing of art-based games:

1 Inventiveness (scenario vote and originality rating)
2 Systematic thinking (strategy vote)
3 Quality of interaction (teamwork vote)
4 Sensibility in handling media (tactics vote)
5 Group balance (target vote)

for the petroleum industries, IBM computers and many other large industrial combines. The making of flags, banners, tokens and all kinds of read-out material which can be understood instantaneously is just as necessary for children in a fast-moving 'research' situation – if anything more so!

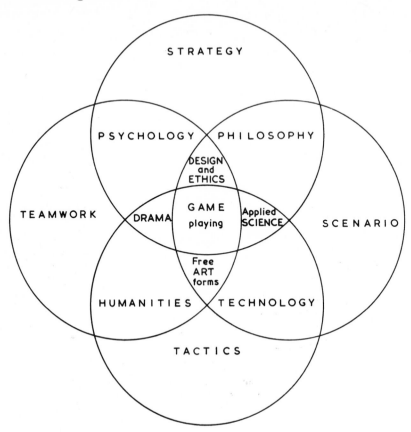

Fig. 21 Art-based gaming linked with other disciplines
The relationship between the processes of the game and aspects of culture
generally

Different attitudes towards the tasks of doing and making are
programmed into A Ag role play, and in this part of the game tactics
are conditioned by (a) the constraints of materials, forms and con-
cepts from the scenario, stimulating inventiveness in the player, and (b)
the need to work fast and spontaneously, leading to a ready mastery of
the medium. An A Ag game encourages the laying-out of new subject
data as a visual constellation of ideas, which can be scanned for patterns.
Similarly, in industrial technology a systematic survey of the field is a
necessary prelude to invention; and a sophisticated mastery of techno-
logical processes is required before prototypes and final production
models can be made. The excellence of Japanese product design, for

example, might well be partly attributable to the visualizing and manipulative skills learned in the systematic Origami games that Japanese children play as soon as they can hold a piece of paper. Invention and productive skills can equally well be programmed into A Ag.

PHILOSOPHY AND ETHICS, AND THE CONCEPT OF COMPETITION

We have not always been able to make the best use of the ideas of some of the younger players in the eleven- to twelve-year-old age-group when they have come up with concepts relating to other dimensions, inner space, space warp, and so on. These are ideas which might be of interest to a philosopher, and there is clearly an area between imaginative inventiveness and systematic thinking which might be followed into philosophy proper. This link has been entered on the second Venn diagram (Fig. 21).

At a more advanced level, art-based gaming theory gives a good lead into contemporary studies of epistemology dealing with the meaning of meaning in terms of qualities of goal-seeking activities rather than purely linguistic concepts. Much that Wittgenstein has said about colour, for example, can be elaborated upon from this viewpoint.[6]

One of the most rewarding of the philosophical categories for discussion is that of the ethics and morality of art-based games. A game that includes teams with contrasting aspirations and goals which must be achieved in addition to the game target common for all players is a model in which there are two forms of goal, a major and a minor: the team goal and the game target – the latter being a super-goal, embodying the cooperative efforts of all players no matter what their team, and in conflict only with abstractions such as time and space. The excitement in pitting oneself against such adversaries should not be underestimated. They can be more frightening and formidable than human antagonists! In one game of 'Pulsar' the team painting right up to the deadline before the universe was destined to explode managed to save the day by getting the last stroke in before the trump of doom, and the cheers were just as loud from the other team which had already finished.

The traditional European concept of the game is in essence that of a little war. Does this have to be? Why should virtually all western games be competitive? Even seemingly innocuous children's games establish that our most enjoyable experiences in childhood tend to be

competitions in which someone has to win and someone suffer defeat and humiliation – even if only in 'fun'. We are conditioned from childhood to believe that war, the rat-race, and oneupmanship are the ineradicable concomitants of the 'achievement' ethic and therefore excusable or even to some extent respectable aspects of life.

When we first began the games with the local children, and teams had been allocated by picking pink and blue table-tennis balls out of a hat, one little girl looked across at the other team and said 'I couldn't live with that lot. It's got to be war even if we both lose!' Towards the end, however, competition had become an amusing irrelevance, and both teams put in a real effort to achieve the game's target.

Some kinds of group unity can, by positive feed-back of enthusiasm, produce very substantial achievement for the individual and for the group. By contrast, competition is usually divisive. It can, on occasion, be beneficial for those who need, sometimes at least, to feel superior to others; and here winning (in our case, doing better than others) may have a very important therapeutic role for weaker and less confident participants, so long as it is allowed to happen in a way that is neither patronizing nor detrimental to the others.

Art Arena is about building games around the capabilities of the people participating and the facilities available. It is not to do with adapting people and things to fit a preconceived rule-system. The whole process is like what happens *after* hostilities, when all are intent on the 'grand strategy' of reconciliation and the attempt at resolution of conflict through exploring the hidden potentialities of people, ideas and things in an overall achievement which draws upon the higher ideals of the protagonists. Above all, it requires, on the part of teachers as well as players, new expressive skills and sensibilities, and the ability to conjure up at a moment's notice a new universe – the world of the game.

References

1 Read, Sir Herbert (1943) *Education through Art*, London: Faber.
2 Gill, Eric (1941) 'Abolish art and teach drawing', *Athene* 1, 5, 21.
3 Brigham, D. L. (1978) *Visual Arts in Basic Education*, Attleboro public schools, Mass. Unpublished guidebook.
4 Personal communication, 1975.
5 Bruner, J. (1967) *Toward a Theory of Instruction*, New York: Norton.
6 Wittgenstein, L. (1978) *Remarks on Colour*, Oxford: Blackwell.

Appendix 1
One hundred games

The following list is intended to offer suggestions for scenarios, and to give an idea of the variety of subjects that have been covered.

Key: j = young junior; J = junior; s = senior.

Airlines (binary exercise) Js
Alien Distortions (anamorphic project) Js
Aliens' Cave (Sci Fi fantasy) J
Atomic Disaster (Sci Fi) Js
Apocalypse (figural drawing) Js
Bionic Battle (ritual pageant game) Js
Billboard (advertising and graphics) Js
Blend (Sci Fi) jJ
Circus (kinetics) jJ
Collision (Sci Fi) J
Copyright (symbol design) s
Cosmic Powers (classical and renaissance mythology) s
Cowboys and Indians (pictorial) jJ
Crystals (geology) Js
Customized Connoisseur (car design) s
Detection (Pink Panther plus puzzle) jJ
Double Star (arithmetic) J
Dragon (R. E. – Taoism) jJ
Eco Machine (ecological fantasy) Js
Elements (renaissance philosophy) Js
Ethicon (Sci Fi morality) Js
Farmers' game (environmental) jJs
Firelight (pictorial fireworks abstract) jJ
Flags (arithmetic) J
Floods (geography) J
Force, The (Star Wars) jJ

Galaxy (Sci Fi) jJ
Genesis (geology fantasy) jJs
Ghosts (distortions) J
Gnosis (Byzantine art history/R.E.) s
Graffiti (writing, graphics) jJs
Hadrian's Wall (history/archaeology) Js
Heaven and Hell (R.E. painting abstract) Js
High in the Sky (pictorial) jJs
House (history of architecture) Js
Ideal Homes (architectural conversions) Js
Isobar (geography) jJs
Icon 1 (mural design) s
Icon 2 (zoning) s
Intellect 1 & 2 (mechanisms-of-mind fantasy) s
Joust (abstract) J
Kidnap (newspaper-reporting/map-making) jJ
Lace Trace (arithmetic) J
Landscanner (meteorological) Js
Lodestar (Sci Fi) J
Lotus (R.E. Tantric yantra) Js
Micro-Worlds (microscopy) jJ
Mizmaze (Sci Fi map-making) J
Monster (fantasy) jJ
Moon Dance (topology) Js
Music Island (pictorial/abstract) J
Mutant (Sci Fi/figure drawing) Js
New Planet (Sci Fi) jJ
Nirvana (flora/landscape map-puzzle) Js
Nuclear Battleships (route-making) J
Orchestra (synaesthesia) J
Oroboros (alchemy) s
Oceanario (marine biology, fish/molluscs) J
Painting Machine (movement and sound) jJ
Peacock (bird-drawing and painting) jJ
Pendulum (painting and movement game) J
Phoenix and the Carpet (pictorial) jJ
Planet of The Apes (abstract) J
Prophecy (R.E./the I Ching) Js
Psychedelic Garden (Sci Fi botany) jJs
Psychon (Sci Fi/Jungian polarities) jJs

Psychonian Treasure (Sci Fi and puzzle) J
Pulsar (Sci Fi and mathematics) Js
Qabalah (R.E./symbolism of numbers) Js
Rainbow (colour juxtaposition) JJ
Reflections (mirror images) Js
Restoration (tapestry compromise) J
Road Blocks (Sci Fi and zoning) s
Safari (zoology) JJ
Secret Garden (pictorial) JJ
Snowflakes (geometrical pattern-making) JJ
Sonar 1 (binary exercise) J
Space Lace (Sci Fi with stochastic matrices) Js
Space Race (quick controlled line painting) JJ
Space Shuttle (pictorial exploded projection) Js
Space Walk (remote control painting) J
Space Warp (anamorphisms) s
Spaghetti Junction (town planning and civic studies) Js
Sphere Machine (3D construction) Js
Sports Day (kinetic silhouettes) JJ
Squircles (Sci Fi/atomic physics) JJ
Squircles Machine (remote control painting) J and handicapped
Steady State (mathematics) J
Sunken Treasure (abstract) Js
Survival (first aid) Js
Top Star Show (painting and mimicry) J
Tarot Rhythms (painting and movement) Js
Traffic Jam (pictorial) JJs
Treasure Trail (reading and writing) J
Tunnel and Cells (fantasy) JJ
UFO (reconstructed from conflicting observations) Js
Virus (biology – symbiosis) Js
Weather (sunshine/storm) JJ
World Tree (ecology and the seasons) Js
Zoncium 11 (Sci Fi) J

A data sheet for each of the above will be published in a compendium
of games. Typescripts of many of them are available from the author.

Appendix 2
Materials and equipment

Basic requirements

A continuous wall or floor *surface* (or open space for a 3D spectacle).

PAPER – pinned, stapled or Sellotaped to the art-work surface, and cut from a large roll; or a wall may be specially primed.

PAINT – powder or PVA ready mixed.

PAINT BRUSHES – especially decorators' brushes not smaller than about 2″–3″ accross the bristles, as many brushes as players.

PAPER (A4) – for the 'Warm-up' rough drawings

GRAPH PAPER OR SQUARED-UP A4 PAPER – for the masterplans

COLOURED PENCILS, CRAYONS, OR FELT TIPS – for drawing up the masterplans.

CHALKS (COLOURED) – for drawing on the art-work surface.

PALETTES, DISHES, BOWLS, OR PAINT TRAYS – about a dozen.

LONG SLATS OF WOOD FOR RULES to square up the art-work surface.

ACCESS TO WATER for mixing paints and cleaning brushes.

TABLES to work at and mix paint on, with as many STOOLS as there are players; and stools or boxes to stand on.

A BELL, HOOTER, KLAXON OR WHISTLE for calling conferences.

OPTIONAL REQUIREMENTS

Some games require special apparatus and materials, such as SPINNING TOPS or teetotums, DICE, STRING (for compasses), STAPLERS, ADHESIVES, SELLOTAPE, SCISSORS, ALUMINIUM FOIL, and so on.

OVERALLS and oldest clothes are advisable. A large old shirt worn backwards gives sufficient protection.

An OVERHEAD PROJECTOR or illuminated slide-viewing table can be especially helpful in giving a fair impression of the result of overlaying two masterplans.

A REDUCING GLASS (diminishing lens) will help players to see the art work as a whole if they are working in a confined space.

NUMBER CARDS for voting are used by some groups, and a PUBLIC ADDRESS SYSTEM can add to the effectiveness of the performance where large numbers are involved.

Some groups like to use SOUND EMITTERS (instead of the human voice) for the calling. These bleep the coordinates. A drone is used for the colours; musical instruments, electronic organs, discarded organ pipes, and so on have been used for this.

Where to get the materials

PAPER

Rolls of white or coloured poster paper 76 cm wide (2′ 6″) from: Slater Harrison & Co. Ltd, Lowerhouse Mills, West Bollington, Macclesfield, Cheshire SK10 5HW. It is easier to handle three strips of this joined with gum-strip, than an 8ft roll, which is the height of the wall surface we use. Alternatively, the printer of your local newspaper will usually have pieces at the end of each roll of newsprint which he cannot use, and may be pleased to have you take them away.

PAINT AND COLOURED PENCILS

Berol Ltd, Oldmedow Road, King's Lynn, Norfolk PE30 4JB
Powder paint or 'Ready mix' are both very good for the purpose.

COLOURED CHALKS

The Cosmic Crayon Co. Ltd, Bedford

REDUCING GLASS

Dan Art, Richmond, 108 Sheen Road, Surrey

Index of concepts with book lists

Art Arena games, 19ff.

Clarke, M. (1975) 'Games without conflict – a new kind of cooperative activity', *TES*, 16 October 1975.

Pavey, D. (1976) 'Art gaming and the concept of the fusion of contraries', *INSCAPE*, J. of the British Association of Art Therapists, 13 February 1976.

Pavey, D. (1976) 'A painted field of Play', *TES*, 27 October 1978.

Arte Povera, 49

'Coarse' art as opposed to Fine Art.

Barilli, R. (1971) 'A propos de l'Exposition de Turin'. *Opus Int.*, March.

artist-designer, artist-painter (AAg), 21, 26, 28, 47

Role in the communication relay of the AAg.

assessment, 25, 36, 96, 134–43, 155; see also evaluation.

Assessment is usually distinguished from evaluation in that while evaluation relates to a feeling judgement, assessment is more specifically a measurement. In AAg the concepts of the assessment of Scenario, Strategy, Teamwork and Tactics can be compared with the CIPP system of Daniel Stuffelbeam, in which C = Context, I = Input, P = Process and the second P = Product.

Stuffelbeam, D. (1976) 'The use and abuse of evaluation in Title III', *Theory into Practice*, 6, 3, 126–33.

In assessing Originality in AAg a team's degree of divergence from its Example is scored, and the mean rank score is computed, the sum of the individual scores being divided by the number of teams. In assessing the Creativity categories in AAg (see pp. 141–2), scores are seen as being simply above or below their mid-points, that is to say they are quantized.

It is interesting to compare the AAg Creativity categories (Creative, Academic, Eccentric, and Embryonic) with Elliot Eisner's Boundary-breaking, Aesthetic-organizing, Inventing and Boundary-pushing categories.

Challinor, M. (1978) 'Assessment in art education', *Athene*, 66 (research issue).

Eisner, E. W. (1972) 'Children's growth in art: can it be evaluated?', in his *Educating Artistic Vision*, London: Collier-Macmillan.

automated art, 161

Art by remote control. Examples are the art works of Moholy Nagy (his automated paintings) and Tony Smith (sculpture) executed over the telephone. Automated is from the Greek 'automatikos', self-acting.

automatic art, 15

Art created by Surrealist automatisms.

Colquhoun, I. (1951) 'Children of mantic stain', *Athene*, 5, 2.

Matthews, J. H. (1978) *The Imagery of Surrealism*, Syracuse, N.Y.: Syracuse University Press.

From the same origin as 'automated' (qv).

Bauhaus, 14
The now classic German institution of the early 1920s for education in architecture and design. From the German *Bau*, construction or architecture, and *Haus*, house.

binary, 42, 43, 47, 116
The binary system is a system of numeration that uses only two numerals, usually 0 and 1, to express all numbers.

***Cadavre exquis*,** 9
Surrealist metamorphosis game.

caller (AAg), 20, 21, 24, 26, 29, 46
A role in the AAg communication relay.

chance, 110; see also probability.

charade
Word-guessing game with clues in visual spectacles and/or dramatized presentations based on the component syllables of the word to be guessed.

cheating
The concept of cheating has no application in AAg unless a game is run as a competition.

Arnold, A. (1972) *World Book of Children's Games*, California: World Pub., 15.
Kapel, D. (1966) 'Analysis of cheating' in Programmed Learning Instruction. *NSPI Journal*, December.
Maskelyne, J. N. (1894) *Sharps and Flats. A complete revelation of the secrets of cheating at games of chance and skill*, London and New York: Longmans Green.
Scarne, J. (1975) 'Cheating ...', *Encyclopaedia of Games*, London: Constable, Chapter 22.

cognition, 54
Bloom, B. S. (1956) 'Cognitive domain' in B. S. Bloom *et al. Taxonomy of Educational Objectives*, Vol. 1., New York: Mckay.
Perkins, D. and Leonder, B. (1977) *The Arts and Cognition*, Baltimore: Johns Hopkins Press.

colour games, 147–9, 121, 161
Holiday, E. (1973) *Altair Design Pad*. Harlow: Longman. Geometrical nets, for colouring in, based on tenth-century Arabic mathematical patterns.
Montessori, M. (1912) *The Montessori Method*, London: Heinemann. Chapter 12, section 3 (on hue-recognition games).

Richardson, M. (1948) *Art and the Child*, London: University of London Press, 43–4.

Sackson, S. (1977) *Colourgrams 1*, Harmondsworth: Penguin. Games played with coloured pencils or felt-tips. Games named after Vasarely, Miro, Mondrian, Arp, Delauney, Klee, and Springer are included.

commedia dell' arte, 14

Medieval and Renaissance Italian comedy in which the dialogue is improvised by the players.

commentator (AAg), 22, 36

A player who takes on the duty of explaining and interpreting the progress of the game at conferences, during the game, and especially at the voting session.

commission brief (AAg), 20, 23, 44, 45, 98, 139, 140, 146

A commission brief or game data sheet describes the Scenario and Target of the game. It names teams, gives details of their strategical opportunities, and suggests tactical rules.

communication network (AAg), 3, 21, 45–7, 111, 143, 155

Krupar, K. (1973) *Communication games*, New York: Free Press.

Mueller, R. E. (1968) *The Science of Art. The cybernetics of creative communication*, London: Rapp & Whiting.

competition, 1, 3, 14, 16, 54, 111, 116–17, 143, 157–8

Competition is striving alongside another or others. Conventionally its goal is something which can only be attained by one or a limited number of people, and is thus essentially a selection procedure.

Harmful, counterproductive, and not so harmful aspects of competition in games are documented in the following:

Aspin, D. (1975) 'Games, winning and education: some further comments', *Cambridge J. Educ.*, 5, 1.

Bailey, C. (1975) 'Games, winning and education', *Cambridge J. Educ.* 5, 1.

Nelson, J. D. *et al.* (1969) 'Children's aggression following competition', *Child Development*, 40, 1085–97.

Selg, H. (1975) *The Making of Human Aggression*, London: Quartet.

Sherif, M. (1967) *Group Conflict and Cooperation*, London: Routledge & Kegan Paul.

Some acceptable uses of competition:

1 The individual competes against himself, contrasting present with past performance, and actual performance with what is believed could be achieved.

2 Playing, valuing and enjoying the game, sharing the winner's triumph, or losing with grace and deference ('sportsmanship'). It is an ideal few games players, even fanatics, can ever rise to! Without it competitive games become symbolic warfare, where symbolic cooperation might have been as exciting, but more productive.

3 Team players (as in AAg) may try to make it difficult for their opposite numbers to succeed, so long as this provides a spur to bring out the best in each other, and does not make things so difficult that a team fails, which in AAg would be sabotage, and illegal. This gives scope both for aggression and its conversion into caring.

computer games

The AAg model offers special opportunities for the designer of video games programmes to devise engrossing games of different tempo suitable for various kinds of popular audience from hospital and clinic groups to community centres.

PCC (1977) *What to Do after you Hit Return, or PCC's First Book of Computer Games*, Cal.: Menlo Park. A useful giant paperback on computer games with lots of graphics.

Ahl, D. (1976) *101 Basic Computer Games*, Southampton: Creative Computing.

Conway, J. (1970) 'Game of life', *Sci. Am.* 223, 4.

concept identification, 45

Bruner, J. S. *et al.* (1956) *A Study of Thinking*, New York: John Wiley.

conferences, 22, 24, 30, 35, 46, 52, 53, 93, 94–7

In the AAg Conference or Court of Appeal, contracts can only be made in the interests of the game as a whole and not solely for the benefit of individual teams.

conference within teams, or masterplan conference, 24, 91–2

When there is an unstable group with difficult or vulnerable players, special care needs to be taken at the first get-together over the masterplans. If players in a team refuse to allow any one part of their plans to be left out of the masterplan, it is best for the umpire to scrutinize each motif, one at a time, and ask its originator 'How strongly do you feel that this needs to be carried through to the final painting? Or, do you not mind very much? Can you give your need a mark out of ten? Say 5 if you don't mind; 6, if you would quite like to have it in; 7, if you really would like it; 8, if you would like it very much; 9, if you would like it passionately; and 10, if your need to have it in the final painting goes beyond all bounds!' Of course, below five means the player would prefer it wasn't in – or likes someone else's work better. This way of quantifying feelings enables the group to appreciate the magnitude of the player's need – and, indeed, sacrifice, if the player's motif is rejected

by group vote. However, if all players are equally possessive towards their own plans, then one has to rely on the virtually limitless transformational possibilities that there are in art, through such combinatory techniques as mixing the different players' colours, counterchanging or interchanging them, superimposition, and so on.

conflict escalation, 22, 143, 158

Bach, G. and Goldberg, H. (1965) *Creative Aggression*, London: Coventure.

Kahn, H. (1965) *On escalation*, New York: Praeger.

Lieberman, M. A. *et al.*, (1973) 'Synanon game', in their *Encounter groups*, New York: Basic Books. The Synanon game expresses anger and attack.

Nicholson, M. (1970) *Conflict Analysis*, Edinburgh: Edinburgh University Press.

Tedeschi, J. T. *et al.*, (1973) *Conflict, Power and Games*, Chicago: Aldine.

See also the publications of the Conflict Research Society, 158 North Gower Street, London NW1 2ND.

conflict resolution, 16, 52, 158

Bixenstine, V. *et al.*, (1963) 'Effects of level of cooperative choice by the other player on choices in a Prisoner's Dilemma game', *J. Abnormal and Social Psychol.*, 66, 308; and 67, 139–47.

Davis, M. D. (1970) 'Prisoner's Dilemma' in his *Game Theory*, New York: Basic Books, 93–113.

Fluegelman, A. (ed.) (1978) *The New Games Book*, London: Sidgwick & Jackson. This describes the work of the New Games Foundation, San Francisco. Competition is rendered harmless in an 'expression of aggression' called 'soft war' with the slogan: 'Play hard. Play fair. Nobody hurt'.

May, M. A. (1937) 'Competition and cooperation', *Social Science*, Research Council Bulletin 25.

Rapoport, A. and Chammah, A. M. (1965) *Prisoner's Dilemma: a study of conflict and cooperation*, Ann Arbor: University of Michigan Press.

Sherif, M. (1956) 'Experiments in group conflict', *Sci. Am.*, 192, 54–8.

Sherif, M. *et al.*, (1961) *Intergroup Conflict and Cooperation*, Norman: University of Oklahoma Press.

Sherif, M. (1967) *Group Conflict and Cooperation*, London: Routledge & Kegan Paul.

Escalation is implicit in the idea of war-gaming, in which there is a reciprocal countering of attack with reprisals of ever-increasing intensity. The 'ladder of escalation' is a phrase popularized by Herman Kahn, who suggested that it could be avoided by meeting assault with a response that is minimal and mutually face-saving.

conflict cooperation, 157–8; see above for references.

constraints, 45, 140, 156
Constraints are conditions specifying the strategical relationships and character of the elements (e.g. motifs) to be used in the AAg masterplans; they determine the strategies and outcome of a game. In AAg they are strictly speaking self-imposed, being based on the strategical opportunities laid down in the game information sheet.

contracts (conference decisions), 22, 24, 30, 53, 93
Contracts and agreements arising from negotiations and conferences must be published clearly to the group as a whole. This also applies to the results of the negotiations of individual members, especially Stabilizers. In addition, the acceptance of a place in a game constitutes a contract to abide by safety precautions, general instructions and majority rulings.

CRANAL (Creative and Analytical Studies), 147
Abbreviation used by the Schools Council 18+ Research Programme.

creativity gradient (AAg), 140–1
In the AAg assessment, the creativity gradient is expressed as a relationship between the quality of the activities of the game and its originality.

debriefing, 95, 100
The game begins with a briefing which gives essential data and explains concepts; it ends with a *debriefing* in which players report back on what actually happened in the development and conclusion of the game. This leads to a discussion about the purpose and value of the exercise. In AAg, the Commentator or spokesman for the players begins the debriefing as an introduction to the voting session, and each player is invited to say a few words explaining his or her vote.

Stadsklev, R. (1974) *Handbook of Simulation Games in Social Education*, Part 1, Alabama: University of Alabama Press.

deduction, 41, 45, 152
Gregory, R. L. (1970) *The Intelligent Eye*, London: Weidenfeld & Nicolson, 160–1. Professor Gregory suggests,

'It is most tempting to suppose that the kind of problem-solving used in perceptual brain processes is *inductive*, while the problem-solving used for abstract thinking and communication and calculation is essentially *deductive*.'

Deduction is from the Latin *deducere*, to draw from. It means finding that some property belongs to a particular case from observing that it comes under a general law.

design games 8, 9
Lethaby, W. R. (1929) *Designing Games*, Leicester: Dryad.

Talbot, R. J. (1973) 'Games for design education', *Programmed Learning and Educational Technology*, July.

Jacques, R. (1977) 'GRIPS: an educational game for designers and others', in J. Megarry (ed.) *Aspects of Simulation and Gaming*, London: Kogan Page.

designer (AAg), 4, 20, 21, 24, 26 (pointers), 29, 46, 47
A role in the AAg communication relay.

drama games 69, 153, 156

Barker, C. (1977) *Theatre Games*, London: Eyre Methuen.

Hodgson, J. and Richards, E. (1975) *Improvisation*, London: Methuen.

Norris, J. (1977) *Drama Resource Cards*, Harlow: Longman.

Owen, D. (1977) *Play-games*, London: Muller.

Spolin, V. (1963) *Improvisation for the Theatre*, Evanston, Ill.: North Western University Press.

For psychodrama, see the now classic work of J. L. Moreno, who first wrote on group activity with children when he was only sixteen years old in 1908 (e.g. *Das Kinderreich*, Vienna 1908):

Greenberg, I. A. (ed.), (1974) *Psychodrama. Theory and therapy*, New York: Behavioral Publications.

drawing games, 1, 8, 9, 15, 16; see also surrealist games.
Popular drawing games are usually listed in books on games under 'pencil and paper games'. Two popular books on drawing games are:

Brandreth, G. (1976) *Pencil and Paper Games and Puzzles*, London: Carousel. For children.

Solomon, E. (1973) *Games with Pencil and Paper*, London: Nelson.

drives, 16

Hedges, S. G. (1964) *Youth Club Games and Contests*, 2nd edn, London: Methuen. This gives: Plane Production Drive, 62; Car Assembly Drive, 63; Jigsaw Drive, 65; and Versatility Drive, 74.

Stevens, K. (1951) *Party Games for All Occasions*, London: Ward Lock. This includes: Beetle Drive, Vol. 1, 112; Cat Drive, Vol. 2, 64; and other drawing games.

Hunter, J. (1935) *Book of Indoor Entertainments*, London: Hodder & Stoughton, 448–9. This book includes what was probably the original model for the drive games, the old game of 'Hangman', or as he calls it, 'Gallows'.

education through art, 120, 122, 149–51

enjoyment, 3, 13, 14, 16, 25 (fun), 37, 53–4, 96, 111, 130, 135, 136, 138, 144, 145, 153

An essential, but many-sided, attribute of the game. Some different aspects of enjoyment are described in the following:

de Bono, E. (1977) *The Happiness Purpose*, London: Maurice Temple Smith.
Callois, R. (1962) 'Simulation and vertigo', in *Man, Play and Games*, London: Thames & Hudson.
Chesler, M. and Fox, R. (1966) *Role Playing in the Classroom*, Ann Arbor: Science Research Associates/University of Michigan Press. The chapter on 'Evaluation' grades enjoyment.
Johansson, R. E. A. (1969) *The Psychology of Nirvana*, London: Allen & Unwin.
Leonard, G. B. (1968) *Education and Ecstasy*, New York: Delacotte.
Rowan, J. (1975) *Ordinary Ecstasy*, London: Routledge & Kegan Paul.
Schutz, W. C. (1973) *Joy*, Harmondsworth: Penguin.
Tomkins, S. S. (1962) 'Enjoyment', in his *Affect, Imagery, Consciousness*, Vol. 1, *Positive affects*, London: Tavistock.
Béebe-Center, J. C. (1933) *The Psychology of Pleasantness and Unpleasantness*, reprinted 1965, New York: Russell.

environment, 7, 148, 155
Crosby, T. (1973) *How to Play the Environment Game*, London: Arts Council/Pelican.
Gould, P. R. (1969) 'Man and his environment, a game theoretic framework', in P. J. Ambrose (ed.) *Analytical Human Geography*, Harlow: Longman.
Lewis, D. and Carson, S. M. (1972) 'The conservation game', in J. Taylor and Rex Walford *Simulation in the Classroom*, Harmondsworth: Penguin (Papers in Education 1972, reprinted 1974). This gives details for a fifth- or sixth-form simulation game.

escalation, see conflict escalation.

evaluation (AAg), 25, 36, 96, 134–44; see also assessment.
At the AAg voting session the quality of performance, experience and attitudes of the players is evaluated, and the game described. An Index of Performance has been devised to produce a single score from sets of votes under six headings. There is also a self-assessment system which can if necessary be extended to the same six categories.

example (AAg), 23, 42–3, 44, 91, 137, 139–40
In AAg a specimen or Example masterplan is given to each team. This is a visual counterpart of verbal instruction, and helps players who are not able to visualize from words alone. Example plans are sometimes folded and placed in envelopes marked 'Secret Instructions' and accompanied by special tactical data.

facilitator, 26; see also animateur and umpire.

'Fatagaga', 15
A form of group art practised by Max Ernst with Hans Arp and Johannes Baargeld in 1919. Fatagaga is an acronym for *fabrication de tableaux garantis gazometriques*. Ernst said he aimed at the 'systematic fusion of the thoughts of two or more authors in a single work' and at 'reducing the active role of the party who until now was called the author of the work to its lowest point' (1934).

Diehl, G. (1973) *Max Ernst*, New York: Crown.

forfeits, 13
Cassell's Book of Indoor Amusements, London 1882, 23.

fun (AAg), 25, 54, 158; see also enjoyment.
Meehan, T. (1970) 'Fun Art', *Daily Telegraph* colour supplement, 30 January.
Kraft, I. (1967) Pedagogical futility in fun and games', *Nat. Educ. Assoc. J.*, 56, 71–2.
Rigby, B. (1973) 'Classroom games must be fun', *The Times Educational Supplement*, 2 February.

gambit
A sacrifice which advances the strategy of a team. Derives from the Italian *gambetto*, a tripping up.

gamesmanship
This term refers to a player's or a team's capacity for advancing the progress of a game through, for example, granting concessions or lending players to another team if it is in difficulties. It was originally used by the writer and humorist Stephen Potter, who meant by it the exploitation of every psychological advantage in the 'art of winning games without actually cheating' (subtitle to his book on *Gamesmanship*, London 1947, Penguin 1978). Potter devised the system at a time when he was no longer a match for younger players, so that he might save face and even take a rise out of games fanatics. Unfortunately, he has been taken seriously.

Potter, S. (1978) *Gamesmanship: The art of winning games without actually cheating*, Harmondsworth: Penguin.

GASP (Games of Art for Spectator Participation)
GASP was formed in 1970 by Rob Con, Julian Dunn and Harry Henderson at Wolverhampton Polytechnic. It supervises children's games and gives stylized ritual performances for adults.
Everitt, A. (1972) 'Four exhibitions ...', *Studio International 138*, 941, 76–8.

goal, 27, 51–2, 157; see also target.
A goal is the successful achievement of a game intention, usually larger and less precise than a target (qv). It may be arrived at by one team or by both

teams, and it may be to the advantage of one team or both teams, actively sought by one and passively hoped for by the other, for example. In AAg it is usually considered sabotage if the attainment of a goal by one team eliminates another team. There are often multiple goals and targets in art-based games. Thus:

1 Goals may be assigned weights which reflect their relative importance, according to the view of the game-designer or supervisor. In AAg two goals, balance of interests and enjoyment, the former more usually described as a target, determine the success or failure of a game. Each carries equal weight.
2 Another target is the appropriateness of the final game-result as an outcome of a particular scenario.
3 The initial strategical intention of a player or team is also better described as a target.
4 A goal achieved by one team is likely in an art-based game to enhance the work of another. This effect is called the 'pareto optimum' in gaming terminology.
5 Targets which obscure or detract from the work of other teams should be open to negotiation in the AAg game. In less well-defined scenarios than those of AAg, where no one goal is admitted as ultimate, the activity is called 'satisficing' (Simon, H. A. (1957) *Models of Man*, Chapter 14, New York: John Wiley).
6 An intention which is even wider and more inclusive than a goal is an objective (qv).

Roberts, P. O. (1968) 'The treatment of multiple goals in systems models', in G. T. Moore (ed.) *Emerging Methods in Environmental Design and Planning*, Cambridge, Mass.: Massachusetts Institute of Technology.

gradients of tone, colour and shape, 148
Pavey, D. (1974) 'Colour psychology in art and design', *J. Colour Group*, 17, 316 ff.

graffiti, 160
Kurlansky, M. (1974) *Watching my Name Go By*, Mathews Miller Dunbar.
Abel, E. (1977) *The Handwriting on the Wall. Towards a sociology and psychology of graffiti*, London: Greenwood.

group-generated art, 3, 5, 12, 14, 145
Andrews, M. (1974) *Synaesthetic Education*, School of Art, Syracuse NY: Syracuse University.
Everitt, A. (1972) 'Four exhibitions...', *Studio International 138*, 941.
Harris, J. and Joseph, C. (1973) *Murals of the Mind*, New York: International

Universities Press. Describes psychiatric patients' murals in pastels in an attempt to identify (1) the direction of the aggressive forces, (2) the type of structural boundaries defining the subculture, and (3) the representational nature of an immediate product of the whole subculture.

Gaitskell, C. D. and Hurwitz, A. (1976), *Children and their Art*, especially the chapters 'Group activities in art' and 'Towards a new aesthetic group art', New York: Harcourt Brace Jovanovich.

Langevin, V. and Lombard, J. (1950) *Peintures et dessins collectifs des enfants*, Paris: Les Editions du Scarabée.

Langevin, V. (1953) 'Collective paintings', in E. Zeigfeld (ed.) *Education and Art*, Paris: UNESCO, 61 and plates 17 and 55.

Moholy-Nagy, L. (1947) *Vision in Motion*, Chicago: Theobald. Chapters 'Integration and the arts' (group poetry) and 'A proposal: Group activity of the future must be more aware of the mechanics of its own operation'.

Popper, F. (1975) *Art-Action and Participation*, London: Studio Vista. Chapters 8 and 9, 'From game participation to creativity' and 'Art, science and technology (in relation to creativity)' deal with performance art games.

Rogovin, M. *et al.*, (1973) *The Mural Manual: How to paint murals for the classroom, community centre and street corner*, New York: Beacon.

Norton, M. (1976) *The Mural Kit. How to paint murals for classroom, community centre and street corner*. Directory of Social Change, 14 Saltam Crescent, London 1976. This is a pack of loose A4 pages in a plastic sheath. As it is called a kit bookshops neglect it.

Rosenberg, L. A. K. (1968) *Children Make Murals and Sculpture: Experiences in community art projects*, New York: Reinhold.

Rubin, S. and Rivera, B. (1973) *A Primer for Graffiti Workshops: How to set up and run a constructive art workshop as an alternative to graffiti writing*, Philadelphia, Penn.: Center for Alternative Graffiti Workshop.

Exploratory work in group-generated painting was being done in the UK in the 1930s with children under the guidance of a group of art teachers headed by Alexander Barclay Russell, the founder of the NSAT (New Society of Art Teachers), which became the SEA (Society for Education through Art). Barclay Russell said:

... the inspiration and stimulus to create is very much increased within a group of people, and from a general sympathy and interplay of ideas which they share, these may be crystallized by one of their number. Individual expression is almost always heightened and given fuller meaning when it becomes the work of a 'school' whereas when art is purely individual and is practised in isolation it stagnates. It should be the duty of art teachers to create this atmosphere for the common discovery of the conceptions that are current and significant for contemporary life, and then to 'pass on' this habit of active association to a wider society beyond the school.

Barclay Russell, A. (1955) 'Some of the factors relevant to achieving social change by means of an Education though Art', *Athene*, 17, 3, 15–23.

gyro, 125; see also randomizers.
A floating teetotum (AAg).

Gould, D. W. (1973) *The Top*, New York: Clarkson N. Potter.

handicap and therapy, 1, 47, 158, 161
The AAg has been used in occupational therapy classes with interesting and successful results. The lecturer says, 'If we accept the basic idea that psychosocial dysfunction is at least in part due to a failure to learn how to function in the community, then the possibilities of art-based games as a means of using the dynamics of group interaction to bring about change, with the support and demands of a cohesive group helping patients to think, feel and act in ways more satisfying to the needs of self and others, become apparent.' Eileen Rennison, Department of Occupational Therapy, College of Ripon and York St. John (personal communication 22 February 1979). See also simplified games under '"Psychon" progeny'.

handling, 3, 4, 48, 135, 137, 138, 155
There are three aspects of handling: the medium (qv) handled, the way of handling,
Scott, V. (1967) 'Brushwork in children's painting', *Athene*, 13, 1. This is particularly relevant to AAg.

and the intentions of the handler (see tactics).

heteronomous, 152
State of consciousness under the influence of other agencies, e.g. (1) *active*, influenced by things, people or ideas from the environment, or (2) *passive*, under influences from below the threshold of consciousness. By contrast, autonomous states are shown in an active assertion of authority and power over one's environment, or in a relatively passive defence mechanism. The word 'heteronomous' is from the Greek 'heteros', other, and, 'nomos', rule. Autonomous is from 'autos', self.

Lüscher, M. (1955) *Psychologie und Psychotherapie als Kultur*, Basle: Test-Verlag.

holistic, 98, 99
This consists in 'explaining the complex by the simple ... stressing the characteristics of 'wholeness' ... while ... 'emergent from the assembly of elements'.

Piaget, J. (1973) *Main Trends in Interdisciplinary Research*, London: Allen & Unwin, 21.
Young, J. Z. (1978) *Programs of the Brain*, Oxford: Oxford University Press.

Describes the importance of having a 'whole' view of the world, containing intellect and emotion, science and art.

hybrid games, 9, 59, 60
Surrealist versions of 'Heads, bodies and legs'. See also '*Cadavre exquis*' and '*Fatagaga*'. The first examples of hybrids are reproduced in *La Revolution Surréaliste*, 9–10, October 1927, but there are better examples in the special Surrealist issue of *Variétés*, 1929. Many hybrids as well as examples of the *Cadavre exquis* and *Fatagaga* can be seen in:

Rubin, W. S. (1969) *Dada and Surrealist Art*, London: Thames & Hudson.

hypothesis games, 118
Games based on the elimination of hypotheses. It is better to inculcate in children an enthusiasm for games which involve the testing and elimination of hypotheses rather than the elimination of one another.

Popper, K. and Eccles, J. (1978) *The Self and its Brain*, London: Springer International.

imagination, 3, 4, 5, 39, 41, 53, 135, 145, 151, 157; see also scenario.
Cobb, E. (1977) *The Ecology of Imagination in Childhood*, New York: Columbia University Press.
Furlong, E. G. (1961) *Imagination*, London: Allen & Unwin.
Griffiths, R. (1935) *A Study of Imagination in Early Childhood and its Function in Mental Development*, London: Routledge & Kegan Paul.
Jones, R. (1971) *Fantasy and Feeling in Education*, Harmondsworth: Penguin.
McKellar, P. (1957) *Imagination and Thinking*, London: Cohen.
Mock, R. (1970) *Education and the Imagination*, London: Chatto & Windus.
Rugg, H. (1963) *Imagination*, New York: Harper & Row.
Sartre, J. P. (1948) *The Psychology of Imagination*, London: Methuen.
Scruton, R. (1975) *Art and Imagination*, London: Methuen.
Steinberg, L. (1972) *Other Criteria: Confrontations with twentieth-century art*, Oxford: Oxford University Press. This is on alternative modes of perceiving.
Taylor, A. M. (1966) *Imagination and the Growth of Science*, London: John Murray.
Warnock, M. (1976) *Imagination*, London: Faber.

imitative game (AAg), 141
Guillaume, P. (1971) *Imitation in Children*, Chicago: University of Chicago Press.

induction, 2, 39, 41, 154
Medawar, P. B. (1969) *Induction and Intuition in Scientific Thought*, London: Methuen.

information (AAg)
From the brief:

(1) scenario data, 39, 40, 41, 109, 111, 118, 155
(2) strategical details concerning opportunities and constraints in shape, colour, effects and meanings, 41–5, 109, 111
(3) tactical instructions concerning interplay procedures, 23, 47–8, 94, 109, 111.

In the interplay:

(1) information transmitted from a team HQ, 20, 26, 29
(2) information received at the art-work matrix, 20, 46–7
(3) new information generated at the matrix and fed back to HQ, and data arising out of transformational operations and noise, 47.

At the evaluation:

(1) values of the players, 45
(2) values of the group (by computation), 135
(3) spectator values, 134.

innovatory game (AAg), 141; see also originality.

jokers' game (AAg), 144

judgement, 4, 5, 14, 30, 45–7, 145, 151, 152, 155
Braithwaite, R. B. (1955) *Theory of Games as a Tool for the Moral Philosopher*, Cambridge: Cambridge University Press.
Jochim, L. D. (1967) 'Forming value judgements', shown on Chart 2, 'Motivational method 1 – the experience-motivated approach to the development of perceptual aesthetic growth', in *Perceptual Growth in Creativity*, Scranton, Penn.: International Textbook Company, 126–7. Jochim deals with aesthetic value judgements, but AAg value judgement is also closely tied up with moral judgement and empathy.
Wilson, J. (1970) *Moral Thinking*, London: Heinemann.

Junior Arts and Science Centres (JASC), 2, 3, 4, 17
Pavey, D. (1968–9) 'Junior explorers in art and science' 1 & 2, *Athene*, 13, 2, and 14, 2.
Pavey, D. (1973) 'Power of transformation', *Athene*, 16, 2.
Pavey, D. (1973–4) 'Wizardry with resin' and 'The versatile vacuum former', *The Times Educational Supplement*, 14 December 1973 and 6 December 1974.
Levinson, H. B. (1969) BBC *Horizon* film on gifted children (edited by Roger Waugh and shown February 1969).
Vaisey, M. (1970) 'The Junior Arts and Science Centre', *Canvas*, 5, 6.

kinetic games, 47, 49, 81, 153; see movement games.
Kinetic games are those in which aesthetic movement is an essential element. The word is derived from the Greek 'kinetikos', putting into motion.

limitations (AAg), 50, 52 (not a substitute for individual art work), 54, 55–8, 87, 97, (precautions), 134–5, 137 (evaluatory).
Although AAG has been run successfully by non-artists outside school, the system is particularly open to over-rigid application. It has not yet been studied in the context of compulsory attendance. If it is to be part of a school lesson other than art it is important that an art teacher should be in attendance, at least on the first few occasions of playing.

lost game, and losing, 3, 13, 17, 46, 53, 96, 135, 144, 158; see also winning.
In AAg, the game in which there has been no enjoyment and nothing achieved. For a psychological view of losing, see:

Stokes, A. (1973) *A Game that must be Lost*, Manchester: Carcanet.

ludic art, 49
Popper, F. (1975) 'From game participation to creativity' in *Art-action and Participation*, London: Studio Vista. Popper describes the French ludic art movement which is similar to performance art. 'Ludic' derives from the Latin *ludus*, a game.

ludemes, 'elementary units of games'
Giraud, P. (1975) *Semiology*, London: Routledge & Kegan Paul, 98.

map games, 30, 37, 44, 67–70, 45, 102–6, 118, 120, 159, 160, 161
Manley, D. and Cotterill, P. (1976) *Maps and Map Games*, London: Pan.

maquette, 5, 146
A painter's or sculptor's sketch model or rough sketch. Can also be used in the AAg sense of a masterplan.

Markov Chain, 121
A mathematical representation of a process whose most probable future evolution is determined by its past and present states. Named after the Russian statistician A. A. Markov, the Markov Chain has applications in physics, communications engineering, traffic flow planning, etc.

masquerade
A masked revel.

masterplan (AAg), 5, 20, 22, 24, 25, 26, 44, 55, 92, 93, 96, 103, 136, 145, 146, 147
A design or pattern on A4 paper squared up to correspond with the wall or art-work grid which receives the design or pattern.

match (AAg)
A match is a union of teams fitted or matched to each other. It is a game in which the teams have been chosen for their qualities, in some way complementary to one another, and which is therefore particularly well

balanced. The match will fail if one team fails, as this will mean that the teams were not perfectly matched. The word 'match' derives from the Anglo-Saxon 'moecca', a companion.

mathematical games, 49, 70–6, 121–9

Epps, P. and Deans, J. (1977) *Mathematical Games*, London: Macmillan.

Green, R. T. and Laxon, V. J. (1978) *Entering the World of Numbers*, London: Thames & Hudson.

Holt, M. and Dienes, Z. (1973) *Let's Play Maths*, Harmondsworth: Penguin.

Kohl, H. R. (1974) *Writing, Maths and Games* in the Open Classroom, London: Methuen.

matrix (AAg), 143; see also stochastic matrix.

The grid of squares on the masterplan (qv) and on the surface to receive the art-work is called a matrix.

maze games, 49

Ken Beagley and Jon Effemey, who have run AAg games, have both devised several maze games.

Bord, J. (1976) *Mazes and Labyrinths of the World*, London: Latimer New Dimensions.

Matthews, W. H. (1970) *Mazes and Labyrinths*, New York: Dover (first published 1922).

Myers, B. (1978) *Super-mazes No. 1*, London: Frederick Muller.

Porteus, S. D. (1965) *Porteus Maze Test*, California: Pacific. A psychological maze test.

media, 3, 4, 15, 34, 47, 48, 88, 96, 100, 151, 155, 156, 162, 163

In AAg the term 'media' is used for information channels, e.g. visual: paint, collage, inks, chalks, etc.; and auditory: noises and sound (electronic and from musical instruments).

meditation pattern, 7, 76–7, 114; see also yantra.

metamorphosis games and concepts, 6, 9, 10–11

In art-games metamorphosis refers to the generation of a new and different form from two or more parent motifs (qv). Historical versions are 'Heads, bodies and legs' games, the Surrealist 'Hybrid' (qv) and the '*Cadavre exquis*' (qv).

Kostelanetz, R. Metamorphosis in the arts (This is quoted as being in preparation by Frank Popper in his (1975) *Art – Action and Participation*, New York: New York University Press.

Massey, I. (1976) *The Gaping Pig: Literature and metamorphosis*, Berkeley: University of California Press.

meta-strategy (AAg), 45

As an aspect of the game universe or scenario, meta-strategy embodies all the available strategical opportunities from which an actual game-strategy is derived. It refers to the classes of colours, shapes, forms and effects, and all configurations of these available to the player after the constraints or rules have been satisfied. The word is coined on the analogy of meta-language, which is language which describes language – grammar and syntax, for example.

model, 13, 15, 19ff. (ch. 4), 137, 150, 152

A model is a construct used to classify and make concrete more general theory. The AAg model, for example, is a procedure which enables a group to join forces in imagining, thinking, appreciating, and exercising sensibility in making a collective art-work. Piaget uses the term 'model' in his argument that a child is at work creating an internal model of his surroundings from his very birth, and that this is enriched from experience throughout life.

Piaget, J. (1937) *The Construction of Reality in the Child*, New York: Ballantine Books.

Holt, J. (1970) *How Children Learn*, Harmondsworth: Penguin. John Holt makes an intuitive model on a more practical level than Piaget.

Shanin, T. (1972) *The Rules of the Game: Cross-disciplinary essays on models in scholarly thought*, London: Tavistock. This describes a great variety of models of many different kinds.

motif, 14, 20, 22, 25 (circular and square motifs illustrated), 27, 45, 59, 93, 101, 140, 142, 143, 145

A motif is a shape, image, design pattern or simple configuration of shapes which can be identified in its own right although it is only part of a larger scheme or area of art-work, e.g. a circle, rosette, human figure, etc. As in music (leitmotiv) it may be a theme for further development.

motivation, 51, 53–4, 134, 151

'External or internal stimuli which generate a change in behaviour, and lead to action'.

Yochim, L. D. (1967) *Perceptual Growth in Creativity*, Penn.: International Textbook 243.

Sources of motivation in the AAg model are considered to be:

(1) inventing and discovering
(2) puzzle-solving
(3) cooperating
(4) exercising practical skill and sensibility
(5) achieving
(6) enjoyment.

Ball, S. (ed.) (1977) *Motivation in Education*, New York: Harcourt Brace Jovanovich.

Evans, P. (1975) *Motivation*, London: Methuen.

move (AAg), 8, 47–50, 91; see also tactics.

A move is a single operation which advances or detracts from the progress of the game. In most art-games moves are not made alternately but proceed simultaneously, following the natural rhythm of a team. An operation may be:

(1) logical, arithmetical or according to geometrical logic, as in the precise construction of some kinds of masterplans;

(2) copied;

(3) a full scale manipulation, applying constraints to current information about the state of play, and bypassing the masterplans;

(4) by accepting a manipulation or series of manipulations already made as satisfying the brief.

movement games, 47–9, 81–6; see also tactics.

More movement is being built into some of the AAg games for the younger age-groups. Many eight-year-olds expect a ten-minute break in a two-hour game. It might be an ideal to produce games which were self-sustaining as physical as well as aesthetically expressive enjoyment. In one game (devised by Ken Beagley) the players become part of a machine into which paint is fed at one end, and picked up – or not picked up – on a brush which is mechanically moved towards a player programmed while in constant motion to receive the brush or miss and let the brush drop. The application of the paint to the wall-surface comes at the end of the production line. With various mechanics at the controls and inventors to alter the machine, this can occupy several teams at the same time and last a couple of hours.

Höper, C. *et al.* (1975) 'Human machine 1 & 2', in *Awareness Games*, New York: St Martins Press, 54 and 156.

Laban, R. and Lawrence, F. C. (1974) *Effort: Economy of Human Movement*, London: Macdonald. First published in 1947, this is now a classic work on movement.

Lewis, H. R. and Streitfeld, H. (1973) 'The people machine', in their *Growth Games*, London: Souvenir, 223.

objectives (AAg), 145ff. (ch. 10); see also target and goal.

Where the terms 'target' and 'goal' have a greater immediacy, 'objectives' has a longer-term meaning directed towards the educational, cultural and suprapersonal achievements of the game. Qualified, as in 'players' objectives', the word may have a narrower meaning, in this case the *commission* targets:

(1) satisfying the scenario;

(2) constructing the masterplans;
(3) balancing the team interests;
(4) negotiating space (e.g. with paint).

By contrast the *tacit* objectives are:

(1) *Art-work* – (a) originality, (b) design, (c) corporate image, and (d) creating the spectacle.
(2) *Educational project work* – (a) invention and imagination, (b) visual thinking, (c) group value judgement, and (d) skill and sensibility.
(3) *Enjoyment* – (a) fantasy, (b) puzzle-solving, (c) tussle and romp, and (d) vertigo.

operations, 14, 15, 45, 111, 152, 155; see also move.

originality rating (AAg), 137, 139–40, 155; see also assessment.
This is determined by the degree of difference between (1) a given strategical example (qv), and (2) a player's plan or a team's masterplan (qv).

Hudson, L. (1973) *Originality,* Oxford: Oxford University Press.
Koestler, A. (1964) 'Degrees of originality', in *The Act of Creation,* London: Hutchinson. Gives further bibliographies.

orthogonal, 41, 90
Right-angled, from the Greek 'orthos' and 'gonia', 'right' and 'angle'.

pastiche game (AAg), 141
A pastiche is an imitation, involving copying bits of genuine examples and combining them to give the impression of an original art-work.

patterns of opportunity (AAg), 14, 41–5, 111, 147–9; see also meta-strategy.
The scenario possibilities from which the ingredients of a team's strategy may be selected.

performance art, 49, 153
'The execution of a prescribed course of action before a live audience' (Walker).

Walker, J. A. (1973) *Glossary of Art ... since 1945,* London: Bingley.
Cooke R. (ed.) (1976) 'Performance', *Studio International,* 192, 982. Special issue on performance art.
Goldberg, R. (1978) *Performance: Live art 1909–1977,* London: Thames & Hudson.

pictorial games (AAg), 40, 55–62, 159, 160, 161
Games in which the team motifs to be fused on the matrix consist of pictorial imagery.

planner (AAg), 4, 20, 21, 26, 29, 46, 47
Role in the AAg communication relay (qv).

play, 3, 14, 15, 46; see also tactics.
Play becomes game when it is organized to achieve a specific outcome, 'a free activity, ordered to a definite end' (Montessori, op. cit.). For Herbert Read play was a form of art, and therefore 'All forms of play (bodily activity, repetition of experience, phantasy, realization of environment, preparation for life, group game ...)' are 'an effort to achieve integration with the basic forms of the physical universe and the organic rhythms of life' (Read, see below).

Alschuler, R. H. and Hattwick, L. B. (1947) *Painting and Personality: A study of young children*, Chicago: University of Chicago Press. This is more significant for art-games than any of the following works.
Bruner, J. S. *et al.*, (1976) *Play: its role in development and evolution*, Harmondsworth: Penguin. Consists of readings from many sources.
Huizinga, J. (1970) *Homo Ludens: A study of the play element in culture*, St Albans: Granada Paladin. Huizinga emphasized the importance of play in civilization. A great work by a scholar who had little or no real understanding of art.
Lowenfeld, M. (1935) *Play in Childhood*, London: Gollancz. Lowenfeld devised the now famous world-tray technique and the mosaic test.
McLellan, J. (1970) *The Question of Play*, Oxford: Pergamon. This is a good short work on children's play.
Read, H. (1943) *Education through Art*, London: Faber, 110.
Schiffer, M. (1971) *The Therapeutic Play Group*, London: Allen & Unwin.

pointilliste, 122
The word is used here in the sense of a configuration consisting of small discrete modules. It is borrowed from the term for an impressionist art technique which makes use of points of coloured paint to build up an image by the additive mixture of colours.

polarities 152; see also heteronomy.
Some works which stress similar polarities to those which have been found useful in AAg are:

de Ropp, R. S. (1974) *The Master Game*, London: Pan. Dr de Ropp is a biochemist specializing in brain research. He identifies four brain centres relating to instinct, intellect, emotion and movement.
Lüscher, M. (1953) *Psychologie und Psychotherapie als Kultur*, Basle: Test Verlag. This short work gives a brilliant exposition of the active–passive, autonomous–heteronomous polarities in relation to art and culture.

probability, 121
Austin, J. H. (1978) *Chase, Chance, and Creativity*, New York: Columbia University Press.

Borges, J. L. (1965) 'The Babylonian Lottery', in his *Fictions*, London: John Calder.

Caillois, R. (1962) 'The importance of games of chance', in his *Man, Play and Games*, London: Thames & Hudson.

David, F. N. (1962) *Games, Gods and Gambling. A history of probability and statistical ideas*, London: Griffin.

probability, transition, 121–6; see also Markov Chain.
A number between zero and one expressing the relative likelihood of a system passing from its present state to a new succeeding state.

project(s), 5, 136, 149
In art, the word 'project' is short for 'mental projection' or 'brain-child' of the originator(s) rather than a commission or solution to a set problem, though it may be contained within these. It is a plan or scheme which extends beyond normal practice. In education, 'a high degree of motivation . . . or a minimum duration of time' may be important conditions. (In some ways the word is better than 'game', and 'group-project' is a fair synonym for an art-game). Other definitions of 'project' are given in the following, which does not, however, consider art or game.

Addeley, K. *et al.* (1975) *Project Methods in Higher Education*, Society for Research in Higher Education.

'Psychon' progeny
The following are more simple game-types derived from 'Psychon', each being capable of suggesting many new games:

'Volcano' (Splat v. Dyno) resulting in large-scale fragmented shapes opposed to big straight-edged shapes in hot colours, suitable for themes of epic catastrophe or 'blasting off'.

'Megalopolis' (Dyno v. Logica) resulting in big, well-organized shapes with systematic patterning, suitable for themes of great organization (e.g. drama plus puzzle).

'Think me to your leader' (Dyno v. Esoterica) resulting in big shapes in vibrant colour alongside formless atmospheric effects, suitable for themes of religious experience or dematerialization.

'Puzzle-shooters' (Logica v. Splat) resulting in large chaotic patterning, suitable for themes of ingenuity and discovery.

'Maze-haze' (Logica v. Esoterica) resulting in pattern and atmospheric effect, suitable for mystery and magic.

'Laser-lights' (Esoterica v. Splat) resulting in atmospheric effects and big fragmented shapes, suitable for themes of revelation – the luminous and radio-active or simply vertigo and fantasy.

quanta (AAg), 111
Quanta are the basic design units or modules transmitted from team HQ to the art-work grid. A quantum consists of a colour effect (or in more complex games a line or shape) addressed at a square within the art-work grid by two coordinates. 'Quanta' is the plural of the Latin *quantum*, an amount.

randomizers, 48, 121, 125
Dice, teetotum, roulette wheel, etc.

recorder (AAg), 21, 22, 36
A role in the AAg communication network, especially in the voting at the end of the game when votes have to be recorded.

rectilinear, 131
Straight-lined.

reductionist, 98–9
Reductionism is the view that 'the objective world consists of physico-chemical entities and explicitly describable interactions between them'.

Waddington, C. H. (1977) *Tools for Thought*, London: Cape.

relay (AAg), 143; see also communication.
A relay is a process by which a signal is passed on. In a game with many players the relay of information creates a communication chain passing data from planner to designer and artist.

remote-control game, 161; see also automated art.
An art-game in which the art-work is an output of the communication network can be described as a remote-control game.

Retch's outlines, 15
A completion game in which 'crooked or straight lines of every description' are put down on a piece of paper at random and passed on to another player to become the 'foundation for a little picture of some kind'. *Cassell's Book of Indoor Games*, London, 1882.

ritual, 84, 159
Ritual in gaming involves repetitions and dramatic emphases serving to clarify and reinforce a game's structure and significance. It may also enhance suspense and group action. In the art-based game different kinds of ritual may be associated with the evocation of the scenario (the numinous), the strategy (the ideological), the teamwork (the judicious and dramatic), and the tactics (the formal rules of performance).

Erikson, E. (1978) See the chart 'Ontology of ritualization' in his *Toys and Reasons. Stages in the ritualization of experience*, London: Marion Boyars, Erikson is Professor of Human Development at Harvard.

Levi-Strauss, C. (1967) 'Some relations between games and rites' in his *The Savage Mind*, Chicago: University of Chicago Press.

Spence, L. (1947) *Myth, Ritual, Dance, Game and Rhyme*, London.

roles and role-play (AAg), 25, 117, 155, 156

Role-play is the carrying out of the functions of one or more communicators in the data relay – planner, caller, designer, artist – or the performing of such functions of the game's interplay, as stabilizer, ecologist, mixer, cutter, sticker or spinner, as may be necessary. In a game with only very few players it is likely that many roles will be condensed into one. A full-dress game will require an announcer, commentator and recorder. Some games involve special operators of some kind other than the above, and other games may make use of cultural polarities such as the inward-looking dreamer, the workers of a system, organizers of resources, or exponents of the spectacular.

Where classroom simulations tend to explore real situations commercial role-playing games simulate the fantasy world and exploit the 'spirit of the game', without being particularly competitive. I am assured by a psychologist member of the Hull University War Gaming Society, Penelope Lansdell, that such games as 'Dungeons and Dragons' and 'Metamorphosis Alpha' have a fanatical following. In 'Dungeons and Dragons' you cast the dice for a character such as strength, intelligence, wisdom, constitution, dexterity or charisma. Your task is to get your character out of each dungeon with as much experience and gold as possible, negotiating or killing dragons in the process, which can be a very skilful operation. In fact, you can rise to different levels of achievement – from Warrior to Hero, for example, if your role is that of a Fighter. Other roles are Cleric, Thief, or Magic-user.

Chesler, M. and Fox, R. (1966) *Role Playing in the Classroom*, Ann Arbor: University of Michigan Press. Especially interesting is the chapter on 'Evaluation' for its categories in the evaluation of *enjoyment* in role-play.

rules, 8, 24, 45, 53, 117, 118, 158

It is always valuable for a player of any game to have a clear idea of what is possible and permitted, and of what is impossible or not permissible because, for example, it is harmful. In art, the restrictions of the commission and the constraints of the medium as well as the artist's own self-imposed limitations, are the equivalents of the rules of a game. But the first can usually be inferred from what the commission omits, while the second and third need no mention as already known to the artist. In the game which encourages a group art achievement the word 'rule' is best relegated to the safety precaution and professional studio practice or subsumed under gamesmanship (qv). In many

Art Arena games *tactical* rules are generated afresh at each game during its tactical phase. Yet again, some games may be specifically about rules, as in mathematical games. It is less important to stress rules in creative group games than in competitions which aim at destroying or at least elimination.

scenario (AAg), 4, 5, 6, 14, 20, 23, 28, 39, 40, 41, 96, 108–11, 118, 121, 135, 136, 138, 139, 141, 144, 146, 147, 152, 154, 155, 156

The scenario is the universe and story-line of a particular game, scientific, mathematical, science fiction, biological, geological, etc. The original scenarios of many games in the history of gaming were cosmological. In an Art Arena game it is valuable to have plenty of visual data available relating to the scenario. In science fiction, for example:

Ash, B. (ed.) (1977) *The Visual Encyclopaedia of Science Fiction*, London: Pan.
Sacks, J. (compiler) (1976) *Visions of the Future*, London: New English Library. A selection of science fiction art.
Marten, M. *et al.*, (1977) *Worlds within Worlds*, London: Secker & Warburg. This is a science picture-book of various micro- and macro-universes – crystal, plant, space, human and other 'landscapes'.

Because children's thinking tends to be dependent upon and 'embedded' in a scenario of 'their own affairs', many clinical studies fail to reveal children's full capabilities.

Donaldson, M. (1978) *Children's Minds*, London: Fontana. This argues for greater attention to be paid to the child's world of reality.

'Scenario' is from the Italian for the outline of scenes and main points in a dramatic production.

score (AAg), 134–9

The most important aspect of the score is its assessment of the quality and success or failure of a game as a whole, and not the extraction of comparative data.

self-assessment (AAg), 96, 135, 136

This is a rough-and-ready subjective estimate made by players themselves of their own performance. To do it properly they need to consider all categories of the game and compare these with past experience. Its chief use is as a safety-valve and check against the organizer's assessment.

simulation, 4, 6, 7, 27, 39, 41, 86–7, 95, 97–100, 110, 111, 135, 154

A 'process which is an analogue to some referent system', Raser, J. R. (1969) *Simulation and Society. An exploration of scientific gaming.* Boston: Allyn; or a 'dynamic representation which employs substitute elements to replace real or hypothetical components', Gibbs, G. I. (1974) *Handbook of Games and Simulation Exercises*, London: Spon.

skill, 3, 13, 15, 50, 96, 110, 111, 137, 145, 151, 153, 155, 157, 158; see also tactics

Welford, A. J. (1976) *Skilled Performance*, distrib. Eurospan, Illinois: Scott Foresman.

spectacle, 3, 14, 16, 39, 47, 84, 122

Amiel, D. (1931) *Les spectacles à travers les ages*, Paris: Edition Du Cigne.

sportsmanship, 13, 17; see also gamesmanship.

Whiting, H. T. A. and Masterson, D. W. (eds) (1974) *Readings in the Aesthetics of Sport*, London: Lepus.

stabilizer (AAg), 21, 22, 26

The balancing role of a player who helps to equalize the teams' performances.

Stochastic, 98–9, 121–2

'Stochastic' is an adjective describing a process or series of events for which the estimate of the probability of a certain outcome approaches the true probability as the number of events increases. From the Greek 'stochos', aim.

Stochastic matrix, 121–6, 161

A complete table of transition probabilities (qv). Also see Markov Chain.

strategy (AAg), 4, 6–12, 20, 22, 24, 27, 29, 40, 41–5, 96, 102, 108–11, 117, 118, 135, 136, 137, 138, 140, 142, 144, 146, 152, 155, 156, 158 (grand)

A team strategy is its masterplan (qv) and the use made of it in the disposition and development of resources at the art-work surface. The word is derived from the Greek 'strategia', generalship.

Klee, P. (1968) *Pedagogical Sketchbook*, London: Faber. (Art)

Jones, C. J. (1966) 'Design methods compared, 1: Strategies', *Design* 212. (Design)

Williams, J. D. (1966) *The Compleat Strategyst, being a primer on the theory of games of strategy*, (Rand Corporation research study), New York: McGraw Hill. (Game theory)

Art and play: Bill Harp of Liverpool uses the term 'patterns of proposition' for suggestions for art and art-game ideas. Our AAg idea of strategy comes much closer to this looseness than to rigid game-theory strategy.

Harp, B. (1970) 'The Great Georges Project – Liverpool' in: A. Schovaloff (ed.) *A Place for the Arts*, North West Arts Association.

super-goal games, 23, 157

Games in which conflict grows into cooperation, and the *game* target embodies, builds upon, and transcends the *team* or players' goals.

superordinate goal (AAg), 3, 16, 51

A main target goal which goes beyond both individual and group goals in

that it cannot be achieved by one of the cooperating teams alone.

Sherif, M. (1966) *Group Conflict and Cooperation*, London: Routledge & Kegan Paul, 88 ff.

surrealist art-based games, 15, 99; see also automatisms, '*Cadavre exquis*' and hybrid games.

Matthews, J. H. (1978) *The Imagery of Surrealism*, New York: Syracuse University Press.

synthesis (AAg), 23
The aesthetic success of an Art Arena game always depends on the quality of fusion and homogeneity of visual ideas contributed by the teams to the finished art work.

tactics (AAg), 4, 15, 23, 27, 31, 47–50, 94, 108–11, 135, 136, 138, 142, 144, 146, 152, 155, 156
The art of manoeuvring in the field of play, negotiating the contrasting approaches of another team, and interrelating, superimposing, interpenetrating or fusing with them. The word 'tactics' comes from the Greek 'taktika' manoeuvring in the presence of the enemy.

Jenks, C. and Silver, N. (1972) *Adhocism. The case for improvisation.* London: Secker & Warburg.
Jones, J. C. (1966) 'Design methods compared, 2: Tactics', *Design* 213.

target (AAg), 14, 16, 20, 22, 23, 27, 32–3, 44–5, 52, 110, 111, 135, 136, 138, 143, 144, 146, 155, 157, 158; see also goal.
A limited objective. The chief of the commission targets is the balance and unity of the contrasting team interests; next the strategy (the making and using of the masterplans). The three well-defined targets of commission are thus usually *balance, strategy*, and the *tactical rules* for the creation of the spectacle. A less well-defined – or even ill-defined – target is the evocation of the scenario and the satisfying of its needs. There are also two tacit and undefined *goals* rather than targets: co-operation and enjoyment.

team and teamwork 12–15, 19, 20, 22, 27, 30, 45–7, 110–11, 135, 136, 138, 139, 142, 143, 144, 146, 152, 153, 155, 156, 158
An AAg team is a group of players contributing towards the achievement of the same ultimate goal as another group of players in the same game, though through a different mode of performance and with different initial targets. The AAg teams begin as discrete units with autonomous powers of linkage with each other in any way they like. When the interplay begins the group structure then becomes in theory a star formation with the Art Arena grid at the centre and communication relays from all the teams' HQs forming the arms of the star, as many as there are teams. After the unscrambling the team

relays break down into individual strategical agents, moving at will over the Art Arena, homing now and again to one reference point, the team masterplan.

Davis, J. H. (1969) *Group Performance*, Reading, Mass.: Addison–Wesley. (Group structures)
Middleton, M. (1967) *Group Practice in Design*, London: Architectural Press. (Design practice)

thinking (visual), 3, 5; see also strategy.

Albarn, K. and Smith, J. M. (1977) *Diagram. The instrument of thought*, London: Thames & Hudson. An evocative but highly idiosyncratic work.
Arnheim, R. (1970) *Visual Thinking*, London: Faber.
Bongard, N. (1970) *Pattern Recognition*, London: Macmillan.
Gregory, R. L. (1970) *The Intelligent Eye*, London: Weidenfeld & Nicolson.
Kepes, G. (1966) *Module, Symmetry and Proportion*, London: Studio Vista.
Moles, A. (1968) *Information Theory and Esthetic Perception*, Urbana, Ill.: University of Illinois Press.
Young, A. M. (1977) *The Geometry of Meaning*, New York: Dell.

three-dimensional games, 100–2
Art and Design
Buckminster Fuller, R. (1975) *Synergetics. Explorations in the geometry of thinking*, New York: Macmillan.
Critchlow, K. (1969) *Order in Space*, London: Thames & Hudson.
Jehrin, J. J. (1971) 'Synergetic sculpture', *Arts in Society* 8, 1, 415–18.

Games-making
Civardi, A. (1975) *Know How Book of Action Games*, London: Usborne. Kids' kitsch games.
Friedberg, P. M. (1975) *Do-It-Yourself Playgrounds*, London: Architectural Press.
Wickers, D. and Finmark, S. (1975) *Play Outside*, London: Studio Vista.
Zechlin, K. (1975) *Games You Can Build Yourself*, New York: Sterling. Excellent translation from a German original.

transition probabilities, 121–6; see also probability.

Trobriand cricket, 14

Leach, Dr J. (anthropologist) *Trobriand Cricket*, a film made for the Government of Papua New Guinea by G. Kildea.

umpire, 21, 26, 92, 134, 135; see also animateur
An umpire is a person outside the teams, usually the animateur, who presides inconspicuously and acts as arbiter in disputes. The word umpire is from the

obsolete 'numpire', from the Old French *nonpair*, the odd man out who so being is referable to as a judge.

unscrambling conference (AAg), 22, 30, 93, 103, 143, 153
The conference at which the mapping of the strategies onto one another is sorted out.

value, 46, 78 (morality), 95, 152, 153; see also judgement.
A central issue of the AAg model is the provision of structures for assessing relative values. In this, the whole subject may be called the axiology of art.

Findlay, J. N. (1970) *Axiological Ethics*, London: Macmillan.

vertigo, 54; see also movement and tactics.
Vertigo is the feeling of excitement in whirling around. It is used as a category of gaming experience by Professor Caillois (see below).

Caillois, R. (1962) 'Simulation and vertigo', in his *Man, Play and Games*, London: Thames & Hudson.

visual thinking, 3, 5, 6, 150–1, 152; see also thinking (visual).

win (AAg), 14, 16, 17, 25; see also lose.
A win in an Art Arena game is one in which the mean assessment of the balance target and the enjoyment goal is above 45 per cent.
The word win comes from the Anglo-Saxon 'winnan', to accomplish by striving.

Newburger, H. M. and Lee, M. (1974) *Winners and Losers. The art of self-image modification*, New York: McKay.

Wff'n proof, 6
This is a type of logic game in which the players construct and prove with propositions in 2-valued propositional calculus, using the Polish notation of Lukasiewicz. It was evolved between 1956–62 by Professor Layman E. Allen of the University of Michigan, and colleagues of the Yale Law School, where the Carnegie Corporation funded the Accelerated Learning of Logic project (ALL) aimed at primary-level school children.

yantra, 7, 8, 78, 114
An Indian geometrical painting used for meditation.

Govinda, L. A. (1976) *Psycho-Cosmic Symbolism of the Buddhist Stupa*, California: Dharma Publishing.
Khanna, M. (1979) *Yantra. The Tantric symbol of cosmic unity*, London: Thames & Hudson.
Pott, P. H. (1966) *Yoga and Yantra*, The Hague: Martinus Nijhoff.
Tucci, G. (1961) *The Theory and Practice of the Mandala*, London: Rider. (This analyses the Buddhist Yantra).

Zen, 15

Awakawa, Y. (1970) *Zen Painting*, London: Routledge & Kegan Paul.
Blyth, R. H. (1976) *Games Zen Masters Play*, New York: Mentor.
Goffe, T. (1977) Judo Games, London: Corgi-Carousel.
Hyers, M. C. (1974) *Zen and the Comic Spirit*, London: Rider.

ADDITIONAL PUBLICATIONS AND SOURCES OF INFORMATION

Books

Avedon, E. M. and Sutton-Smith, Brian (1971) *The Study of Games*, New York: John Wiley. (This covers anthropology, folklore, history, war-gaming, educational and business games, diagnostic games, social science and the function of games, as well as giving extensive book lists.)

Belch, J. (1974) *Contemporary Games: A directory and bibliography* (2 vols), Detroit, Michigan: Gale Research.

Cruickshank, D. R. (1976) *The First Book of Games and Simulations*, Columbus, Ohio: Ohio State University.

Davison, A. and Gordon, P. (1978) *Games and Simulations in Action*, London: Woburn Books.

Diagram Group (1975) *The Way to Play*, London: Paddington Press. (An encyclopaedia of games with full diagrammatic explanation of each game.)

Gibbs, G. I. (1978) *Dictionary of Gaming, Modelling and Simulation*, London: Spon.

Grunfeld, F. (1977) *Games of the World. How to make them. How to play them. How they came to be*, New York: Ballantine Books. (A well-designed and informative colour book, lavishly illustrated with large photographs and diagrams in colour, but lacking comprehensive bibliography.)

Opie, I. and P. (1969) *Children's Games in Street and Pavement*, Oxford: Oxford University Press.

Reichardt, J. (1969) *Play Orbit*, London: Studio International. (Illustrates and explains many artists' and designers' attempts to design games and toys.)

Organizations

Action Space, 16 Chenies Street, London WC1.